VIDEO PRODUCTION
THE PROFESSIONAL WAY

CARL CAIATI

TAB BOOKS Inc.
Blue Ridge Summit, PA 17214

Also by the Author from TAB BOOKS, Inc.

No. 1555 *Airbrushing*
No. 1955 *Advanced Airbrushing Techniques Made Simple*
No. 2112 *Customizing Your Van—2nd Edition (with Allan Girdler)*
No. 2132 *Installing Sunroofs and T-Tops*

FIRST EDITION
FIRST PRINTING

Library of Congress Cataloging in Publication Data

Caiati, Carl.
Video production—the professional way.

Includes index.
1. Video tape recorders and recording. 2. Video recordings—Production and direction. I. Title.
TK6655.V5C35 1985 778.59′9 85-22241
ISBN 0-8306-0915-6
ISBN 0-8306-1915-1 (pbk.)

Cover photograph courtesy of Mattingly Productions, LTD.

Contents

Acknowledgments

This is the most complex and far-reaching book of all the ones I have had the pleasure to write. Due to the complexities involved, I have had to rely on many people in the video technical and manufacturing field. Most were helpful, but some stand out in giving unstinting assistance and cooperation.

First and foremost is Tom Lauterback of Quasar-Matsushita. Mr. Lauterback, the Quasar advertising and public relations manager, gave his time, and Quasar provided equipment and technical assistance without which this book would have been weak and shallow. In addition, Tom never failed to be on the other end of the phone in a crucial situation or when advice or data was needed, which is rare for public relations people these days.

Joan Ruhela of Ambico also showed what quality advertising and public relations assistance is about. I am particularly grateful to Sony, and especially Barbara Micale of Geltzer and Co., New York, Sony's public relations and advertising representatives. Barbara proved to be the epitome of efficiency. John Kenny and Steve Scherr of V.D.O. were also vital to this book, as was Lester Bogen of Bogen Photo Corporation.

Credit and grateful appreciation to Lisa Caiati, the "resident family artist," for her renderings of storyboards seen in Chapter 8. My son Brett also assisted by producing and creating the cartoon cel animation in Chapter 16.

Kim Chipman helped grace the pages of this book with her pretty face and great modeling capabilities. Paul Perez of Recoton also came through when he was needed.

Sid Weigner greatly assisted with technical expertise and some of the procedures I describe in this book.

I am particularly grateful to Rose-Marie Botting who laid out the groundwork and all the procedures in the computer projects. The kids in the computer program, who also helped Rose, get a vote of thanks, as does Coral Springs Elementary School, which let me use their computer room.

Introduction

Video is fast becoming one of the most popular and practical electronic diversions. It is estimated that by 1990, one out of every four TV set owners will also own and operate videocassette recorders for home entertainment use.

The video camera has already displaced the home movie camera and has made movie film obsolete, expensive, and impractical, though better in optical fidelity. To shoot and process a few hours of movie film would cost a lot of money whereas a videotaped production of up to six hours would not cost more than the price of the videocassette itself. Take into consideration the relative simplicity and ease of operation related to videotape photography, and you can see why the consumer public has taken videotape to its heart.

This book is geared to the videophile who wishes to transcend from home-movie record shooting to more sophisticated production. Even home movie enthusiasts will benefit by some of the hints and tips found within these pages. I discuss basics and basic approaches to more complex videotap-

ing themes. I also delve into the more difficult, select phases of videowork such as animation, electronic special effects, and optical photographic special effects, as well as all the equipment and accessories that make it all possible.

At first glance this might seem to be a VHS book; it isn't. It's just that the predominance of VHS equipment so far exceeds that of Beta that it might seem the book favors the VHS format. My opinion is that the two formats are unequivocally equal in quality, fidelity, etc. The furor over VHS has been promulgated not by a superiority factor, but because the consumer public favors the VHS format and has taken a preference toward it. Accessory manufacturers likewise go the way of consumer favoritism for practical business reasons.

Fortunately, much of the sophisticated electronic equipment is compatible to both formats. Some VHS equipment even is harmonious with Beta.

An in-depth analysis of much of the contemporary available equipment in all formats will help

you analyze and evaluate products that will be essential and valuable to your personalized videotaping system and video production approach. As one of the few books that discusses videotape production and covers everything from shooting to lighting to trick effects, this manual should prove helpful to the serious videophile.

Chapter 1

Video Sources

There are no video supermarkets and not even many video camera shops like the ones we have become accustomed to in the photographic film field. To obtain our diversified state-of-the-art or even general equipment, we must invariably pool our sources, relying on merchandise marts, audio shops, department stores, and so-called Video Shops which specialize mainly in movie rentals, minor accessory, and tape sales in order to bring in the "bread and butter." Generally, the video shops will stock just the lines of one or two manufacturers for economic and stock balancing reasons, which limits consumer selection. The bigger name brand manufacturers do, however, market extensive accessories and relative components so that some consumers may satisfy their wants in a "one-stop" shopping situation.

Keep in mind that a great many accessory items marketed by individual accessory manufacturers that specialize in just one or two items may not be stocked by certain video shops that specialize in high ticketed all-inclusive lines. Then too, many accessory items billed as video components

are common also to the photographic film field, which is bigger, resulting in some accessory items being easier to locate in common camera shops. In this chapter, I discuss various alternatives for video buffs who may be seeking parts or accessories not readily available in video shops.

CAMERAS AND VIDEOCASSETTE RECORDERS

Cameras and recorders are best obtained from authorized dealerships, featuring full equipment lines and full service. The shop should provide full instructions and demonstrations to prospective customers. The customer should receive first-hand information as to the operation of components of interest to the consumer. An ideal type of shop is one that I stumbled across when studying the local video shops. Located in Coral Springs, Florida, Video Days & Ways is an exclusive, modern video shop catering to the serious enthusiast, carrying four lines of equipment on an authorized dealership level. Styled in boutique fashion, the shop was functionally designed by owner Rick Weed, who specifi-

cally fashioned the shop to allow the utmost in product demonstration facilities. Each salable component or component block situated on a modern display case can be fed into individual TV monitors (Fig. 1-1), allowing the customers not only examination but operational privileges as well. Comparisons may also be individually made with customers testing at their leisure prior to purchasing. Operation and usage of the more sophisticated equipment is also demonstrated aptly and exactly by a sales staff quite astute in all facets of videowork (Fig. 1-2).

The prospective videophile should seek out a similar establishment prior to purchasing his equipment. In this way he will not have to rely solely on advertisements or writeups which may be misleading or confusing. Equipment may be studied and sampled first-hand and all features may be examined in order to familiarize him with integrated controls of various components. In this manner the consumer can best evaluate what equipment is best suited to his individual needs.

LENSES, FILTERS, AND OTHER OPTICAL DEVICES

Generally, for special visual effects, lenses and filters are easily obtained from any of the better camera stores or camera chains, which usually stock an ample array of color, starburst, soft focus, split image and rainbow filters (Fig. 1-3). In addition to the filters, camera shops will stock adapters, stepup or stepdown rings or filter holders that will simplify mounting to individual videocamera lenses.

TRIPODS

Light-duty tripods are carried by many better

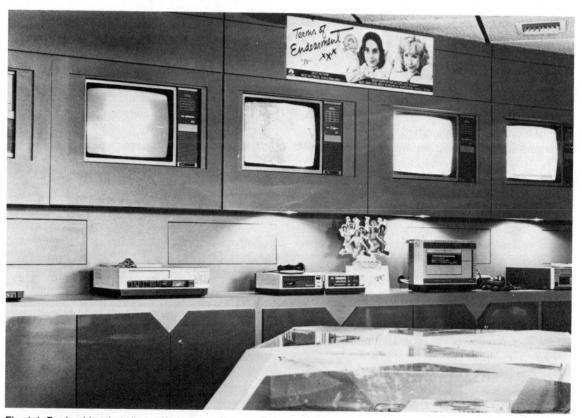

Fig. 1-1. Dealerships that allow self service testing will best enable you to choose equipment tailored to your own specific needs. Courtesy Video Days & Ways.

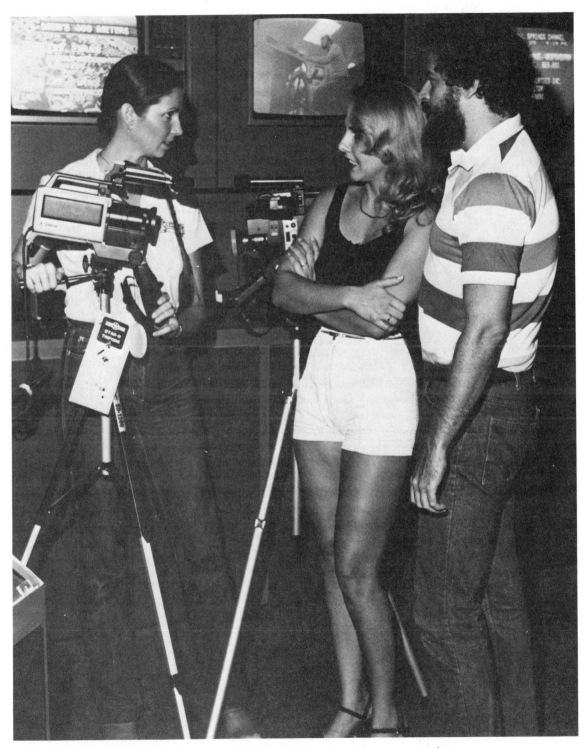

Fig. 1-2. On the spot instruction and demonstration are the keys to good customer service.

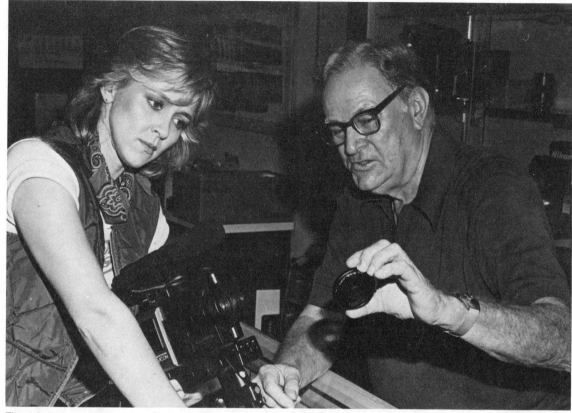

Fig. 1-3. Local camera dealers are the best sources for filters and lens equipment.

department stores and basic camera shops. The light-duty models may not always be applicable to video camera support, as the standard large video camera needs more than adequate support, not generally offered by the light-duty models. Lighter tripods are only for 35mm still camera work. A good studio or heavier duty tripod is best located by browsing through large or professional commercial camera stores. Chapter 7 will serve to enlighten you in the proper selection of a tripod for video-camera work.

LIGHTING EQUIPMENT

Aside from handheld or small camera-mounted quartz iodide units, you will seldom find sophisticated lighting equipment in anything but a professional camera store. Scan the Yellow Pages for pro shops that carry, or can obtain by special order the better, more sophisticated lighting systems.

This is the only solution for obtaining larger professional type studio lighting units, which are virtually never stocked in camera chain stores.

EQUIPMENT SALES

Always keep an eye peeled for giant sales, often announced in local newspapers (Fig. 1-4). They are the key to excellent bargains. Some merchandise outlets may feature manufacturer's closeout sales which will make available previous or discontinued component models. This is one way to obtain quality state-of-the- art equipment at high discounts.

DISCOUNT CHAINS

Without a doubt, discount chains offer the best buys. Some major outlets offer discounts as high as 40 to 50 percent. These stores can do this be-

cause they buy from *their* manufacturers in large volume and get better prices, enabling the outlet to pass down the savings margin (Fig. 1-5). The only difference in buying from these types of discount outlets is that you get a "no frills" sale. If the unit purchased is damaged or defective (which is rare) the discount house will not always be responsible.

In most cases, if the damaged or defective part is returned within 24 hours, it will be replaced. After an extended period it becomes a warranty problem that must be handled by an authorized service facility. Through my experience it has been found that 99 percent of the items purchased from a reputable discount house offer no problems. Should minor problems arise, the warranty covers them. If you are economy minded, the discount warehouse is a good video supply source. Don't

expect any red-carpet treatment though when you enter to make your purchase. The margin of profit is slim in the discount warehouse; there is not much time allotted to the customer.

TAPES

There are continous price wars on videotape, and the consumer *always* benefits. It is ridiculous to pay list price for tapes when they can be obtained at a discount. Tape is virtually never defective and packaging and cassette housings are such that they are trouble free and destruct proof. Scan the papers for slash sales. You need wait only a short interval until your particularly favored brand of videotape will go on sale at one of the giant discount outlets. Tape purchases can offer you wide range savings if you peruse your local papers daily stocking up

Fig. 1-4. Giant store sales offer savings on a competitive level.

Fig. 1-5. Discount outlets offer astoundingly low prices.

on your tape supply whenever the price is lowest.

For the more refined projects delineated in this book, I recommend high-grade tape, which is offered by tape manufacturers in addition to their standard consumer line. This tape is considerably more expensive than regular tape, which should give you all the more incentive to scan newspapers and periodicals for tape sale wars.

Chapter 2

Videocassette Recorders

The videocassette recorder (commonly referred to as VCR) is the heart of the video reproduction system. Videocassette recorders run the range from basic to ultra sophisticated. Selection of a VCR is determined by both budgetary status and the intended purpose of the unit. Many consumers relegate the use of their units to basic TV reproduction or video movie scanning. The more sophisticated consumers, to whom this book is geared, will have to look to the more refined state of the art VCR's for the special effects and editing procedures necessary to attain true videocraftsmanship.

BETA VERSUS VHS

There are two basic formats in video reproduction equipment: *Beta* and *VHS*. There is also controversy as to which is the more favorable of the two. VHS is the most popular, having its finger on the pulse of the consumer market. There are some minor differing aspects between the two systems; the buyer should consider the merits of both systems in order to evaluate which system is

more applicable to his individual needs.

Both systems utilize 1/2-inch magnetic tape, but since the videotape traverses through each format at varying speeds and along different guidelines (packaged in different sized cassettes) the two systems are not compatible.

Beta

Many feel that Beta has an edge over VHS in terms of performance even though it offers fewer features. Sony is the forerunner in the Beta marketplace. Toshiba and Sanyo also manufacture Beta units.

Some popular VHS features that are not common to the Beta format are slow tracking, video sharpness controls, auto indexing, and extended long play modes. Pricing between Beta and VHS is striking, with Beta being the more economical format. The lowest priced Beta VCR costs almost 120 dollars less than its economical VHS counterpart. Price differential between Beta and VHS is 50 to 100 dollars in the mid-price recorder range;

in the top-of-the-line bracket, price can vary several hundred dollars.

Beta has recently pioneered stereo and audio fidelity as part of its quality package; VHS is following suit with most manufacturers.

Those of you favoring Beta are advised to stick to the Sony brand, as their offerings are true state-of-the-art representatives in the Beta format.

The Sony Betamax SL-5000 (Fig. 2-1) is about the finest Beta unit manufactured. Featured in the SL-5000 are Betascan high speed picture search, pause control, freeze frame and wired remote control. The SL-5000 also offers 5-hour recording on a single videocassette.

For in-the-field camera work the Sony Portable SL-2000 (Fig. 2-2) excels. The SL-2000 operates with any Sony Trinicon videocrafting goals presented in this manual. Though no one format is superior to the other resolution wise, the VHS format has been found to be more favorable due to its versatility and numerous desirable options. The following units offer the most in the VHS state-of-the-art VCR category.

The RCA VJT 700 is a 5 head stereo unit offering excellent performance at the SP speed. The fifth head provides jitter free stop action and dubbing and editing are incorporated as standard features.

The top-of-the-line portable RCA VCR is the VJP 900. The 900 is a convertible unit that allows removal of the recording (portable) portion for field camera work.

The portable deck section weighs only 8 pounds and contains a special 1 hour running time battery that may be recharged in an hour's time.

The Mitsubishi HS-330UR tabletop VCR (Fig. 2-3) is a "lots of frills" model. Its input selector will allow selection of LINE, CAMERA, or TUNER for input recording sources. Dolby noise reduction makes for clean audio reproduction especially in slow speed mode. Audio dubbing allows individual left or right channel recording if desired. The Mitsubishi Fx4 four-head assembly is an asset for special effects: still-frame; slow motion; speed search. A remote control key pad is also a part of the package.

Hitachi enriches the VCR field with some fine state-of-the-art equipment.

The model VT-11A video deck (Fig. 2-4) provides touch control and automatic re-wind. The fast

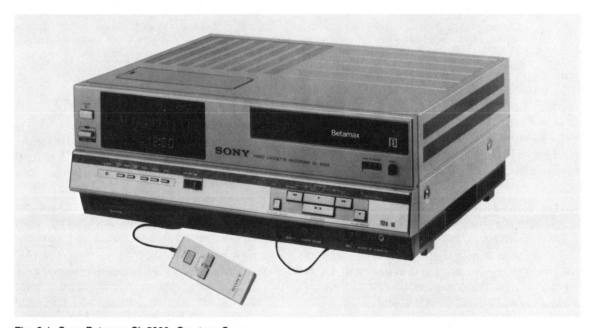

Fig. 2-1. Sony Betamax SL-5000. Courtesy Sony.

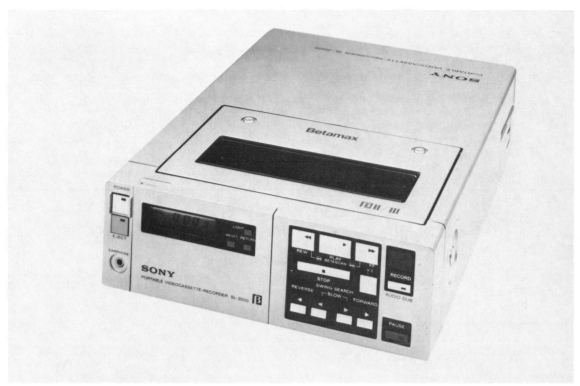

Fig. 2-2. Sony Beta Portable SL 2000. Courtesy Sony.

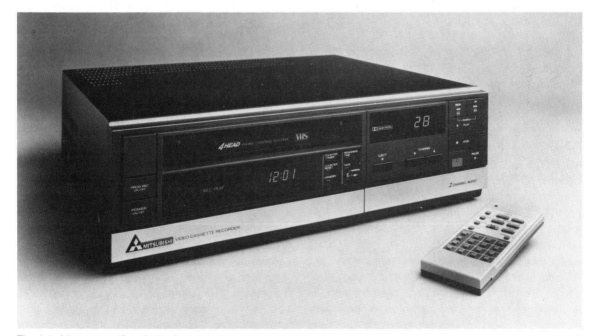

Fig. 2-3. Mitsubishi HS-33OUR. Courtesy Mitsubishi.

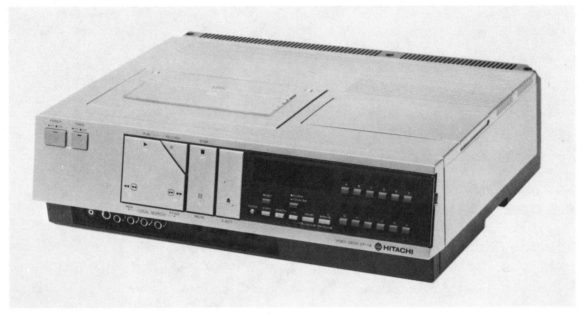

Fig. 2-4. Hitachi VT-11A. Courtesy Hitachi.

forward and reverse and freeze frame video camera features ac or dc operation with an optional rechargeable battery pack. Car battery power operation is also possible with this unit if you have the proper adapter cord. Other features include high speed search and slow motion effects, pause control, and freeze frame. Provision is also made for audio dubbing. The SL-2000 will record up to five hours on a single videocassette.

VHS

VHS can be considered the all encompassing format; newest VHS models (which are plentiful) entice the consumer with a host of functions and options. VHS has become the most formidable of the two formats, far overriding Beta in sales and popularity, with 70% of the current market.

Currently, Hitachi, Matsushita, and JVC are the leading manufacturers of VHS equipment; Matsushita is the most progressive and innovative. Hitachi, in addition to their own line, produces VHS equipment for RCA. Matsushita (also the largest supplier of VCRs for the United States) packages equipment for Quasar, Panasonic, Sylvania, Philco, Canon, J. C. Penney, Magnavox, and Curtis

Mathes. JVC is another large supplier marketing their own VHS brand as well as supplying Akai, Sansui, Jensen, and Kenwood. Mitsubishi and Sharp also manufacture and market their own VHS equipment.

There are many offerings in VHS videocassette recorders. Styling and features will govern for the most part which unit the buyer will select.

Testing and evaluating state-of-the-art VHS recorders, I have found the following versions above average, for the capabilities are also built in.

Two portable VCR models are featured in the Hitachi line: the 3 head VT-3A (Fig. 2-5) and the 5 head VT-7A Portadeck. The VT-7A is one of the most advanced portable VCR's offering a very wide range of viewing effects, including fine slow, stills, frame advance, and reverse play at normal speed. Another inherent feature with the VT-7A is sound with sound, enabling merging of two separate sound sources simultaneously or one after the other.

Another unique Hitachi portable VCR is the VT-680 MA (Fig. 2-6). In addition to traditional 4 head effect features, the VT-680 contains a built in 4″ flat screen color monitor that can be utilized for video photography, playback or editing. This

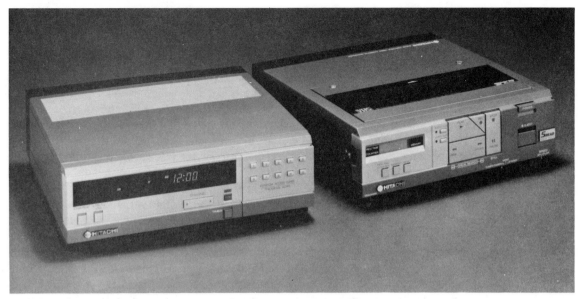

Fig. 2-5. Right, Hitachi VT-3A portable; left, VT-TU3A tuner unit. Courtesy Hitachi.

feature makes the VT-680 a most commendable unit particularly for video editing at home or in the field.

JVC has all the state-of-the-art functions built into their HR- D225 Vidstar model. Included as part of the stereo adaptability package is a special input selection switch for recording FM simulcast programs. An LED simulcast indicator light also informs the viewer when an FM-Video simulcast signal is being transmitted. Picture sharpness can

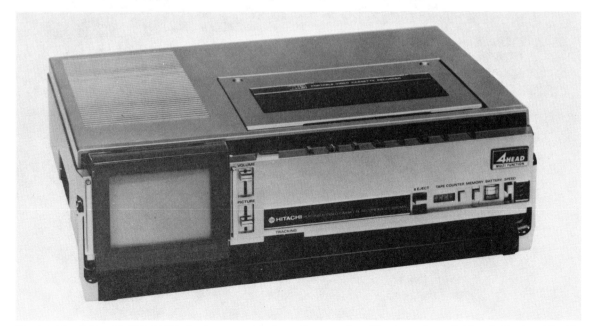

Fig. 2-6. Hitachi Portable VT-680 MA also features a 4-inch monitor, great for editing in studio and field work. Courtesy Hitachi.

be manipulated for sharper or softer effects. Still frame and frame advance facilities are also built in, activated through the VCR control panel or via a wireless remote control box.

JVC also produces the lightest, most compact portable VCR, the HR-C3. The HR-C3 weighs in at only 4.4 lbs. Though light in weight, this compact is heavy in features. Editing and glitch-free consecutive scenes are obtainable due to a special backspace editing feature of the machine. Special video and audio outputs are also provided for editing ease. The special remote control unit of the HR-C3 controls all operations, and specially raised bars between control buttons make it nearly impossible to press the wrong combinations. Ac or battery power options are provided.

The Quasar line is most extensive and of the highest quality due to the unsurpassed Matsushita technology that conceived the components in the Quasar catalog.

The model VH5235 (Fig. 2-7) is the Quasar front-loading design VCR featuring the revolutionary True Track 4 system. The membrane touch controls offer positive one touch operation that is not only novel but highly efficient.

A deluxe upgraded version of the VH5235 is the VH5635. The 5635 is similar to the 5235 but additionally provides full stereo reproduction capabilities and a built in Dolby noise reduction circuit for optimum audio reproduction. Provision is made for foolproof video/audio dubbing. Due to the efficiency of the True Track 4 head system, noise and jitter are eliminated when utilizing the special effects modes. Fast forward and reverse scanning are included, as well as single frame advance for frame-by-frame study. The fine variable slow motion control of the Quasar VH5635 VCR virtually eliminates noise bars in the SP/SLP modes, permitting varied speeds from 1/30 to 1/4 speed for improved scrutiny of subject material during playback.

The most versatile of (portable) VCR units is

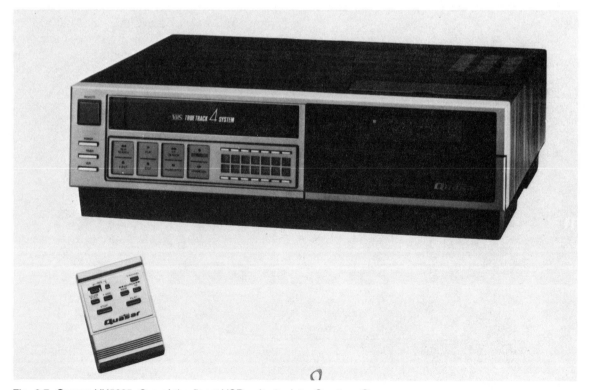

Fig. 2-7. Quasar VH5235. One of the finest VCR units to date. Courtesy Quasar.

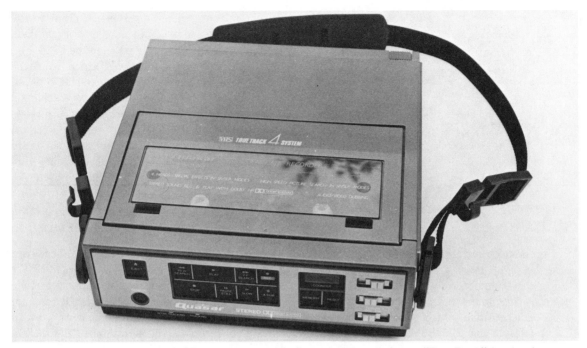

Fig. 2-8. Quasar VP5435 portable VCR. Improved special effects due to revolutionary "True Track" four-head system.

the Quasar VP5435 (Fig. 2-8). This Matsushita component has been upgraded with installation of a four-head video drum which vastly improves recording and special effects playback at SP speed.

Not only is picture quality improved but the special effects created by the True Track 4 system are of the "field by field" type, promoting optimum clarity in the still frame. In still frame mode some

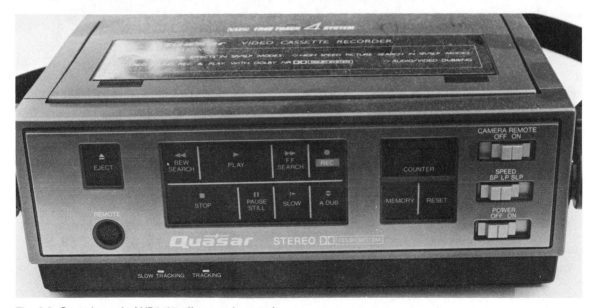

Fig. 2-9. Control panel of VP5435 offers touch control.

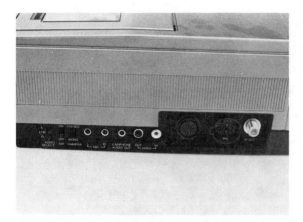

Fig. 2-10. Plug in panel. Quasar VP5435.

VCR's reproduce an entire video frame (two fields). In the new True Track 4 head design, a jitter-free field (half a frame) is reproduced twice, composing a composite frame that is more stable and jitter-free. Touch sensitive controls (Fig. 2-9) are a welcome feature of the VP5435 and give the face of

the component a clean, level look. Adding to the clean look and conveniently located for in-the-field or tabletop work is the plug panel of the 5435 (Fig. 2-10). Here in close but functional proximity are the inputs for camera and power lines, the outputs and inputs for audio/video, left of right stereo channel controls, mike inputs, stereo or mono record selector, rf out-cable connector, and even provision for earphones if desired. A healthy array of cables are provided with the VP5435 for all necessary connection configurations: (Fig. 2-11) dubbing, editing, etc.

THE "HEAD GAME"

You've heard the expression, "two heads are better than one." This particularly applies to VCR's and their designated head configurations. For the casual viewer a 2-head VCR system is adequate for recording TV programs, simple camera work or playing pre-recorded commercial tapes. For the dis-

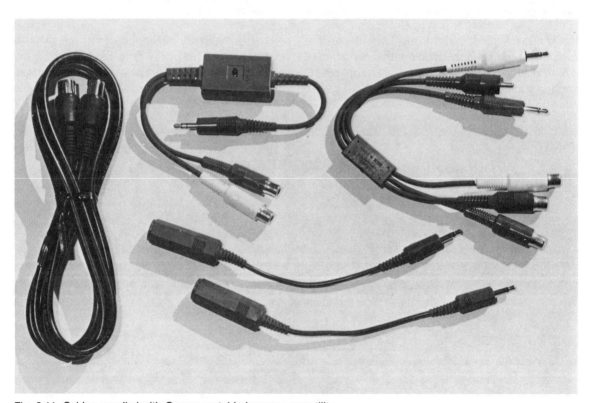

Fig. 2-11. Cables supplied with Quasar portable increase versatility.

cerning videophile, however, multiple head designs are not only desired, but for some special or refined effects, mandatory.

Head configurations go all the way up to 5-head designs and JVC even boasts a 6-head drum. Matsushita (VHS) promotes their conventional 4-head design and is recently promoting its highly refined 4-head True-Track design. Sony (Beta) sticks to its 3-track (SL 2500) configuration, while Toshiba favors its own (V-8500) 4-head design (Beta). Hitachi recently broke through with their highly improved VHS 5-head configuration, with JVC out front in the VHS multiple head race.

Multiple head design machines tend to reproduce clearer images while reducing unwanted horizontal and other noise bars that prevail in special effects modes of operation.

Effects like still or freeze frame were first realized on the early Sony SL-500 Beta machines. In order to freeze frame on the early machines, you pressed a button to achieve the freezing effect. The major drawback was the appearance of a white noise bar that would occur at random within the picture. This primitive system then gave way to an improved, noiseless special effects system in which the tape did not lock in at a random point. In this improved version a noise bar would only appear momentarily for a split second. In consumer VCR, noiseless frame-by-frame special effects did not become a reality till JVC introduced the first 4-head VCR (model HR6700).

Sony broke through again with the "field" special effects applying them in the SL-5800 Betamax. This unit was the first to incorporate 3 video heads. Two of the heads served for recording and playback and the third could be used in conjunction with one of the others to create more controllable special effects. The Sony system was labeled Double Azimuth and is used and promoted by Sony to this day in all high-end Beta VCR's. Double Azimuth seemed the solution at the time, but like any established system there is always room for improvement as the electronics world progresses rapidly technologically. Soon after, Toshiba introduced a 4-head video drum incorporating two record and playback heads with two matched-azimuth heads to create noise free, "field" special effects. The

4-heads were interspersed at 90° angles to each other within the circumference of the video drum.

In VHS, Panasonic countered by introducing two VCR's with matched azimuth systems. These industrial level VCR's (the NV-8950 and 8350) provided matched azimuth systems similar to the Toshiba design. The NV-8950 head system offered an additional improvement: the special effects heads were mounted on a movable (Piezo-electric) ring allowing them to change position as required in order to retrace recorded "field" tracks, enabling high speed picture search free of visible bars.

Recently RCA and Hitachi introduced yet another double azimuth system comprised of 5 heads to duplicate the fault free special effects afforded by the Panasonic NV-8950. In the Hitachi innovated 5-head system, 2 heads record and playback at the SP mode; 2 record and playback at the LP or SLP mode. The fifth special effects head has a matched-azimuth angle which can be utilized for creating interference-free special effects from tapes recorded in either SP or SLP mode. Actually, the Hitachi system (Fig. 2-12) is a 5-head system in which only 4 heads are implemented for recording.

The Matsushita True Track 4 design incorporated in Panasonic and Quasar VCR's is a head system innovated by Matsushita engineers to improve playback of special effects at SP and SLP speeds, eliminating noise bar interference in high speed search, as well as jitter and double imaging in still and slow motion settings.

Unlike the RCA/Hitachi system, the True Track 4 system uses 2 heads for recording and 2 for playback (including picture search). One of the azimuth heads from each pair serves to create steady still "fields" or promote "field by field" slow motion reproduction.

The new True Track 4 system offers optimum noise-free special effects which are jitter and blur free. The reason this system is so efficient is because of the ingenuity involved in resolving the placement of the heads. The 4 heads are not equally interspaced around the drum. Instead, Matsushita incorporates 2 opposite azimuth pairs into a common chip, with the 2 chips mounted opposite each other on the drum. Because of this close positioning, all that is necessary for efficient azimuth match-

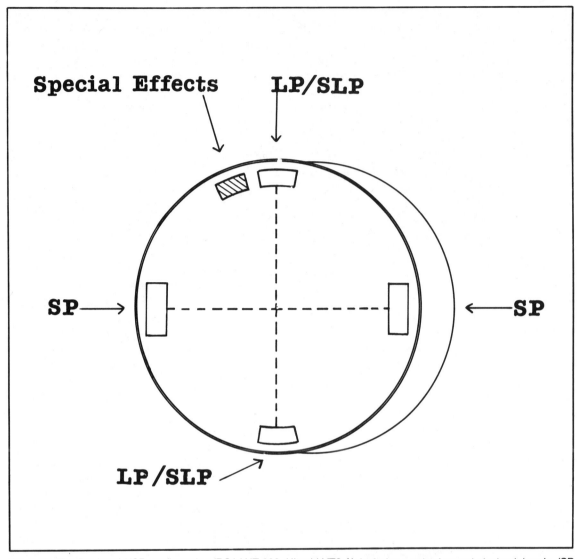

Special Effects

LP/SLP

SP →

← **SP**

LP/SLP

Fig. 2-12. The five head VCR configuration (RCA VJT-900, Hitachi VT3-A) includes a pair of record playback heads, (SP speed) a second set for LP and SLP speeds and a fifth head for jitter-free "field still" and slow motion performances.

up is the teaming up of a plus head (utilized for SP videotaping) on one side of the videodrum with a corresponding azimuth plus head (utilized for SLP taping) on the opposite side of the drum.

Which is best for the intended purpose and goals of this book? My personal preference is for the 4-head True Track 4 System in the VHS format. VHS systems must utilize 4-head (or more) systems in order to attain fault free special effects. The Hitachi/RCA 5-head system is also admirable

but not as good as the True Track 4 Matsushita system, which is the most noise free in field-by-field special effects.

In the Beta format, the Sony system works well at both speeds even though it is only a 3-head system. Toshiba accomplishes the same but with a 4-head setup.

Multi-head designs are more expensive than their more basic predecessors. This is due in part to the fact that multi-head designs require more

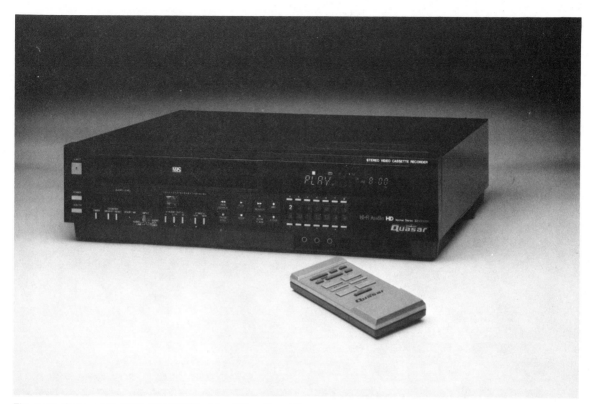

Fig. 2-13. Quasar VH 5346. Hi-Fi VCR of the "New Breed."

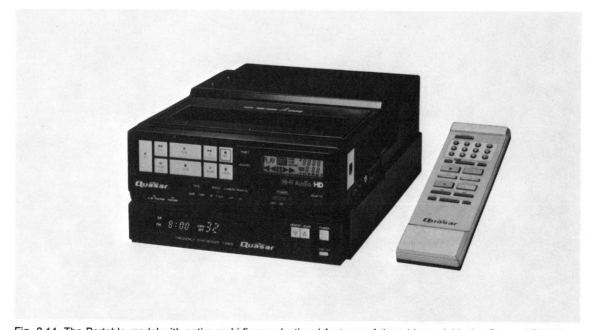

Fig. 2-14. The Portable model with optimum hi-fi reproductional features of the table model is the Quasar VP5747.

sophisticated circuitry (within the videodrum) in order to switch signals from head to head when required.

For the serious videophile the more refined multi-head units are highly recommended; for the advanced videocraft projects depicted in this book, they are almost required. See Figs. 2-13 and 2-14.

Chapter 3

Video Cameras

There is a wide array of video cameras on the market, from basic inexpensive units to more sophisticated units that readily classify as State-of-the-Art. Usually the more expensive units contain refined image pickup circuitry and integrated features that tend to upgrade and automate (thus simplify) operation, increasing camera versatility.

Though there are a multitude of brand names to choose from, all cameras marketed and distributed are produced by four major companies: Hitachi, Matsushita, Sony and JVC.

The leading camera offerings rely on 4 types of internal mechanisms or component blocs for image pickup or light sensitivity: the *Saticon tube*, the *Vidicon tube*, the *Newvicon tube*, or the *Charge Coupled Device.*

Sony promotes the SMF Trinicon tube as the pickup element which is basically the Saticon concept. JVC cameras include the Saticon tube. Hitachi utilizes the Saticon tube in most of their models but also markets a high resolution camera (VK 3400) which alternately relies upon a solid state image sensor. Matsushita utilizes the Newvicon tube, con-

sidered by many experts to be the optimum low light pickup sensor. The Matsushita line goes as far as producing extended-red pickup tube units capable of reproducing images within light levels as low as 25 one-millionths of a footcandle.

Cameras should be evaluated for quality and definition of the videotaped results.

THE SATICON TUBE

The Saticon tube and SMF Trinicon pickup tubes are coated with a Selenium arsenic tellurium layer which helps inhibit lag. Lag is an inherent tube phenomenon which is experienced as sometimes noticeable image decay. Lag is basically the predilection for an image to be retained after camera or subject has moved and becomes more pronounced when light or white images are scanned by the tube. The lag image is exhibited on the screen as a "ghosted" or trailed image. The lag factor can be decreased by using higher light levels or auxiliary lighting. Reduction in the size of the signal plate (governed by manufacturer modification) will also serve to decrease lag. A half inch

pickup area, for instance, will tend to defeat lag more than a tube two thirds or three quarters of an inch in diameter. The only negative factor concurrent with smaller tubes, however, is loss of resolution.

THE VIDICON TUBE

Vidicon tubes use a surface coating layer of Antimony trisulfide. Vidicon tubes are not as effective as other tube types for the prime reason that they are prone to lag.

THE NEWVICON TUBE

The newest Newvicon tubes personify the high point of tube pickup technology and improvement. Newvicon tubes are highly lag-resisting at minimal lighting levels, relying on a surface coating formulation of Zinc Selenium and a band of Tellurium/Cadmium Tellerium. Other factors that amplify the definition quality inherent in the Newvicon tube are:

☐ Bias light for high color sensitivity.
☐ Lag compensating circuitry.
☐ Preamplification of signal pickup.
☐ Color shading compensation.
☐ Stripe filters in the color separation system.

The revolutionary Newvicon tube has many technical advantages. Those of you who are technically oriented may want to peruse the data on Newvicon tubes laid out in detail at the end of this book in the technical section. The Newvicon treatise was reproduced from the Quasar technical manual VK 747WE, complete and in context. It makes for good reading and will enlighten the discerning videophile who wishes a more detailed explanation of the technical aspects of the tube pickup.

CHARGE-COUPLED, SOLID-STATE PICKUP CAMERAS

Cameras relying on solid state pickup draw less electrical power, can be designed smaller than tubed cameras (weighing less), and are more durable (less prone to camera impact damage). The new MOS image sensor featured in the Hitachi and RCA cameras affords good image resolution and compensates for over and under exposure far better than the tube-type sensor. Lag and "bleeding" is also greatly minimized; under good lighting conditions it is practically nonexistent.

The disadvantage is promoted by the physical surface property of the solid state sensor which differs from that of the coated tube.

The face of the solid state sensor device is composed of thousands of separate picture points. If the scene or subject videotaped exhibits fine details that concur with the solid state sensor picture points, strobing (flashing) effects can occur as the camera is panned. In addition, major details may be lost whenever the lens is zoomed in or out. Solid state pickup sensors also require higher light levels for optimum reproduction, a factor not as vital to tube-type pickups.

In my estimation, though solid state sensor cameras offer high-level picture and resolution quality, tube pickup cameras offer wider optical reproduction range from one end of the lighting spectrum to the other. In low-light conditions, tube pickups unequivocally excel.

CAMERA FEATURES

All cameras exhibit special features; some more than others. Automation features seem the keynote with all manufacturers. Which are more important and most applicable in the long run must be deliberated by each videophile according to individual preference and intended goals.

Autofocus

Many cameras contain it, but its importance is open to controversy. The novice requires it; the serious and knowledgeable audiophile can find it a hindrance and not totally reliable; it can be an added feature if it works reliably.

Two modes of autofocusing prevail: one involves infrared waves as a sensory medium, the other utilizes ultrasonic sound waves.

The brands incorporating infrared sensing are GE, Hitachi, Quasar, Panasonic, Philco, Toshiba and Zenith. The newer ultrasonic models are offered by RCA and Panasonic.

The Infrared Category

The infrared mode of autofocus is based on the triangulation measurement principle, which measures camera to subject distance. Operationally, millisecond infrared light bursts are transmitted from windows contained in a special focusing module usually situated under or over the lens or in the front face of the camera. The beams of light concentrate on the closest subject centrally located within the scope of the lens, then reflect back to a sensor in one of the windows. Electronic determination of the reflected beam's angle to the transmitted beam calculates the distance from lens to subject. Then, an internal microprocessor transforms the signal into information which commands a special motor, automatically turning the focusing barrel till it revolves to an appropriate setting. Unfortunately, the infrared method is weak for focusing on small objects and is seriously impeded by very dark surfaces, which tend to absorb the light.

The Ultrasonic Category

In this method sound waves govern the focus setting, eliminating the small or dark subject problem. The ultrasonic system emits high frequency sound waves from a special mini-transmitter also housed in close proximity to the lens. The sound echoes, reverberating to the transmitter receiver section, measuring the lens-to-subject distance and calculating the focus setting. Certain factors will affect the proper operation of the sound wave transmission; for example, glass or other translucent surfaces. Sound waves will bounce back from the surface planes, culminating in a false focus calculation. This can be detrimental if one wishes to focus on a subject or plane behind the glass. Inclined planes will also serve to bounce sound waves in a direction other than the receiver's. Ultrasonic focus is also affected by wind, snow, smoke and heavy rain. Anything that intrudes on the sound waves will affect focus operation. Ultrasonic focusing does not fare well for long distance or scenic photography. In panoramic type situations the autofocus mechanism must be released, with the cameraman reverting to manual focus for positive results.

The novice as well as serious videophile should learn not to rely on autofocusing totally. Fine focus situations depend on utilization of the eye and manual focus (Fig. 3-1).

Daylight-Artificial Light Switch

Incorporated in all videocameras, this switch must be set religiously before taping. In sunlight, use the daylight setting; under artificial light conditions (floods, quartz lites, etc.) make sure the switch is in the artificial light position. This is important in order to attain proper color balance and harmony when videotaping.

Exposure Control

The more sophisticated cameras have a dual exposure control system. One is the automatic white balance control and the backbone of the automatic exposure system. When set, the internal exposure control mechanism will automatically adjust to light reflecting from a white card or large light reflective area. Setting automatic white balance is an effective method of exposure setting, but is not always deadly accurate. Density and color values must be properly evaluated by the cameraman. If one arrives at a proper white balance setting, then proceeds to photograph dark or dense subject material, a loss in definition or color may occur. Though automatic white balance setting is adequate, it is recommended that the discerning audiophile purchase and learn to use an exposure meter. A typical, excellent and reasonably priced meter is marketed by Ambico (Fig. 3-2). This pocket size video meter measures in both foot candles and lux, conforming to the scales or value numbers present on videocamera lenses. The Ambico meter is exceptionally versatile in that it will measure either incident or reflected light. (Proper meter use is elaborated upon in Chapter 5—Lighting).

For general lighting situations the automatic white balance setting will serve the purpose and can be manipulated blindly at the flick of the AWB switch (Fig. 3-3). An internal viewfinder light will automatically clue the camera operator as to when the balance is set. Automatic white balance should be reset whenever lighting conditions change.

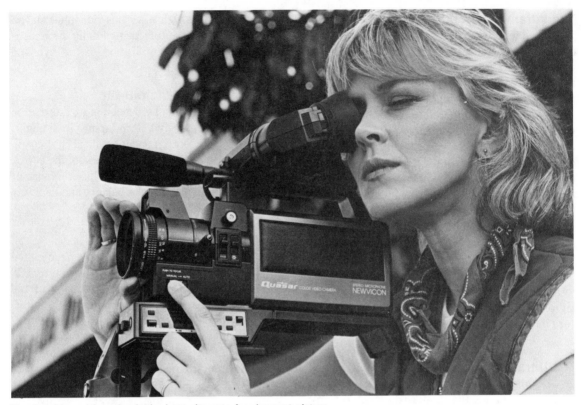

Fig. 3-1. Manual focusing is the best alternate for sharpest picture.

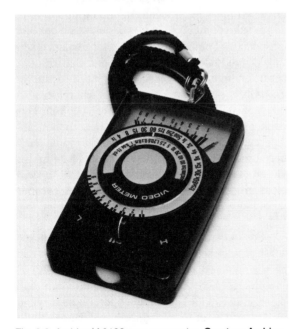

Fig. 3-2. Ambico V-0198 exposure meter. Courtesy Ambico.

To ensure exposure accuracy, which may necessitate manual iris (aperture) control, the camera operator must know how to release the aperture from automatic mode setting exposure by implementing meter readings which will indicate appropriate manual setting of the lens (lux and light value scale). Virtually all cameras contain Auto/Manual Iris control switches (Fig. 3-4). The one illustrated shows the auto control release button on the Quasar 747. When the switch is pushed in to auto-iris function it automatically adjusts the lens opening for the proper admission of light. When the switch is pulled out, the lens aperture may be manually adjusted.

Electronic Viewfinder

All cameras possess electronic viewing systems; they are similar and most effective. The viewing screen inside the eyepiece is similar to a TV screen and when scanned appears to be a min-

Fig. 3-3. White balance can be calculated automatically without removing your eye from the camera. Most cameras will indicate in the viewfinder when white balance is correctly set.

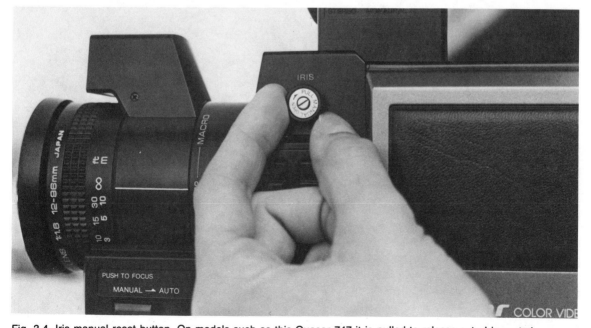

Fig. 3-4. Iris manual reset button. On models such as this Quasar 747 it is pulled to release auto Iris control.

iaturized TV screen. In addition, the viewfinders contain LED or similar indicators that monitor the operations of the camera and clue the operator onto the functions transpiring without his or her eye leaving the eyepiece. The indicators will signal when white balance is set, when the camera is in play or pause mode, and will even indicate fades. The viewfinder modules also offer mounting options so the viewfinder can be secured for left or right eye monitoring. The eyepiece section usually revolves to face up or down for easy eye access if the camera is tripod mounted in overly high or low positions (Fig. 3-5).

Microphones

Most of the microphones offered with cameras are almost in the novelty-item class. They are deficient in quality and operation and offer nothing in the way of good sound reproduction for the serious audiophile. Mounted directly onto the camera, they also tend to pick up motor noises and vibrations. Their sensitivity is marginal; sound pickup and fidelity are less than desired. Their only applicable use is in home movie situations where sound and voice fidelity is inconsequential.

When sound track quality of a videotape is as essential as video quality, external auxiliary microphones should be used for truest sound reproduction. Most videocameras provide phone plugs enabling the videocraftsman to attach accessory, quality microphones which are essential to proper live sound reproduction.

Power Zoom

A great functional additive almost mandatory for ease in aesthetic and functional purpose is the power zoom facility, fortunately an integral part of all state-of-the-art cameras. The power zoom switch allows the cameraman to zoom in for selective close-up or zoom out to achieve wide angle effects.

Fig. 3-5. Eyepiece viewfinders are adjustable for versatility in varied viewing angles.

Most power zoom cameras also feature a speed control which allows zoom speed setting according to individual preference.

Character Generators

The top level videocamera offerings provide character generator circuits that aid the user in producing his own titles. Titles may be injected, deleted and superimposed on the videotape where desired. They can even be faded into a scene segment while taping live situations. Though an icing-on-the-cake feature, having a character generator as a built-in feature is an option highly recommended. Cameras with this integrated feature tend to be more costly but well worth the added expense.

CAMERA AND VCR COMPATIBILITY

Though rf signals will transmit, playback, and record through all video equipment, intermixing brands of components may not always be feasible, due to the fact that the big four manufacturers have never fully standardized. Most companies differ in the means of channeling video, audio, and operational functions from cameras to VCR's as well as transmitting power between VCR and camera. Sometimes, even common brand names may be incompatible due to the mode of cable and plug attachment. There is one means of connection available to virtually all, however; using RCA (audio type) plugs to connect VCR's to VCR's or using the camera "black box" power unit which will accept multi-pin hookup on one end and translate it to the RCA plugs on the other. Of course you must purchase the "box" designed for the specific camera to be used. The ultimate solution is to use similar, compatible brand name components, but occasionally the consumer may prefer the operational facilities of one camera and the VCR merits of a contrasting manufacturer. This can pose a problem if you do not know which brands will successfully interface with others. Sales people can be misleading as many of them spout the erroneous theory that any ten pin plug camera will connect to a 10-pin VCR receptacle. This is *not* true. Standards all VHS manufacturers agree on only stipulate that their components utilize 10 pin connectors, that pin #ten serves as the 12 volt power connection and

that pin #9 is the power ground. The remaining eight pins leave functional control routing to the discretion of each manufacturer. When mixing cameras and VCR's in the VHS format you will most likely be able to manipulate record, sound, and pause functions using the camera's cable. For contrasting brand units that do not interface properly due to differing pin assignation, you can either purchase adapter cables or have them tailor made by a reputable repair facility. Various manufacturers provide differing (opposite) polarities in the stop and start functions of the pause button. When the polarities conflict, the "running" indicator light in the camera viewfinder will light up when the VCR is not recording and go out while it is. This problem is being overcome as more and more cameras are adding trigger polarity switches which internally reverse and rectify the problem.

Though Beta Cameras can be used with VHS equipment (or VHS cameras with Beta), cameras by Beta manufacturers use 14 pin connectors as opposed to the VHS camera's 10 pin plug. For those who wish to intermix Beta and VHS camera components, 10 to 14 pin adapters (which also serve as 14 to 10 pin converters) are available. Consult a knowledgeable dealer, the manufacturer, or the manual before deciding which way to go and what interconnections best serve your particular purpose. Even with proper 10 to 14 pin cabling it is often impossible to make review or remote VCR control functions on Beta cameras work with VHS recorders since the cables themselves don't transmit this function.

A number of manufacturers feature common compatibility which facilitates interfacing between certain brands. For instance, JVC, the most adaptable, features three-position switching, making their GX-N5 camera compatible with Matsushita VCR's and with a special 10 to 14 pin cable, Beta VCR's. The JVC GS-N70 camera with two position variable switching makes it compatible with Matsushita, Sharp and Beta portables. The Okai VCX2 camera incorporates a four position switch, making it connectable with Hitachi, RCA, Sharp, and Matsushita.

As an example illustrating pin functions, study

Fig. 3-6, a schematic diagram of the pin pattern for the Quasar 747 camera cable (Matsushita).

VHS CAMERAS

The many videocameras produced today give the consumer a wide choice; they are all good units. However, a few models stand out as superior offerings which I consider true state-of-the-art cameras: top of the line quality units capable of the optimum reproduction requirements desired by the serious videocraftsman.

Quasar 747 WE

Probably the finest tube pickup camera capable of extremely high resolution and extreme versatility in all light level conditions (Fig. 3-7). The 747 even features highly desired stereo recording capabilities which I feel should be incorporated into all state-of-the-art videocameras as a required feature.

The new improved Newvicon type S4165 pickup tube in the 747 features unequalled resistance to burns due to bright light conditions and reflectance, with minimal ghosting, coupled with the F:1.6 lens optimum definition even under the lowest lighting conditions prevails. As a low light camera, the 747 excels: under average to bright lighting conditions the 747 offers color harmony and clarity not surpassed by any other contemporary offering.

In addition to low light formidability, the lens exhibits excellent characteristics in zoom and macro function plus sharpness throughout its entire zoom range.

Other admirable features include: Monochrome electronic viewfinder (left or right side mount option); Auto-focusing; VHS compatibility switch allowing use of the camera with most other VHS portable recorders; automatic white balance control; record review capability allowing monitoring of the last few seconds of recorded material on viewfinder screen at the touch of a button; auxiliary stereo microphone inputs for external microphone (600 ohm impedence) connection. The Quasar 747 was personally selected over other brands for use in the projects and videocamera work featured within this book. As an added option the 747 offers character generator and titling facilities which are efficient and simple to implement. Titles may be printed in three colors.

Canon VC-20A

The Canon VC-20A is another excellent camera. Produced by Matsushita, it is similar in both appearance and function to the Quasar 747 but relies on the Hi-band Saticon tube for high resolution image and light pickup. Auto-zoom, auto focus, and a character generator are additional integrated features. The VC-20A is stereo-audio compatible.

RCA Selectavision CC030

Newest and most revolutionary in the RCA line, the CC030 (Fig. 3-8) features the new solid state M.O.S. (Metal Oxide Semiconductor) pickup

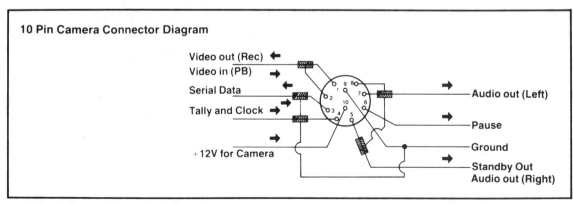

10 Pin Camera Connector Diagram

Video out (Rec)
Video in (PB)
Serial Data
Tally and Clock
+12V for Camera

Audio out (Left)
Pause
Ground
Standby Out
Audio out (Right)

Fig. 3-6. Pin Pattern (Matsushita). Courtesy Quasar.

Fig. 3-7. Quasar 747 camera; state of the art at its peak.

Fig. 3-8. The RCA CC030 with solid-state pickup.

Fig. 3-9. The CC030 viewfinder scans in color and is removable to act as a mini-monitor.

system free of troublesome image "lag." The camera also contains a white balance control that automatically and constantly adjusts color balance as lighting conditions change.

The unique, new viewfinder (Fig. 3-9) views and scans in full color. The revolving eyepiece is adjustable and detachable for remote viewing. The viewfinder also doubles as a color monitor for instant replay. The automatic new focusing system will zero in on the camera's subject, adjusting focus accordingly.

RCA CKC020

This new 2.2 pound camera is an ultra-light model that does not sacrifice state-of-the-art features. With the handle tucked in, the CKC020 folds down to a compact 5×5×8 inches.

The unit contains a one inch black and white electronic viewfinder, auto iris, power zoom, manual Macro adjustment, and automatic/manual white balance control. The basic drawbacks with the CKC020 are right hand operation and manual focus (which is of no real consequence to the pro).

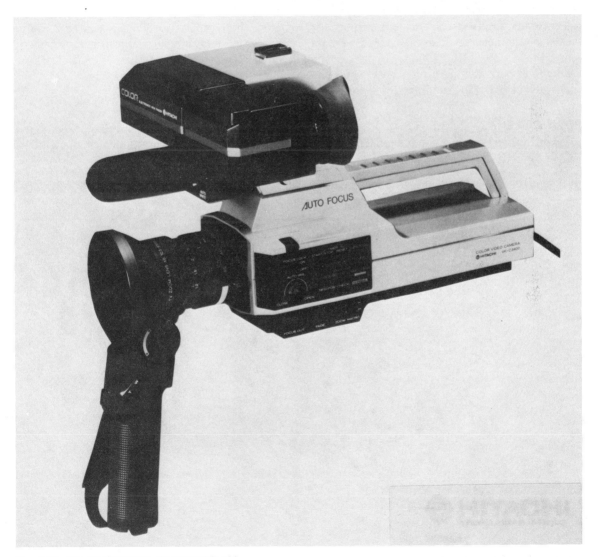

Fig. 3-10. Hitachi VKC-3400. Courtesy Hitachi.

It features the M.O.S. solid state sensor, and it is the most light sensitive camera incorporating solid state sensing. The CKC020 is lag resistant, consumes less power and needs no warm-up time. It's a mini marvel.

Hitachi VKC-3400

The VKC-3400 (Fig. 3-10) is the Hitachi counterpart to the RCA CC030, offering such similar desirable features as a 2/3 inch M.O.S. solid state sensor, color electronic viewfinder, F 1.2 6:1 zoom lens with auto focus and auto iris. A built-in character generator to insert titles, date and time into scenes is also included. Like the RCA solid state sensor models, the VKC-3400 is not considered a low-light camera but performs most admirably under adequate lighting conditions of 35 lux or up.

BETA CAMERAS

Beta cameras are marketed under various brand names other than Sony, but in my opinion, the top level Sony models are the forerunners in the Beta format.

Sony HVC 2800

The Sony HVC 2800 (Fig. 3-11) is similar to the HVC 2500 but is more light sensitive as well as lighter. The SMF Trinicon sensor tube offers high sensitivity and minimized lag, working well in light levels down to 20 lux. Also featured is internal fade control, power zoom from tele to wide angle with variable zoom speed from 6 to 12 seconds. The electrons viewfinder acts as a replay monitor for instant in-the-field playback. Automatic white balance control and Macro lens facilities are also part of the high quality package.

Sony HVC 2200

Another first rate Beta offering by Sony, the HVC 2200 (Fig. 3-12) also contains the goodies

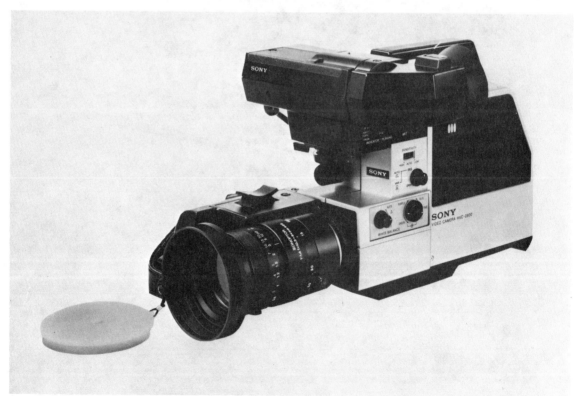

Fig. 3-11. Sony HVC-2800; class in the Beta format. Courtesy Sony.

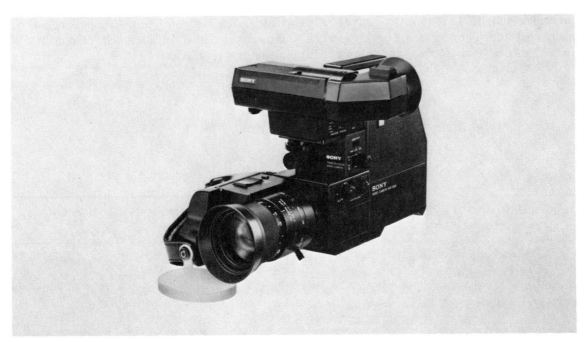

Fig. 3-12. Sony HVC 2200. Courtesy Sony.

Fig. 3-13. Quasar VK 724 XE. Courtesy Quasar.

prevailing in the HVC 2800. A distinctive feature also found on Sony cameras is a peaking switch. In low light conditions, focusing and viewing is difficult. The peaking control aids in sharpening viewfinder image contours. Also, if the peaking switch is on during fading, an image will still remain visible on the viewfinder.

Chapter 4

Videotapes

After VCR and camera, the most important facet for good videotaping is the videotape itself. There are many standard high and low grade tape materials available; selection should be motivated mainly by use or application and quality of resolution. With the wide discount sale options on tapes today you need not be concerned pricewise. For instance, the Luskins discount outlets offer many hi-grade tapes, discounting the tapes to a $5 to $8 level, making even hi-grade tapes feasible for any videophile's budget.

Selecting a brand of tape applicable to your particular use should be as simplified as selecting fruit once you have determined what your requirements are. You can go by the guidelines presented in the various tape writeups in contemporary video magazines, study the manufacturers specifications, and make comparison and resolution tests of your own. For the high level quality results specified in this book, stay with the reputable brands and always choose their top of the line tapes in order to attain optimum reproduction.

TAPE QUALITY

The criteria to be considered when evaluating tape performance are *luminance, chroma* and *dropout count*. These should be studied and evaluated when matching one tape against another.

Luminance

Luminance is the indication factor for how much "snow" or video noise is inherent in a black and white picture. This is visually also indicated in terms of bad or weak contrast. For people favoring black and white taping (which is rare or confined to collectors) this measure is of little importance when selecting tapes for duplication or even rare black and white taping. Calculated in terms of decibels, good luminance figures should attain more than 42 dB; virtually all marketed good quality tapes exceed this figure and the superior Maxell HGX Gold tape reaches a 45.6 dB figure.

Chroma

Chroma, like luminance, is expressed in "sig-

nal to noise ratio" terms and also calculated in decibels. Again, the higher the number, the better the chroma. Chroma figures are indicated as AM chroma and PM chroma; a 40 dB is average for AM and a 39 dB is average for PM in standard grade tape offerings. AM (Amplitude Modulation) chroma figures are similar to luminance measurement but with snow and noise imperfections appearing along the horizontal lines of the color picture. PM (Phase Modulation) chroma aberration presents itself in color change, as opposed to snow or noise effects.

Dropout

Dropouts which are visually transmitted into the picture, are inaugurated by imperfections in the blank tape coatings and manifest themselves in the form of glitches, white specs, horizontal white lines, and in extreme cases, a rolling picture. Dropout count is evaluated by size and frequency of the visual "noise" aberrations encountered. Short dropouts last an average of five microseconds; long dropouts may measure around 15 microseconds. These are minute time increments but nonetheless visually apparent; and in the case of long dropouts, most annoying. A rate of fifteen dropouts per minute (large or small) can be considered average, and large scale dropouts usually are rarer than small ones. Ideally, the fewer dropouts the better, and for this reason limited dropout high grade tapes are chosen and desired; for the purposes and projects presented in this book, almost mandatory.

With personal testing and comparison evaluation you will discover that differences may be insignificant in regard to brand names. The most visual differences will become apparent through scrutiny between standard-grade tapes, high-grade tapes, and ultra-high grade tapes. In general, high-grade tapes offer superior luminance and chroma factors coupled with lesser dropout rates. A difference of 3 dB or more in chroma value, for instance, can affect color tonality which is visibly detectable.

Unlike film, there is no such thing as black and white or color reproducing tape; videotape unilaterally serves both functions within control of the user. High grade tapes offer little in terms of quality enhancement when used for black and white reproduction. The higher grade tapes show their superiority when used in videocamera work, affording the best color and minimal dropout rate. High grade tape is essential for dubbing from original or commercial tapes. Clean, clear tape reproduction will be more the rule than the exception when highest grade tapes are utilized.

THE EVOLUTION OF TAPE

To give you a better understanding of videotape per se, I shall go into the evolution of tape from its inception to the current marketed tapes which have been popularized in two basic formats: Beta and VHS.

Ampex is credited with the first manufactured videotape released in 1956, formulated for Ampex's production video recorder. The world's first video recorder used two inch tape and utilized four record-playback heads integrated on a drum which revolved along the tape as it was transported longitudinally. This enabled the laying down of parallel tracks and the utilization of high tape-to-head speed. This concept allowed an hour of taped material per reel with each single reel of tape costing over a hundred dollars. This system proved to be so beneficial that this original recorder concept is still in use and favored for many broadcasting and taping applications.

In the early 1970s Sony made its impact in the videotaping world, introducing the innovative U-Matic cassette system which used videotape cassettes the size of a book, housing 3/4-inch wide tape. This method of tape containment presented a more convenient, more portable overall package; even the recording machinery was more compact.

In 1975 Sony introduced the Beta-Max as the first consumer oriented video recorder based on the U-Matic principle, but utilizing an even narrower tape format, 1/2 inch. It has been widely accepted and used to this day.

Months later the VHS system was introduced by Matsushita, also on a 1/2 inch tape format. It was the first cassette system to extend the one hour recording time with initial provision of two hours recording time per cassette.

Today, Sony and VHS tape formats are in strong competition, with the general public favoring the VHS System, though both formats provide good quality consumer reproduction systems.

TAPE DESIGN

Another factor affecting tape performance is cassette enclosure and design. Keep in mind that in order to record the video audio signal on the tape, the tape must be carried across the heads at a steady speed without twisting or slipping side to side. The key to proper tape transport is the cassette housing; the housing can be as critical to recording and playback performance as the tape itself. Physical properties of the tape must also be considered. Tape width must be consistent and exacting throughout to minimize weaving and twisting which can distort picture and sound quality.

Today each tape manufacturer is concerned with incorporating long term reliability, color fidelity, and audio quality into their products, while minimizing dropouts and other visual noise tendencies. TDK has introduced a super high-grade tape with tinier magnetic oxide particles, improving signal-to-noise ratio by increasing tape output, which has improved picture resolution.

PD Magnetics and BASF are concerned with developing chromium dioxide super-hi-grade tapes, which also show significant upgrading of signal to noise ratios.

Maxell, a leading and progressive tape manufacturer, has improved bonding between oxide and tape backing.

Scotch (3M) has vastly improved the mechanical finishing of its tape, treating the surface with an antistatic medium which inhibits dust buildup.

When choosing a tape for either the Beta or VHS format and before judging it as your standard, study tests and reviews, manufacturers specs, and above all, make personal tests and comparisons.

Inherent color saturation or hue and resolution is not universal; the color intensity and quality of one tape may appeal to one observer but not another. The variances along these lines are not as apparent as with photographic color films for instance; but one may prefer the color or color tendencies of one videotape to another in personal terms or for specific interpretation or enhancement of the videotape project. When selecting a tape, ignore the statements that specify using a particular tape for a specific VCR or camera; all tapes of the same format are compatible for use in all recorders. Of course the quality of the VCR heads can drastically affect tape performance, but this is not a major problem unless recording on a cheap VCR and consecutively dubbing on a top-of-the-line model.

When testing a videotape you should use the best source material for test recording whether live taping or dubbing from VCR to VCR. You must study and scrutinize tape for dropouts, color fidelity and picture resolution. Watch for picture quality loss if the tape has been frequently viewed. If any one tape tested outperforms its counterparts in your estimation, then it is the brand best suited to your particular camera or VCR.

I personally advocate the use of a high-grade or super-high grade tape. They are unequivocally the highest in quality, offering the best reproduction possible, particularly at the slower recording speeds.

AUDIO QUALITY

For the serious videotaper who is considering live video, audio reproduction should also be considered. Audio performance is also measured in terms of signal to noise ratio. This can be especially critical when recording in stereo which has recently been implemented in VCR's and videocameras. As in the case of video, audio signal-to-noise ratio measures the amount of noise, but in audio, *audible* aberrations are considered (harmonic distortion-background hiss). In stereo, the sound quality and clarity of Beta is superior to VHS at present, but the gap is closing as VHS is undergoing upgrading on the audio level. Ideally, the audio tracks of the VCR should record uniformly or equally regardless of frequency or musical pitch. Unfortunately, audio tracks, when video-audio recording, exhibit poorer frequency responses at the extreme bass and treble levels. If sound is important, check the

manufacturer's audio specs in addition to video performance specs for determining what tapes may be most suitable.

8MM VIDEOTAPE

The newest videotape format to hit the market is the 8mm tape cassette touted and promoted by Kodak for use in the newer scaled-down cam-corders. The miniaturized cassettes utilize tape half the width of conventional VHS, Beta formats, and are obtainable in 30, 60 and 90 minute lengths.

Though the 8mm cassettes are competitively priced, the cameras and video systems are costly. As for picture and reproduction quality, I feel that the serious videophile will be more satisfied sticking to the VHS and Beta formats though I predict that the 8mm system will have a great impact on the consumer and may well become a most acceptable format.

Fig. 4-2. PD Magnetics standard grade.

The following is a listing of quality tape offerings which we have tested and evaluated in terms of which were most applicable to the goals and aims of this book.

For the most discerning videophile I would recommend available reprints of Beta and VHS tests compiled by the CBS labs which give critical and exacting unbiased evaluations. The reprints may be obtained by sending $2.50 to:

Tape Test Reprints
c/o Video Review
350 E. 18 St.
New York, NY 10028

TAPES

BASF (Fig. 4-1). In the Beta Format the luminance signal to noise ratio is above average whereas the AM & PM signal to noise ratio is a bit

Fig. 4-1. BASF tape has above-average luminance. The Hi-grade Chrome version even better.

Fig. 4-3. Pd Magnetics Hi-grade.

below. Dropouts are fairly low, gaining towards the end of the tape.

BASF VHS Tape (Chrome). Some dropout at beginning and end of tape but a good low long term dropout rate throughout. BASF (Chrome SHG) even better. Some dropout at beginning and end but video and audio frequency response better than average.

PD Magnetics (Figs. 4-2, 4-3). Dropouts at end and beginning of tapes characteristic in both Beta and VHS formats. Audio frequency response and signal to noise ratios are among the best exhibited and luminance is above average.

Polaroid HG. In both formats this tape is of exceeding quality even though the company is a newcomer to videotape production. Polaroid promotes less long and short term dropouts; this tape also features above average video frequency response and signal to noise ratios. Audio frequency response above average extending to 12.5 kHz in

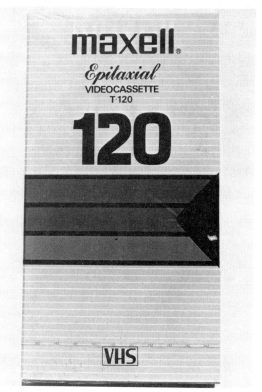

Fig. 4-4. Sony Dynamicron T-120. Specifications are low on audio but the color excellent.

Fig. 4-5. Maxell Epitaxial is a superior, all-around tape.

Fig. 4-6. Various quality brands.

Fig. 4-7. A newcomer in the tape field is Quasar Super HG. High-quality results.

VHS form. In VHS it is an excellent choice and particularly applicable in situations where fine detail, color accuracy, dropout free pictures and good audio reproduction is relevant. Audio specs in the VHS format exceed those of the Beta format.

Sony Dynamicron (Fig. 4-4). Another above average videotape in both formats. Overall low short-term dropout count and an especially low long term dropout rate. Other performance characteristics are average; color is excellent, specs a bit low on the audio bandwidth.

Kodak HGX T-120, T160. Equally good in Beta and VHS formats formulated for optimum picture sharpness and color brilliance which is immediately apparent. Dropout factors are better than

average; HGX is an excellent all around high grade tape.

Maxell Standard (Fig. 4-5). A superior all around tape with low short term dropout, excellent signal to noise ratios, excellent signal retention and good video frequency response. Only negative factor is high 30 microsecond dropout count but this is usually only encountered at the extreme end of the tape, making it a negligible factor. Reproductional all around quality prevails in both Beta and VHS formats.

Maxell HGX. An even higher grade tape, Maxell's HGX Gold offers even a lesser dropout factor at extreme ends of the tape. Well above average audio measurements, signal-to-noise-ratios and bandwidth. Of optimum quality, Maxell HGX is excellent for critical video recording and excels on the audio end.

There are many brands of tapes available to the consumer and no one brand can appeal universally (Fig. 4-6).

For the exacting work undertaken and featured in this book, the aforementioned brands gave the best, fault-free results. My personal preference was for the Maxell HGX if I had to choose one over all the others. My basic reasons were above average color saturation and clarity, minimal dropouts, long and short term; and audio reproduction somewhat better than with other videotapes. I also highly recommend the Polaroid and Sony offerings also in the high grade versions.

Whatever tape (Fig. 4-7) and whatever format you select, prior to videotaping or recording, run the fresh out-of-the-box tape through the VCR in the fast forward, then rewind mode. This will loosen and free the tape which may have inherent stickiness due to prolonged shelf storage. If possible and if time permits, run the tape in playback mode to stabilize the surface area more, resulting in less dropouts. Whenever possible, rewind only before use, so you don't have to store the tape in a tightly wound state, which can affect tape performance down the road.

Chapter 5

Lighting

Lighting is as important in videotaping as in all photo reproduction. Without light you have no picture; with inadequate or improper light balance you will experience quality and color loss.

THE BASICS OF LIGHT

To familiarize yourself with the qualities of light, you must first have a basic understanding of its color, texture, intensity, and direction in order to understand how it will affect video camera reproduction. This chapter will enlighten you on the proper use of light, whether it be natural or additive.

Natural Light

Almost every conceivable type of lighting, including that presented within this treatise, can be observed in nature or outdoors where the singular predominant light source is the sun. Studio or artificial light must also imitate basic natural illumination.

Daylight, whether it is comprised of bright sun-

light, or overcast, cloudy conditions, has one singular aspect: it projects downward; directly at noontime and somewhat angled at different times of the day. Since light helps us to perceive objects or overall definition, we assume or accept that all lighting should simulate this downward, natural illumination. Outdoor lighting can be corrected, enhanced or added to; in the studio it can be manipulated to achieve special, even distorted effects.

Another fundamental of natural lighting is that it emanates from a single source; (the main light is the sun). In artificial or studio situations we must also emulate this one-source approach even though auxiliary lighting must be utilized to fill in or balance the overall lighting ratio to enhance or minimize shadows, reflections, etc. Save for dramatic or trick effects, a natural approach to lighting is favored: outdoors, techniques that serve to balance and fill in the natural source are required in order to maintain the one light concept.

One must take into account the daylight and learn how to use it as a basic factor, manipulating it as much as one can with auxiliary equipment in

order to arrive at correct and well balanced exposures. The video photographer works with three dimensional objects which translate to two dimensional reproduction through the camera. The cameraman must try to achieve a three dimensional look in a two dimensional transition. Lighting is the key factor assisting in mastering and presenting the three dimensional illusion. You must understand and learn to manipulate the differences in highlight and shadow in order to match or harmonize with the capabilities of videotape.

Artificial Light

There are two types of artificial light: *instantaneous* and *continuous*. Instantaneous light comprises electronic flash or single burst bulbs. This type of lighting is useless in video work; the videophile is only concerned with continuous artificial light sources such as floodlights or quartz iodide (high intensity) light sources. These are known as studio lights. They are usually bulky and must be mounted on stands or dollies.

INVERSE SQUARE LAW

In order to properly apply natural or artificial lighting you must understand the *inverse square law*, which is not very complicated, even to the neophyte.

The greatest discrepancy between natural and artificial illumination is that artificial illumination diminishes in intensity as it radiates from the source. The rule works the same in nature, but the sun source is so far off that light will saturate with equal intensity objects that are even miles apart.

The *inverse square law* defines that *light diminishes in intensity as the distance between light source and subject is increased*. The intensity of light is inversely relevant to the square of the distance between light and subject. With a light source at a given distance from subject or object illuminated, the light will cover an area proportionately to the physical qualities of light source intensity and reflection.

As an example: when a subject is double the *original* distance from a light source, it will receive only a quarter as much light intensity since the light is covering an area four times the original area. As light spreads out it diminishes.

These factors are adequately compensated for by using automatic white balance exposure settings or calculation with exposure meters important to have in order to properly determine exposure settings. The inverse square law applies in most lighting situations save for when light diffusers, barn doors or other beam manipulating lenses (spotlights) are introduced into the beam source.

TYPES OF ARTIFICIAL LIGHTING

Photofloods. Photoflood bulbs are similar to conventional home light bulbs and must be placed in special reflectors. Reflectors come in many sizes and shapes and the size, depth and degree of polish of their reflective surfaces govern the quality and intensity of light emitted. Photofloods burn very brightly for their wattage and will last only several hours before they expire and must be replaced. They are convenient in that the average #2 photoflood bulb will work on normal household current. Photofloods burn at either 3400° K. or 3200° K. There is not much difference between the two except that the 3200° K. bulbs will burn longer. Using the artificial light setting found on videocameras will allow proper color balance between tape and light source when using 3200° K. and 3400° K. lamps.

Quartz Iodide and Tungsten Halogen Lamps. Extremely popular and favored for artificial lighting sources, these bulbs have quartz tubes and self-regenerating filaments. Though much more expensive than standard photofloods, these bulbs have extremely long life and are available balanced for 3200° K., 3400° K. and 5500° K. (daylight). They are extremely versatile, very portable and the most efficient artificial lighting source of all.

BASIC ARTIFICIAL LIGHTING

To illustrate some basic lighting configurations, here are the following typical setups commonly utilized.

Flat Lighting (Fig. 5-1). In this setup, the lights are placed at an equal height and distance to

Fig. 5-1. Lighting setup #1.

the subject. This ensures an even flat lighting though undramatic effect (see insert closeup).

One Light (Mainlight) (Fig. 5-2). Here the light is placed high and at a 45° angle to the camera. This type of lighting gives good modeling for the face but creates strong shadows.

Mainlight with Fill (Fig. 5-3). Here we utilize the mainlight in the same manner as the previous setup but add a second light of equal intensity at another 45° angle to the subject but at twice the distance. Here we preserve the modeling effect of the previous setup but open up the shadows for a more pleasing effect.

Sidelight (Fig. 5-4). Here the light is placed at a 90° angle to the camera and is effective for certain dramatic effects though tending to create a harsh shadow area. Fill in can be used to counteract some of the heavy shadow effect.

Dual Bounce Light (Fig. 5-5). This is a two light bounce setup using one light bounced off the ceiling and another off a side wall or reflector. This type of indirect lighting is good for soft light and soft shadow effects.

Single Ceiling Bounce Light (Fig. 5-6). Main light is placed close to the ceiling and to the left of the subject. Good soft effects and modeling prevail but bounce fill as in the previous setup adds to the illumination clarity.

Bounce Light with Umbrella (Fig. 5-7). Bounce lighting using umbrella reflectors is popular and affords excellent, pleasing lighting results. Facial features are considerably softened, making this a very flattering form of illumination.

Grotesque Lighting (Fig. 5-8). Strictly for effect, this type of lighting gained popularity in horror movies. To achieve it, the mainlight source is placed below the face near the floor facing upward. It is a highly unflattering and "scary" lighting effect.

EXPOSURE METERS

No videocamera freak can be without an ex-

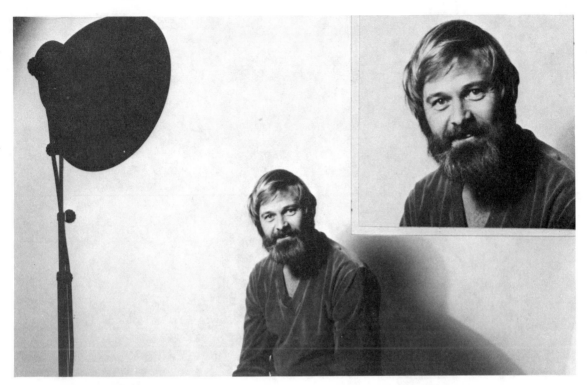

Fig. 5-2. Lighting setup #2.

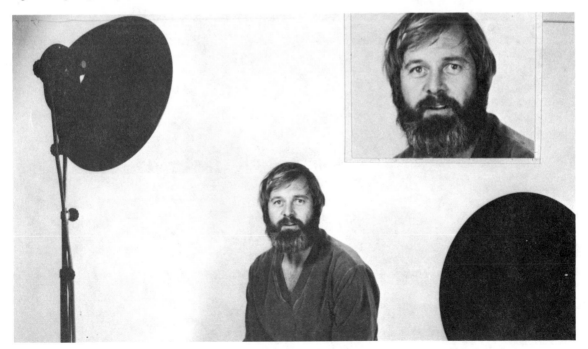

Fig. 5-3. Lighting setup #3.

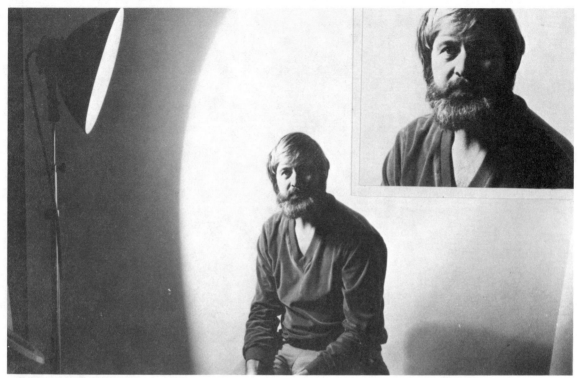

Fig. 5-4. Lighting setup #4.

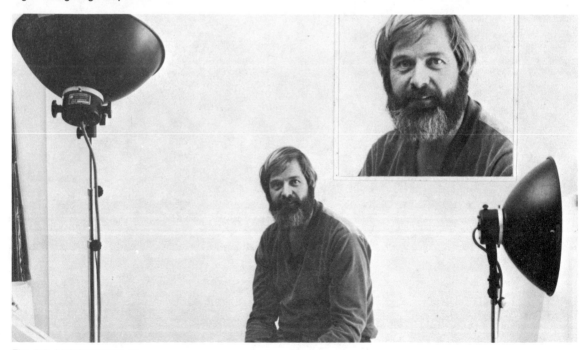

Fig. 5-5. Lighting setup #5.

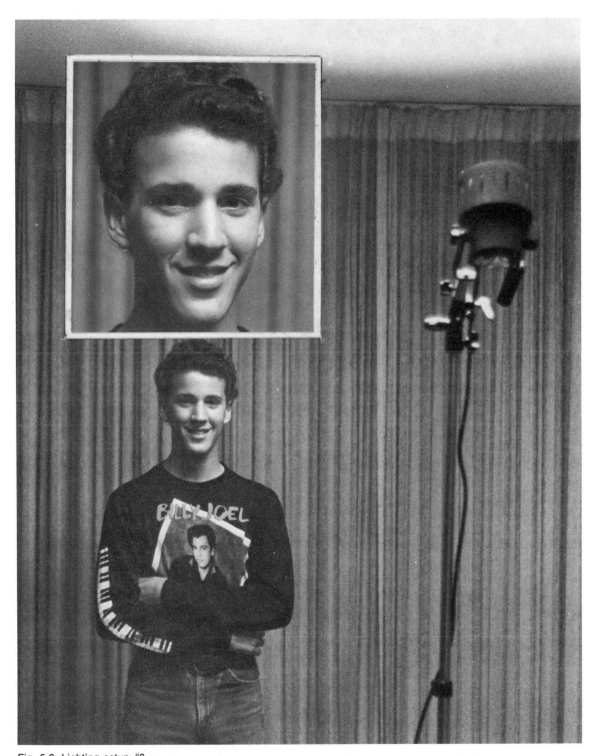

Fig. 5-6. Lighting setup #6.

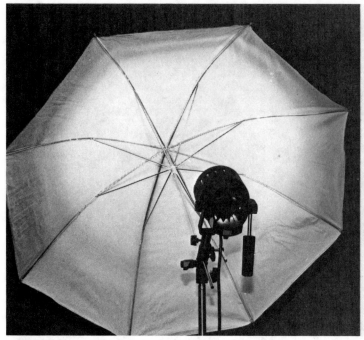

Fig. 5-7. Lighting setup #7.

posure meter if he wishes to obtain optimum results and fine picture fidelity. The white balance settings on all videocameras are adequate, but they cannot compete with accurate illumination reading and brainwork necessary for proper exposure compilation.

If you are relying on automatic white balance setting, discrepancies in lighting may influence unwarranted automatic settings which may counteract the proper illumination balance on the subject.

Shooting a figure standing against an open sky is an excellent example. At camera distance, the overbright sky will influence automatic white balance setting, closing down the aperture. This will give a perfect sky exposure but the subject will go dark. Reading the exposure factor directly from the subject up close with the exposure meter will give a more accurate exposure for the subject. The white balance meter can also be fooled. If you are shooting in shade and there are patches of sunlight in the picture area, the automatic white balance element may pick up the stray light affecting the exposure setting. Exposure meters are also effective

Fig. 5-8. The effects of "Grotesque" lighting.

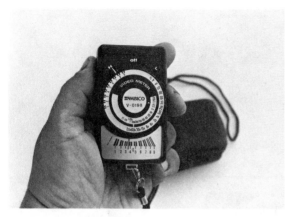

Fig. 5-9. Setting the selector switch: "H" for normal lighting; "L" for low lighting.

in calculating proper exposure when lighting is below specific levels.

An excellent video light meter highly recommended for its efficiency and reasonable price is the Ambico model V-0198; it will measure in footcandles and lux scales widely used and prevalent on all state-of-the-art videocameras. This meter can also assist in determining whether the brightness

range of the subject is too extreme for obtaining high quality images.

For normal light the selector switch is set to high or "H" position (see Fig. 5-9). In low light situations this indicator switch is moved to align with the "L" position.

The photocell will read either incident (light falling on the subject) or reflected (light reflecting off the subject). To measure incident light, the diffusion grid (at the frontal plane of the meter) is slid over the photocell (Fig. 5-10). The light is read from the subject position with the photocell facing the light source (see Fig. 5-11). The setting ring can be turned with the thumb (Fig. 5-12) until the transfer index scale marker coincides with the number indicated by the printer in the exposure scale window. The proper footcandle or lux value can then be read from the scale and set on the camera.

To measure reflected light, the sliding photocell cover must be moved to the side exposing the photocell (Fig. 5-13). The meter is pointed at the subject (as close as possible) and the setting ring is revolved (as in Fig. 5-12) till the marker indicator coincides with the pointer number. Exposure is read

Fig. 5-10. The diffuser in position for incident light reading.

Fig. 5-11. Reading incident light.

off in the same manner as with incident reading. The "H" and "L" switch also serves to turn the meter off and on since it is battery powered. Make sure the switch is in "off" position (Fig. 5-14) when not in use.

QUALITY LIGHTING SETUPS

There are varied and numerous lighting sources from simple to complex. Featured here are the more formidable units in both the luxury and economic price ranges. Also included for reader study are recommended lighting accessories to upgrade lighting versatility.

Since photofloods are antiquated and not as well suited for video work, we recommend and present the currently favored quartz iodide types following.

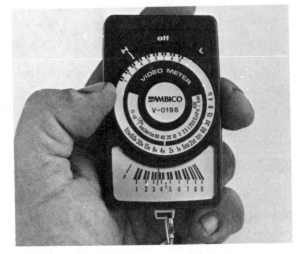

Fig. 5-12. Aligning pointer and scale to obtain lux or footcandle reading.

Fig. 5-13. Sliding panel set for reflected-light reading.

Studio Lighting

In the studio lighting category probably the most prominent offerings are by Bogen, a leading manufacturer of quality lighting. Bogen units are efficient and sturdy and can be purchased in sets or singly.

The best lights for video use are the Model 7000 and model 7050, both using Quartz halogen lamps for high light output.

The Bogen model 7000 (Fig. 5-15) weighs only 2 lbs. 13 oz. and features a 600 watt DYS quartz lamp. The 7000 has an integrated handle for aiming or moving the light.

The Bogen model 7050 (Fig. 5-16) provides a 3 to 1 continuously variable flood ratio and a broad source transmitting soft, even, light. A locking support permits adjustment through 270: The axial focusing assembly works on ball bearings adjustable by means of a rear knob which functions smoothly even under high temperature.

A number of fine and necessary accessory items are also marketed by Bogen. In Fig. 5-17 are two light stands for light mounting that will work with Bogen or other brand units with proper adapters. The 3086 compact is an 8-foot stand that telescopes down to 34 1/4 inches. Mounting stud is 5/8 inch for standard studio lights with 1/4-20 thread adapter. The 3082 master stand extends to 11 feet and closes down to 41 1/2 inches. Light mounting stud is identical to the one on the 3086. Excellent

for heavier type studio lights.

Acme-Lite manufacturing has been around as long as I can remember. Their line of lighting equipment is good, extensive, and reasonably priced. The Acme model 710SL (Fig. 5-18) produces brilliant illumination and a wide angle light pattern 110 degrees by 100 degrees. It comes with its own barn doors and universal swivel bucket. The model 710LL is identical but contains a special 400 hour long life lamp particularly suited for videotaping.

Portable and Convertible Lighting

The ultra compacts can be used under studio conditions but are particularly applicable in the field and on camera mounting.

Bogen M-100 Mini Video Light

Particularly handy as a portable unit, the M-100 weighs only 1 1/4 lbs. and attaches to standard camera shoe adapters. An accessory handle allows hand held off camera use. The Bogen Mini Lite (Fig. 5-19) comes complete with barn doors, handle, safety glasses, shoe adapter, and cigarette-style plug adapter, allowing it to conform to most battery pack units.

Smith-Victor Q 250

A budget priced unit, the Q 250 serves as stand mounted or camera mounted illumination and

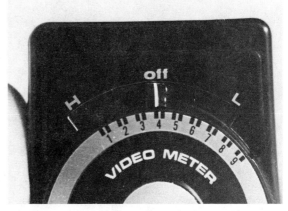

Fig. 5-14. Meters should be shut off when not in use.

Fig. 5-15. The Bogen 7000 quartz lamp studio light with accessory barn doors.

Fig. 5-16. The Bogen 7050 studio light. Courtesy Bogen.

comes complete with a 250 watt 3200° K., 50 hour quartz lamp and shoe mount bracket.

Acme-Lite Low Voltage Videolights

The extensive Acme-Lite line also features some commendable portable lighting units. In Fig. 5-20 we see two of their most popular units the model 7DL and model 7PB. The small compact 7DL features a 250 watt quartz lamp with a 75 hour duration. Battery powered, it features cigarette-type plug and has barn door provisions on the housing. The 7PB (3 × 3 inches) is a 100 watt unit with a 50 hr. quartz lamp that is battery operable.

The Model PBB is a combination package containing the 7PB light and a compact but efficient battery pack (Fig. 5-21).

Ambico

Ambico markets two units that are compact, sturdy and ideal for both studio and field use.

The Ambico V-0100 (Fig. 5-22) is a combination Flood/spot unit that will mount on stands or camera shoes (see Fig. 5-23). The handle mount makes it easy to hand hold the V-0100 for off camera shooting (Fig. 5-24). The light intensity at the center of the beam can be adjusted from 60 to

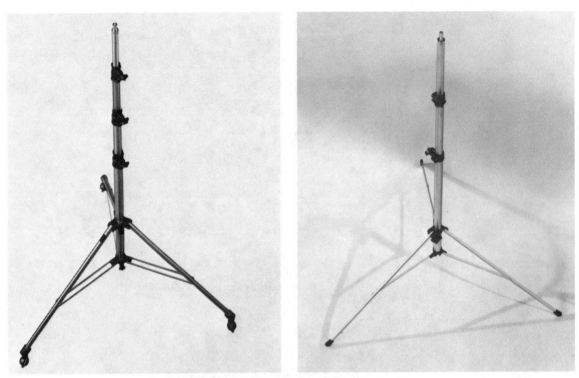

Fig. 5-17. Bogen light stands. Left: 3082 master; Right: 3086 compact. Courtesy Bogen.

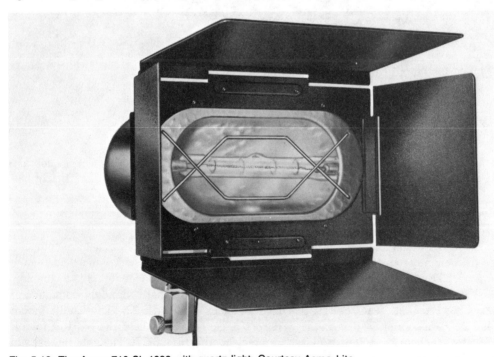

Fig. 5-18. The Acme 710 SL 1000 with quartz light. Courtesy Acme-Lite.

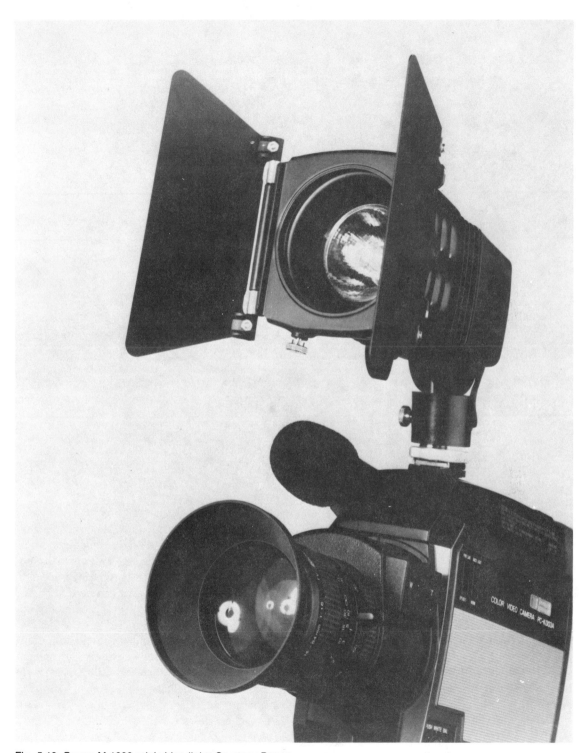

Fig. 5-19. Bogen M-1000 mini-video light. Courtesy Bogen.

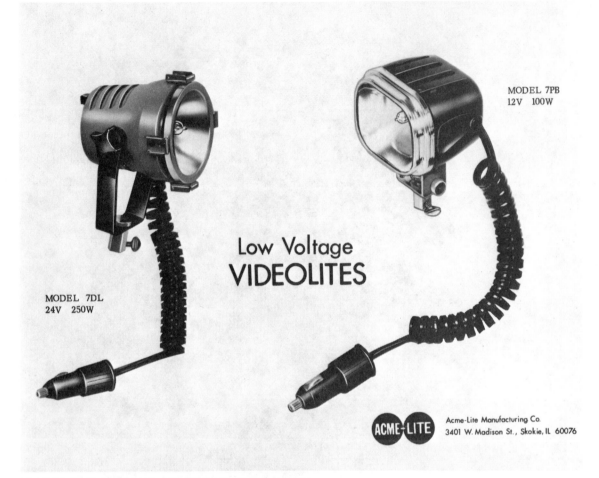

MODEL 7PB
12V 100W

Low Voltage
VIDEOLITES

MODEL 7DL
24V 250W

ACME-LITE Acme-Lite Manufacturing Co.
3401 W. Madison St., Skokie, IL 60076

Fig. 5-20. Acme low-voltage video lights. Courtesy Acme-Lite.

150 foot candles at 100 feet. Lamp, handgrip, table-top mount and extension cord are all part of the package.

The Ambico V-0200 (Fig. 5-25) is the mini-lite in the Ambico line, featuring 100 watt quartz-halogen lamp, Facet-focus reflector for optimum light dispersion, and a tilt control for 120° bounce lighting. Also available is a V-0800 battery pack that can be purchased as a light battery package or separately (Fig. 5-26).

VDO-Lite

Manufactured by VDO (the power pack people) the VDO-Lite is a very reasonably priced unit and one of the most versatile manufactured (Fig. 5-27). Its dynamic modular design allows compactness for packing plus ease of mounting either on stand or camera. Because of its uniquely designed bracket, the VDO-Lite can be swiveled side to side, while the light housing can be tilted up or down; a commendable feature. Three model options are provided, further increasing the value of this unit. The L9000 model features ac/dc operation; the L8000 model features ac operation; and the L7000 features dc operation. The L9000 is the most recommended model as it makes this light unit applicable for all videotaping situations. The VDO-Lite ac/dc model is supplied with both a 250 watt 110 volt lamp and a 75 watt 12 volt lamp. A special adapter plug set up allows both cigarette-type

Fig. 5-21. Acme Lite battery unit; PBB combo kit. Courtesy Acme-Lite.

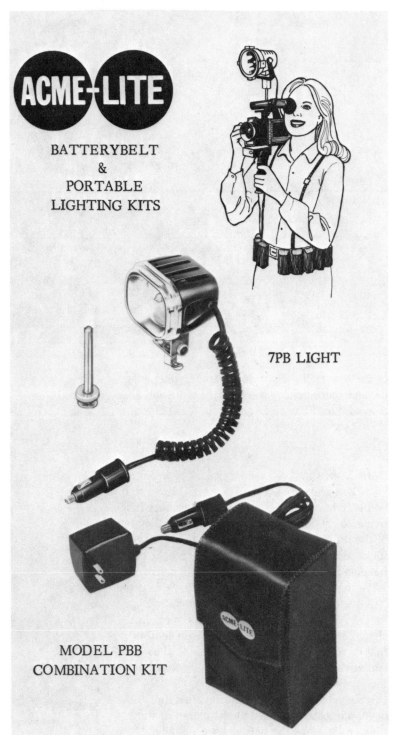

ACME-LITE

BATTERYBELT
&
PORTABLE
LIGHTING KITS

7PB LIGHT

MODEL PBB
COMBINATION KIT

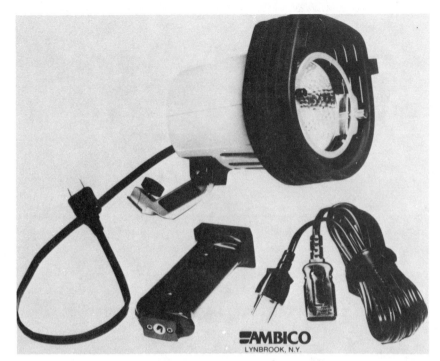

Fig. 5-22. Ambico V-0100 Videolight. Courtesy Ambico.

or 110 volt wall socket use. Changing plug adapters and lamps quickly converts the unit from ac to dc operation. Figure 5-28 shows the VDO Lite camera mounted.

Barn Doors

Barn doors are accessory items tailored to fit on the front of light housings. Their primary function is to cut down the amount of light spilling out of the reflector. Barn doors are essential not only for cutting down or concentrating the light beam but also for partial blocking off of light on the subject for special effects. In Fig. 5-29 we see the highly efficient barn door unit designed by Bogen for the 7000 studio light. Note how the specially designed doors allow variable light beam concentration or selective blocking. Figure 5-30 shows the Ambico V-0105 barn doors specifically designed for the Ambico V-0100 light.

Since barn doors are not universal items, the doors purposely designed by the manufacturer for a given light are the only ones which should be used.

Fig. 5-23. Ambico V-0100 light (camera mounted).

Fig. 5-24. Handle makes off camera manipulation simpler.

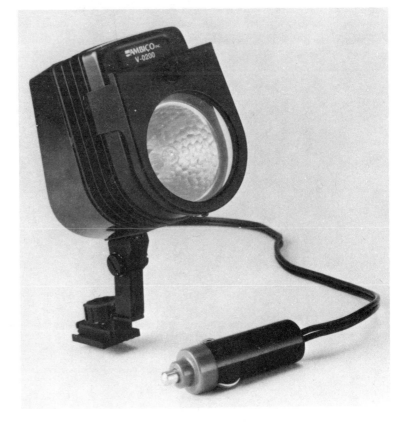

Fig. 5-25. Ambico V-0200 mini-lite. Courtesy Ambico.

Fig. 5-26. Ambico V-0802 battery/light combo. Courtesy Ambico.

Fig. 5-27. The VDO Lite is compact and ultra-versatile.

Fig. 5-28. The VDO Lite
camera (mounted).

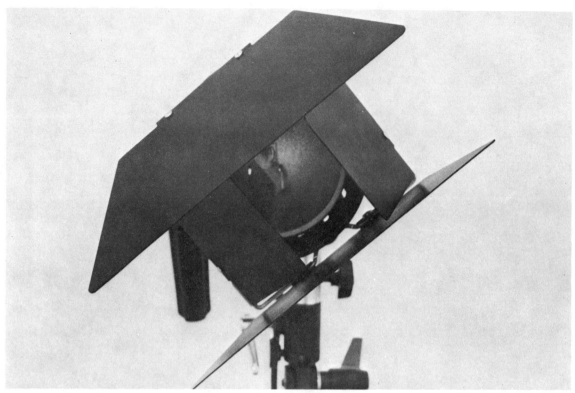

Fig. 5-29. Bogen Barn doors for model 7000 studio light.

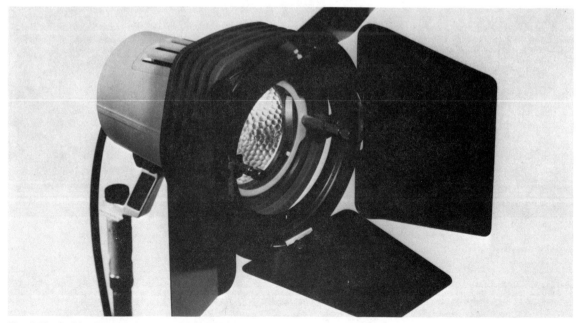

Fig. 5-30. Ambico V-0105 barn doors for V-0100 light.

Chapter 6

Power Sources

Video cameras differ from other types of photo image producing media as they rely solely on electric as opposed to mechanical sources for operation. The ideal electrical power source is the ac wall outlet, but this confines practical shooting to the confines of the home or study. Unending ac is the optimum electrical supply, but in the field the only alternatives are batteries and battery packs.

Cameras and VCR units made for in-the-field videotaping rely on a standard battery pack: a slab-type ni-cad battery that is rechargeable (see Fig. 6-1). These batteries are adequate but subject to one serious limitation: short running time. If auxiliary lighting must also be utilized, power drain may put such a strain on the portable battery, further decreasing power potential.

This internal VCR battery unit (providing it is powering the camera/VCR solely) will allow about an hour of use before it becomes drained. Turning off or disconnecting power at the end of each shot (which is tedious) may tend to give you a few extra minutes with some camera/VCR combos. One can carry spare batteries and add an extra hour per bat-

tery but this can be costly.

The best alternate is to purchase a good pro-cadmium battery pack which in all cases will be cheaper and more compact, allowing up to eight hours of reliable power. The serious videocraftsman in the field may also need to power additional accessories like enhancers and color processors in addition to camera and VCR. This can put a 40 watt or more draw on a power source and in no way can a VCR slab battery handle this load. Add on quartz lighting, which draws even greater gobs of power, and the VCR slab battery becomes impractical. There are instances (like for short "takes") when the VCR slab excels and you should always have one or two on hand for backup. VCR batteries are also easy and simple to recharge. Each company makes its own charging unit, each of which is excellent. The budget minded can utilize a standard auto accessory trickle charger. The only problem is connection. In Fig. 6-2 you can see a small home brew connector that was fashioned for slipping the trickle charger to the slab battery contacts. Wires are soldered to the lugs; the pressure contacts fash-

Fig. 6-1. A VCR battery unit that is typical of the types used in portables.

ioned from copper strips. A wood or plastic block properly spaces and isolates the power and ground sides. To charge, the clip side is slipped onto the contact receptacle of the battery. If you utilize this charging method, you must be sure not to overcharge and destroy the battery. Charge capacity can be periodically checked by inserting the battery into the VCR recorder and reading the battery capacity indicator.

How do you determine the power requirements for your particular shooting gear? Simple; first add up and calculate the maximum power requirements for Camera, VCR, accessories, including a power safety margin. Multiply all the wattage factors by the total of hours and divide the results by 11. Keep in mind that recorders automatically cut out at about 11 volts with battery capacity diminishing with age. This basic calculation (A/H rating) can relate your needs to manufacturers accessory battery ratings. Consider a 12-volt battery with an A/H rating suitable to your particular needs.

SELECTING BATTERY PACKS

Some manufacturers list accurate power ratings; some tend to be conservative. The more efficient units tend to be heavy and bulky. Because

of this it is advised that when selecting heavy duty units, you consider the belt or waist types which will allow you better unhindered movement and weight control.

Try batteries for weight, comfort, and fit, and study all power specs so that you will ensure against purchasing an inadequate unit or one whose capabilities you will outgrow. Never cheat on power; it is the necessary prerequisite for successful in-the-field videotaping.

BATTERY TYPES

Studying spec sheets will make it immediately

Fig. 6-2. A homemade clip for using auto trickle chargers for recharging portable batteries.

apparent that there are a wide range of battery types with similar A/H ratings. Batteries can range in price from $70 to over a thousand. What are the basic differences to be evaluated? Reliability; chargeability; maximum recharge cycles. There are a few basic battery types, each with specific relating characteristics.

Two of the types are *lead* and *acid*. One of them features a gelatinous form of acid (the lead-gel cel). Lead and acid batteries are composed of multi-cels that together deliver the necessary 12 volt dc outputs required. Size usually equates to capacity, and when internal lead plates are used for electrodes, weight is increased.

As the cells are recharged, gases (in lead-acid batteries: oxygen and hydrogen) are released. In video batteries, these gases are contained and not released into the air except in cases of extreme overcharging. For this reason, manufacturers include escape vents which must always be kept free, especially during recharging.

The amount of recharging a battery can be subjected to is also variable from type to type and manufacturer to manufacturer. Older style lead acid units will not take as many charges as the newer improved types. A good many of the newer types will handle over a thousand charges, giving them excellent longevity even with constant usage. Number of charge/discharge cycles should be taken into account when overall cost is considered. The consumer should also realize that when a battery's capacity is not totally taxed, one can get more cycles out of it.

With most battery offerings, full charging takes between 12 to 24 hours; charging length has no relation to performance, power or quality. Most battery units cannot be left in charge mode continuously. Some manufacturers may specify a maximum charging time and it should be adhered to whenever possible. Some of the better battery packs (like the VDO-PAK) are supplied with trickle chargers and can be left in charge mode continually. Of course charging requirements are also determined by how much of the batteries previous full charge is utilized. Total number of charges a given battery will accept is also affected by amount of discharge. According to data compiled by Matsushita, acid-lead batteries allow 1 to 2 thousand discharges if only a 30 percent discharge takes place between recharging. If the discharge level reaches 60 percent, 600 to 700 charges are possible. If batteries are totally discharged, you will shorten recharge cycling down to 200 to 250 charges. Since batteries are seldom used to their total discharge point, it is innocuous to assume that the average videophile will experience the increased longevity factors.

Nickel Cadmium or Ni-Cad batteries are very popular, more compact, lighter power sources. In re-cycling, Ni-Cads will exceed acid-battery types though they exhibit short storage life between charges if they are not used occasionally. Ni-cads can, however, be stored completely discharged without any inherent damage. Incomplete discharge cycles can promote "memory effect" in Ni-cads, causing battery capacity decrease, the battery only charging to a certain level, (usually the level to which the battery has been discharged). It is best to keep Ni-cads fully charged or fully discharged.

As with all video equipment, battery or power supply options should be evaluated according to personal requirements.

AC POWER SUPPLY

Whenever applicable, ac power supply is the most versatile, offering optimum long term electrical supply. This power (for camera, etc.) can be tapped directly from VCR connection socket or from optional supply (boxes) accessories tailor made for cameras by their respective manufacturers. Optional power supplies can be used to operate camera, VCR, and, with intelligent application of adapter cables, even accessories and lights. Figure 6-3 shows typical connection situations prevalent with contemporary camera/VCR manufacturers. Ac power sources, whether internal or accessory "black box types," are highly recommended.

BATTERY PACKS

Mentioning and categorizing all available battery packs and power sources would constitute a book in itself.

A: Camera Head and VCR with 10-pin connector

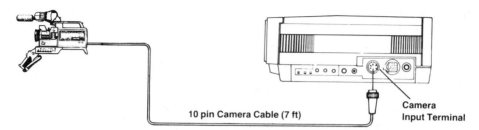

10 pin Camera Cable (7 ft)

Camera Input Terminal

Connect the camera cable to the 10-pin socket on the portable VCR as illustrated. Be sure to connect the camera to the portable VCR before turning on the power switch on the VCR. If the switch is turned on prior to connecting the cable, trouble could develop.

B: Camera Head, optional power supply and VCR without 10-pin connector

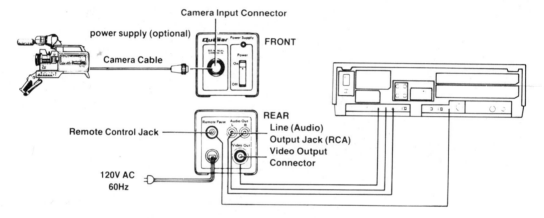

Camera Input Connector

power supply (optional)

Camera Cable

FRONT

Remote Control Jack

REAR
Line (Audio)
Output Jack (RCA)
Video Output
Connector

120V AC
60Hz

1. Connect the camera cable from the camera head to the 10-pin camera socket on the power supply.
 (Make sure that the power switch of the power supply is turned off before connecting the cable.)
2. Connect the video cable from the VIDEO OUT socket on the power supply to the VIDEO IN connector (RCA phono connector) on the VCR.
3. Connect the audio cables from the AUDIO OUT connectors (Left and Right) on the power supply to the AUDIO IN connectors (Left and Right) on the VCR.
4. Connect the VCR remote control cable from the REMOTE connector on the power supply to the REMOTE PAUSE connector on the VCR.
5. Plug the power plug of the power supply into the wall socket (120 Volts) and turn power on.
6. Insert the AC power plug of the VCR into the wall socket and turn power on.

Notes:
1. The camera cable between camera head and power supply or between camera head and portable VCR can be extended by using the optional extension camera cables.
 (Use a maximum of three 20 feet extension cables to extend up to 67 feet)
2. The connections between the VCR and TV set are explained in the operating instructions for the VCR.

Fig. 6-3. Camera-VCR power boxes (ac use) and how they are connected. Courtesy Quasar.

I have personally studied and used virtually every model and type available. I have found that the following respective models are the most recommendable in terms of state-of-the-art quality, reliability, and overall dependable performance.

The VDO-PAK

The VDO Paks (Fig. 6-4) distributed by VDO-PAK products are about the best available in belt-type power pack units. They not only offer excellent portability due to the belt configuration but also power for long running times. Different VDO-PAK models are available with power ranges running from 6 amps to 20 amps. The VDO B2000 20 amp belt is unsurpassable in state-of-the-art qualifications. It will run a camera and VCR (fully charged) from 14 to 16 hours. Two to two-and-a-half hours of running time is allowable for powering a 100 W. quartz light. When power requirements in the field are high, the VDO B2000 is the best choice. Another good feature is a quick conversion option that allows the user to eliminate some of the cell units when less power is necessary, thus cutting down the weight also. The B600, B850, B1000, B1200, B1700, B2000, VDO-PAKs feature gel- electrolyte power cells rechargeable with special chargers that

Fig. 6-4. VDO-PAK superpowerful battery source shown with its ac wall outlet charging units.

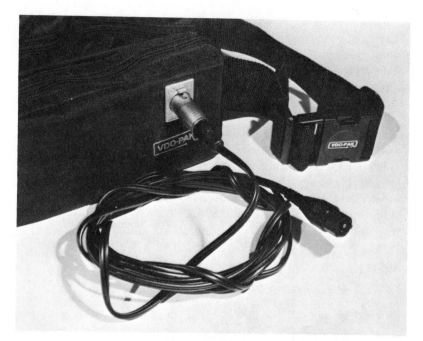

Fig. 6-5. A battery-to-VCR adapter cable.

come with the belt units. The consumer has two connection options available to him for hooking his equipment to the batteries; the professional XLR (4 prong) connectors or the standard accepted cig-

arette lighter type connector. VDO will supply connectors of your choice with the proper plug for your particular VCR unit. Though the cigarette lighter connectors are more common, the XLR plug is

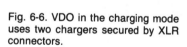
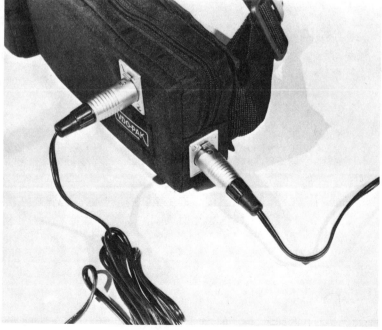

Fig. 6-6. VDO in the charging mode uses two chargers secured by XLR connectors.

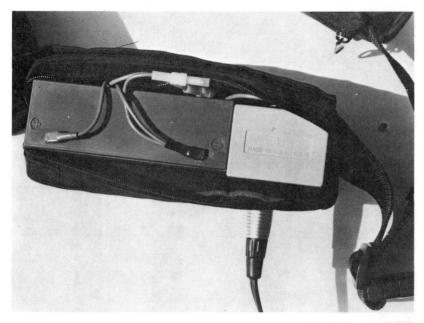

Fig. 6-7. Cell-to-cell connections should be checked frequently or before battery use.

more efficient and more securable. If you are going for a power pack and an XLR option is offered, go for it; you can always use intermediate adaptors that will convert XLR to cigarette lighter and some are shown in the latter part of this chapter. Figure 6-5 shows the XLR connector hooked into the pack, as the other end is a Quasar VCR plug.

Changing the VDO-PAK is simple and efficient. You simply connect the charger XLR plugs as shown in Fig. 6-6 and the 120 volt ac plugs on the opposite end of the charger into a standard household outlet. Charging requirements are always specified by manufacturers. One word of advice when using gel-electrolyte packs: since the cells are interconnected, always check to see that the spade lugs are securely connected (Fig. 6-7) so as to circumvent faulty operation.

For the videophile desiring less in weight and bulk, VDO also manufactures an excellent, efficient, lightweight nickel-cadmium "Ni-Pak" (Fig. 6-8). This rechargeable 12 volt unit will run a VCR 6 to 8 hours and a quartz light up to 40 minutes. Optional XLR, cigarette lighter connectors are offered.

Another good portable belt battery unit is the Acme 12BB (Fig. 6-9). Shoulder straps are also provided with this unit, which assists in weight distri-

Fig. 6-8. VDO Ni Pack.

Fig. 6-9. Acme 12BB Batterybelt.

Fig. 6-10. Ambico V-0805. Courtesy Ambico.

Fig. 6-11. Ambico Decathlon.

69

Fig. 6-12. Bescor "Big Nic."

bution. The Acme-Lite 12BB battery pack will run VCR and camera units continuously up to five hours. Wall socket chargers are provided for cell rejuvenation; overnight charging will bring the 12BB battery packs up to full power.

A lighter, but still highly efficient battery pack is the (Fig. 6-10) Ambico V-0805, featuring sealed, rechargeable lead-acid cells with high cycle-life and excellent recovery rate. This 5 amp belt pack will power a standard VCR for about five hours or a 100 W. videolight for about half an hour.

The Ambico Decathlon Model V-0810 (Fig. 6-11) has a high power to weight ratio; it weighs only 3 lbs. A 12-volt Ni-cad type, the V-0810 contains adjustable straps that allow over-the-shoulder or waist placement. With heavy duty ac charger included, the Ambico Decathlon will recharge from household outlets in 12 hours.

Bescor Video Accessories Ltd. markets two formidable units, the Model NC4 "Little Nic;" both nickel cadmium units. The "Big Nic" (Fig. 6-12) provides eight hour recording while weighing only 5.7 lbs. It has a seven amp capacity, is rechargeable, and can be hung on the shoulder or belt. The

Fig. 6-13. Bescor "Little Nic."

Fig. 6-14. VDO Power Connector for Quasar, Canon models.

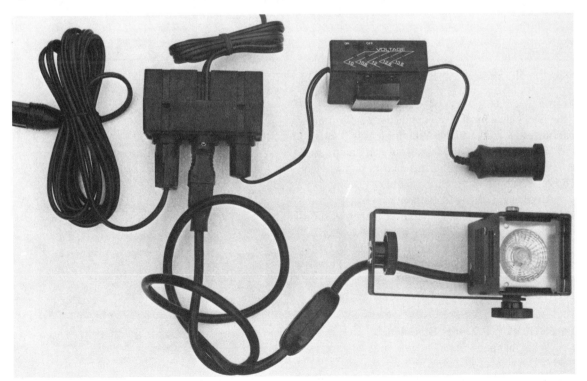

Fig. 6-15. Connectors can be most useful. A three-way junction box allows provision for lighting, a power-voltage monitor, and a camera unit all from one cigarette lighter battery socket.

Fig. 6-16. XLR connector (to battery) with end adapter for Quasar portable VCR. Cable by VDO.

"Little Nic" is a stepped down version of the "Big Nic," ideal for the videophile demanding compactness and light weight. Weighing only 3.4 lbs., the "Little Nic" (Fig. 6-13) puts out 4 1/2 amps and is rechargeable, achieving full charge capacity in 18 hours via a plug-in charger unit.

Auxiliary battery selection will vary from videophile to videophile. High power usually results in added weight and added expense.

The casual camera buff can make do with the smaller, more compact, less efficient units. For serious long range requirements, though, the heavy duty state-of-the-art power sources are a must.

EMERGENCY POWER SOURCES

What happens when power runs out in the field or the videocraftsman discovers that his shooting time or accessory load requirements are running down his power supply? If he has made

Fig. 6-17. Three-way junction box converting a single to a multiple power source. Courtesy VDO.

Fig. 6-18. A cigarette lighter socket to XLR connector will help standardize connections when necessary.

Fig. 6-19. From VDO this power connector for use with VDO PAK battery or automobile hookup.

Fig. 6-20. Another power cable unit specifically for Canon cameras/VCRs.

Fig. 6-21. Ambico V-0601 dual connector.

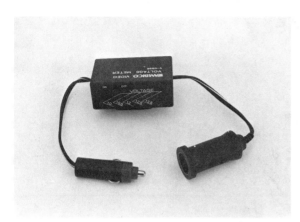

Fig. 6-22. An Ambico voltage meter is a must for serious and proper videotaping.

provisions, he will have an extra battery pack or cells on hand. When all options run out, however, there's nothing better to have around than a VCR to cigarette lighter (auto) outlet cord, provided of course that one's automobile contains a plug-in lighter receptacle (Fig. 6-14). Using the auto as a power source in an emergency situation is sound, but there are some inherent factors to be considered. First of all, battery drain. If the engine is turned on, no battery drain will occur. This is especially warranted when using auxiliary lighting equipment (Quartz, etc.) which tends to drain power drastically.

A VCR will not drain as much power from a car battery, but operations should be limited to short spurts with intermittent engine running to beef up car battery amperage. I say intermittent spurts, for it has been found that electrical engine noise can be transmitted into the videocamera as the engine runs, which reproduces as minor "glitchy" type blasts, dropouts and other electrical visually perceptible interference aberrations. This will not transpire if the engine is not running *or* if electrical noise suppression wiring is present in the automotive electrical circuit. In a pinch, the car battery is great where discretion is introduced into its implementation.

PLUGS, CORDS, AND ATTACHMENT ACCESSORIES

With power sources we have an infinite selection of adapters, cords, etc. in order to increase equipment versatility (see Fig. 6-15).

Figure 6-16 shows a VDO cord specially formulated with an XLR connected on one end and a Quasar portable VCR plug on the other. Adapter cords for power/lighting/accessories are usually provided by the accessory manufacturers; the buyer must specify what equipment the chosen accessory must be compatible to. Always make sure you get the *proper adapter;* guessing can result in equipment damage or burnout.

Figure 6-17 illustrates a very handy item; a three-way connector to enable lights accessories or camera to be attached to a common power source. This connector is designed for cigarette lighter plug use, a common standard in video connection. Power packs for the most part either have cigarette lighter or XLR connectors; some offer a choice option. This is not overly critical, however, as special adaptor cables are marketed (Fig. 6-18) to assist in equipment inter-changeability.

Figure 6-19 shows a portable VCR to cigarette receptacle adaptor. This can be used in conjunction with cigarette lighter receptacle power packs or for direct connection to automobile receptacle power. A similar cable made for Canon equipment is shown in Fig. 6-20. Y-connectors or dual from single connective sources are handy to have (Fig. 6-21). The extra socket can be used to power a light or for mounting a power meter.

Voltage meters (Fig. 6-22) are necessary and every videocameraman should have and utilize them. This excellent yet modestly priced model V-0898 from Ambico plugs in unobstrusively between power supply and equipment. A built in clip allows it to be secured to a belt, power cell belt, pants, waist, etc. LED indicators show the remaining charge monitoring the battery capacity accurately throughout operation.

Chapter 7

Tripods

Tripods are for the most part the last considered accessory, but for the serious videophile they should be given as much importance as camera or lighting equipment. In still camera photography the tripod, save for special studio situations, can be dispensed with; in video camera work it is an essential additive no cameraman should be without.

There are many tripod types and models available, as there have been for years. They range from the compact portable types of the bulky heavy studio types. Though any tripod can be utilized in conjunction with consumer type videocameras, the heavyweights are the best (and the most expensive). The ultralightweights offer no redeeming factors outside of lightweight portability. For the average, serious videophile, the middleweights offer a feasible solution; moderate weight and bulk yet steady securement of the camera body.

Since it would take a small book in itself to feature all applicable tripods and accessories, I have selected what I feel are the major tripod offerings best suited to the aims of this book.

BOGEN

Bogen is considered by many pros to be the undisputed leader in the tripod field and their quality, workmanship and sturdiness is second-to-none. Bogen also offers a wide array of tripod accessories that play an important assisting role in videotaping work.

The Bogen sturdy 3140 with Mini Fluid Head is an ideal all-around choice for a top of the line type tripod. Not as heavy as the more massive Bogen studio models, the 3140 (Fig. 7-1) is more than adequate for all camera work necessitating tripod assistance. The all-aluminum 3140 is of two section design, center braced weighing only 11 lbs., 6 oz. It can be used with a video dolly and will extend to a full 73 inches. This model folds down to a compact 32 1/2 inches; legs are furnished with convertible cushion/spike tips.

Another formidable, moderate weight unit is shown in Fig. 7-2. This excellent tripod is mounted on the 3127 portable dolly which assists in making the legs sturdier while allowing freer movement of

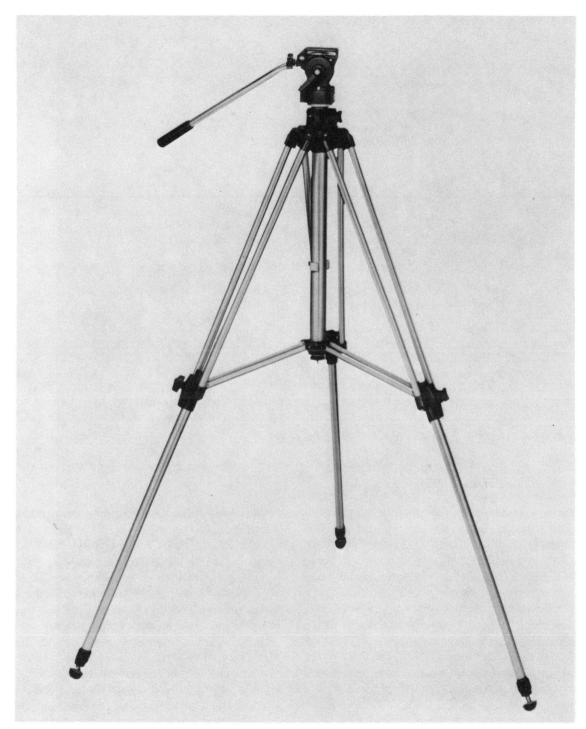

Fig. 7-1. The Bogen 3140 Tripod. Courtesy Bogen.

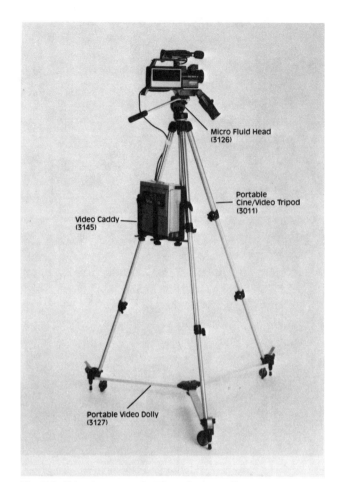

Micro Fluid Head
(3126)

Portable
Cine/Video Tripod
(3011)

Video Caddy
(3145)

Portable Video Dolly
(3127)

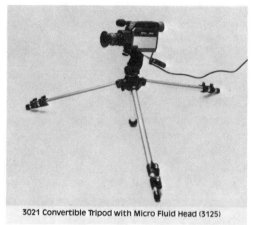

3021 Convertible Tripod with Micro Fluid Head (3125)

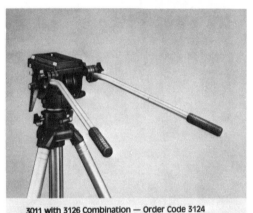

3011 with 3126 Combination — Order Code 3124

Fig. 7-2. Tripod types and setups. Courtesy Bogen.

the tripod unit via the integrated rolling casters. This tripod is illustrated rigged up for a typical videotaping situation with added accessory items to aid in simplifying videotaping. Also illustrated in Fig. 7-2 is the 3021 Convertible tripod which contains a removable center post section and variable leg spread controls that allow low angle shooting as shown. The 3021 is shown with the 3125 Micro Fluid Head. In the lower right hand corner of Fig. 7-2 we can examine a close up of the Bogen 3126 Micro Fluid Head an optional head unit highly favored for exacting videocamera work. The 3126 incorporates a tilt angle of $+90°$, -90 and features variable friction tilt drag and super smooth $360°$ pan rotation.

For optimum steadiness and smoothest action

in video work, fluid heads exceed in performance. The Bogen 3063 (Fig. 7-3) Mini-Fluid Head allows smooth, shudder-free action promoted by fluid damping. A quick release mounting plate is also featured to accommodate all video cameras. The versatile handle is positionable on either side and can be separated into two individual segments. Separate pan and tilt locks are incorporated and vertical drag is continuously adjustable. The Bogen 3126 Micro-Fluid Head (Fig. 7-4) is choice for the newer lightweight VCR cameras and camcorders. Weighing in at only 2 lbs. it is perfect for a six pound or less camera. This ultra smooth panning head can be tilted up or down $90°$ with locking pan and tilt controls. Left or right handle mounting is optional.

The 3115 Ball Camera Leveler is a highly ap-

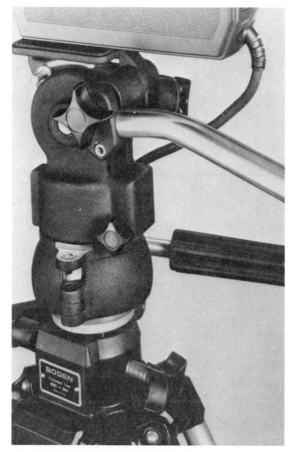

Fig. 7-3. Bogen Mini-Fluid head. Courtesy Bogen.

plicable if not crucial tripod accessory (Fig. 7-5). In conjunction with the Mini or Micro Fluid head it allows quick camera and head removal for switching to another tripod if desired plus easy camera leveling even if the tripod is mounted out of level. Ideal for rough or uneven terrain use.

A tripod accessory item I would enthusiastically recommended for everyone owning a camera, portable VCR, and tripod is the Bogen Video Tripod Caddy (Fig. 7-6). It mounts between any two of the three tripod legs and will house most portable VCR's on the market.

ACME-LITE MANUFACTURING COMPANY

Acme has been a major tripod and light manufacturer ever since 1939. Their outstanding feature is reasonable pricing for their light and middleweight units.

The average videophile will find the Acme Ensign Royal and Video Ensign models (Fig. 7-7) easy to use and jocky around and adequately stable. The Ensign Royal is the economy version and a basic tripod. The Video Ensign includes the same structural features with added spring loaded panhead for camera weight balance in tilt positions and tripod to unipod conversion. Another good feature incorporated into both models is elevator friction control, enabling elevator adjustments without fear of the camera falling downward when tension is released.

The Acme Vidipod System offers two more-rigid units incorporating fluid head design (Fig. 7-8). Acme is not behind in innovative support accessories. The Video Kaddykart (Fig. 7-9) offers an inexpensive way to support camera and accessory equipment. It serves as a combination camera support and accessory cart.

The Acme Shelva-Dolly (Fig. 7-10) is illustrated with all its listed and desired features.

Two other tripods worthy of mention are the Videotripod (Fig. 7-11) V-0511 and Videotripod V-0512, both marketed by Ambico. The V-0511 offers a gear drive ball bearing center column, large professional control handle for positive panning, quick release leg locks, spiked and rubber leg tips, and closed cross section legs for excellent rigidity. The Videotripod V-0512 offers all the features of the V-0511 plus heavy duty, channeled tubular legs for maximum strength and stability.

Since space does not permit listing all manufactured units, I chose to list a few models which I feel are most recommendable, encompassing a price range from economical to moderate to expensive. Other units are marketed which may be equal or more favorable to the reader. Information on the competitive tripod market may be obtained by writing to these other established manufacturers and distributors.

Bilora Products
148 Veterans Drive
Northwale, NJ 17647

Davis-Sanford
24 Pleasant St.
New Rochelle, NY 10802

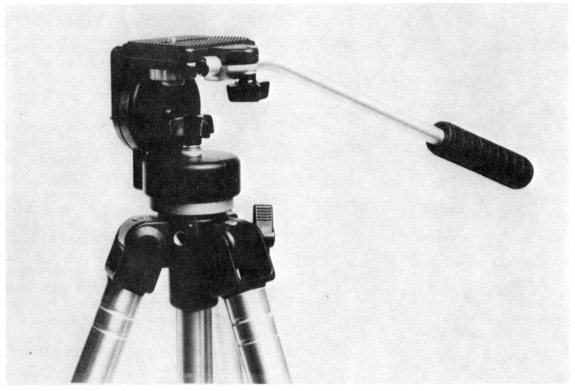

Fig. 7-4. Bogen Micro-Fluid head. Courtesy Bogen.

KB Systems
10407 62nd Place West
Everett, WA 98204

Quik-Set
3650 Woodhead Drive
Northbrook, IL 60062

Velbon International
2433 Moreton St.
Torrance, CA 90505

CHOOSING A TRIPOD

Tripods can vary greatly in price, weight, sturdiness, flexibility, and versatility. The serious camera buff should consider a tripod that will perform all the functions necessary to guarantee foolproof videotaping results. When considering tripods, one should choose a unit that will allow adding on (heads, components, etc.) if skills and demands down the road may require it.

There are many inherent features in tripods that should be considered and evaluated according to personal requirements.

Weight

The weight factor should be important. Light weight offers mobility but may cause you to sacrifice rigidity or sturdiness. The heavier the tripod the more secure it and the camera will be.

Leg Types

Three basic types are manufactured: the tubular, the open channel, and the closed square channel.

The tubular leg is the strongest; it is also professionally preferred and economical.

The open channel, or U-type, is the least strong; it is costly, though good looking.

The square channel is equal to but not as pop-

Fig. 7-5. Bogen Ball Camera Leveler. Courtesy Bogen.

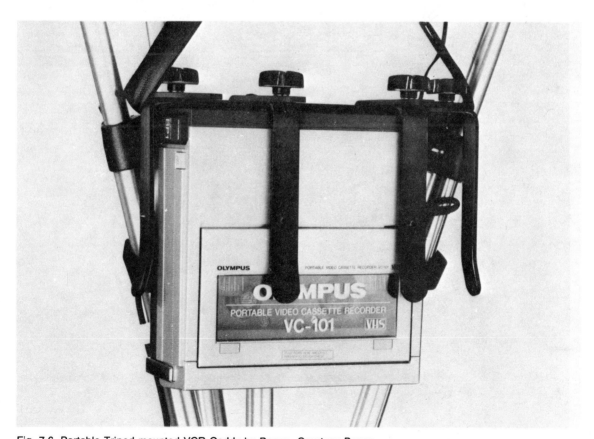

Fig. 7-6. Portable Tripod mounted VCR Caddy by Bogen. Courtesy Bogen.

ular as the tubular leg type.

Leg Sections

The less the sections, the sturdier and cheaper the tripod. When setting up the tripod, the heaviest leg sections *should* be utilized first when full extension is not required. Remember, the fewer segments in the legs, the lesser the leg extension, the better the rigidity factor.

Feet

Combination rubber and spiked feet are the best for inhibiting sliding and slipping. When free tripod mobility is required, dollies with rolling casters reign supreme.

Leg Locks

Secure locking of the telescoping leg sections is of prime importance. Two locking devices are popular today: the threaded collet and the lever tension lock. Tubular legs feature the threaded collets which are not as easy or fast to manipulate. Figure 7-12 illustrates the more favorable lever tension lock system as found on the Bogen tripods. A quick

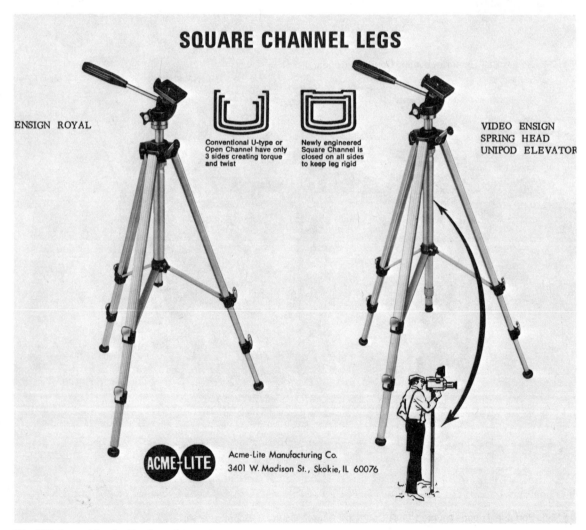

SQUARE CHANNEL LEGS

ENSIGN ROYAL

Conventional U-type or Open Channel have only 3 sides creating torque and twist

Newly engineered Square Channel is closed on all sides to keep leg rigid

VIDEO ENSIGN
SPRING HEAD
UNIPOD ELEVATOR

ACME-LITE Acme-Lite Manufacturing Co.
3401 W. Madison St., Skokie, IL 60076

Fig. 7-7. Acme tripods. Courtesy Acme.

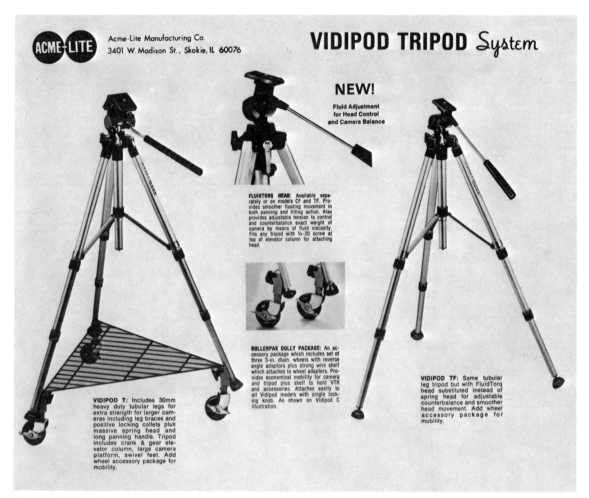

Figure content:

ACME-LITE

Acme-Lite Manufacturing Co.
3401 W. Madison St., Skokie, IL 60076

VIDIPOD TRIPOD *System*

NEW!
Fluid Adjustment
for Head Control
and Camera Balance

FLUIDTORQ HEAD: Available separately or on models CF and TF. Provides smoother floating movement in both panning and tilting action. Also provides adjustable tension to control and counterbalance exact weight of camera by means of fluid viscosity. Fits any tripod with ¼-20 screw at top of elevator column for attaching head.

ROLLERPAK DOLLY PACKAGE: An accessory package which includes set of three 3-in. diam. wheels with reverse angle adaptors plus strong wire shelf which attaches to wheel adapters. Provides economical mobility for camera and tripod plus shelf to hold VTR and accessories. Attaches easily to all Vidipod models with single locking knob. As shown on Vidipod C illustration.

VIDIPOD T: Includes 30mm heavy duty tubular legs for extra strength for larger cameras including leg braces and positive locking collets plus massive spring head and long panning handle. Tripod includes crank & gear elevator column, large camera platform, swivel feet. Add wheel accessory package for mobility.

VIDIPOD TF: Same tubular leg tripod but with FluidTorq head substituted instead of spring head for adjustable counterbalance and smoother head movement. Add wheel accessory package for mobility.

Fig. 7-8. Vidipod Tripod Systems. Courtesy Acme.

flick of the thumb (Fig. 7-13) tightens or releases the leg lock.

The Elevator

The function of the elevator is to further extend the height of the tripod (Fig. 7-14). There are three recognized types of elevators: lift, crank, or clutch. Though there is speculation as to which type is best, all function well. Mechanical mode of elevator operation should not be a serious factor to be considered when purchasing a tripod. Regardless of what mechanism is selected, you should make sure that the mechanical action is easy and responsive.

Platform

The head is the most important facet of the tripod, and it usually governs the price and operational quality of the tripod itself. A panhead is mandatory and panheads will vary in size, function and special features. The camera platform size is important. It should be large enough to securely seat the camera. It can be oversized and work ideally, yet undersized it can pose problems in camera securement. The platform should be slotted so that the camera securing screw can be moved back or forward to aid in camera balancing and seating.

Panhead Functions

Panheads fall into a two-way or three-way cat-

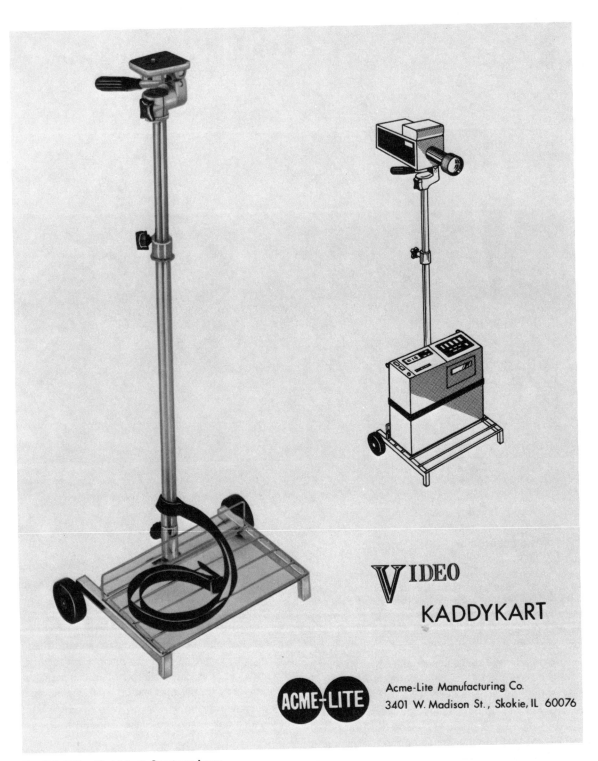

VIDEO

KADDYKART

ACME-LITE

Acme-Lite Manufacturing Co.
3401 W. Madison St., Skokie, IL 60076

Fig. 7-9. Video Kaddykart. Courtesy Acme.

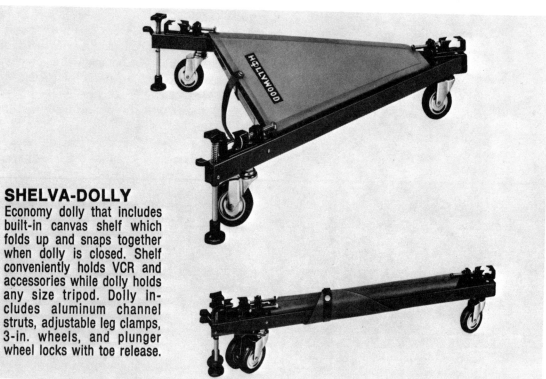

SHELVA-DOLLY
Economy dolly that includes built-in canvas shelf which folds up and snaps together when dolly is closed. Shelf conveniently holds VCR and accessories while dolly holds any size tripod. Dolly includes aluminum channel struts, adjustable leg clamps, 3-in. wheels, and plunger wheel locks with toe release.

Fig. 7-10. Shelva Dolly. Courtesy Acme.

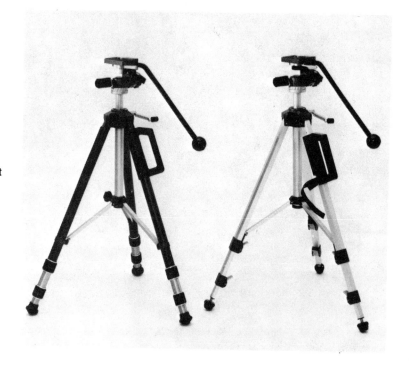

Fig. 7-11. Left Ambico V-0512. Right V-0511. Courtesy Ambico.

Fig. 7-12. Leg lock system on Bogen tripod.

egory. The three-way adds a flip-over function only necessary for some still cameras; the two-way pan head is perfect for videowork since only side to side and up and down motion options are required. Panning action (side to side) should be friction free, smooth yet lockable if required (see Fig. 7-15). Identical smooth action is required for up and down (tilt) motion.

There are three head-action types in respect to tripods. They are: mechanical or friction, spring-loaded, and fluid.

In the mechanical or friction head all the parts work moving in contact with each other. The operation of this type of head action mechanism depends upon how well the integral parts are machined and aligned. Mechanical or friction actions tend to cause jerky movements throughout operation.

The spring-loaded head is also a friction type head but with the addition of a spring to provide tension and smooth out the operation of the contacting mechanism.

Fig. 7-13. A flick of the lever securely locks the legs. This is the best type of leg-locking device.

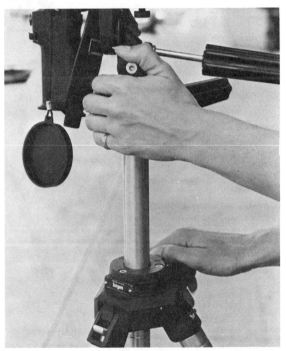

Fig. 7-14. Elevator mechanism shown is lift type popularized in the Bogen tripod.

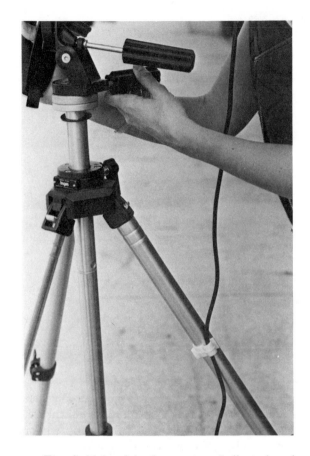

Fig. 7-15. Pan action on Bogen head is smooth due to action of swivel and lock handle. Leg clip (shown) serves to keep wire contained and out of the way when working head controls.

The fluid head is the most complicated and costliest of all. For performance it is unexcelled and provides the best head action, which is most favorable and preferred for videowork. In a full hydraulic fluid head, the action is governed by fluid controlled pistons which operate the moving posts. This results in the smoothest, most positive pan and tilt operation possible. Fluid heads are unequivocally the finest and most desired for both studio and in-the-field photography.

The merits and qualifications of tripods have been fully elaborated on in this chapter. You should study and evaluate all the presented factors, decide what tripod best suits your individual needs and by all means purchase one, as it is a most necessary tool.

Chapter 8

Videotape

Production and Layout

Whether on an amateur or professional level, videotape production commences with preliminary planning stages usually inaugurated on the drawing board. Though you can haphazardly put together or compile sequential material in your head, it is far better to plan, document and lay out themes carefully on paper where necessary ingredients to be compiled and presented can be studied, evaluated and placed in their proper perspective in terms of proposed visual and audio presentation.

In addition to conforming to accepted processes and procedures, each producer or individual should evolve his or her own style and approach predominately in visual areas which promote the greatest impact. Goals intended must be pursued and achieved at the same time regardless of whether the feature is a home movie, documentary, travel, comic or drama piece. The ideas of the producer and the aims of the feature should be expressed. An individual must be ready to try, even experiment with new and standard methods to see which work best. Following a main theme or mood is foremost and should be adhered to from start to finish. In addi-

tion, the producer (or director) must be willing and able to make changes to adapt to, or enhance the "mood" with flexibility and spontaneity without losing sight of the production's objective.

The video segment is the most important aspect of the overall production, essential for arresting attention and promoting impact. Audio is an enhancing yet nevertheless necessary ingredient to strengthen the overall package; in documentary or how-to-type formats additive audio is essential for total description and communication.

Compiling and editing the various integrated elements of a feature is usually preliminarily done on story boards. Story boards are akin to "comps" in the artfield and are rough sketches and plans. The story boards can be considered the schematic of the production and can be interchanged, juxtapositioned, corrected, re-corrected or manipulated until the overall flow (scenes, music, narration, trick effects) is finalized. Following the script or scenario, the story boards depicting scene changes are drawn; sketches may be rough or finished (Fig. 8-1). In the illustrated story board

Fig. 8-1. Storyboard segments are hand drawn; they can be rough sketched or detailed.

description here, we show how a typical theme "Egypt by Camel" is laid out and created in storyboard form.

The opening scene is showed in Fig. 8-2. Theoretically presentation commences, with a fade in to scene one planned in the first storyboard frame in Fig. 8-2. Indicated in the lower margins are scene durations, special effects to be included (if any), videographic approaches, background music, narration (if any), etc. All notations and instructions naturally are added after all the visual presentation (sketches) have been decided upon and collated in proper sequence (singly or attached) into a fold out package as shown in Fig. 8-3. Figure 8-4 shows two scenes joined together in their proper sequence with instructions and editing/musical procedures spelled out. In Fig. 8-5 we see a number of scene considerations and in the lower margins, scene duration suggestions, narration and musical requirements,

plus proper implementation and placement of each integrated element.

A special commercial TV production template is made available and may be purchased from Eastman Kodak, Motion Picture and Audiovisual Markets Div., Rochester, N.Y. (see Fig. 8-6). This TV Graphics template (Kodak 4426) is based on American National Standards and on Society of Motion Picture and TV Engineers Recommended Practice, designed for proper sizing and preparation of graphics for television transmission.

Common sizing for TV artwork is 10 × 12 inches. In connection with television, this format applies in particular to the formulation and use of acetate cels universally accepted by film makers, artists, photographers, and graphic art media representatives. The template provides relative sizes of image areas utilized primarily in television. These areas apply to 16mm motion picture film as

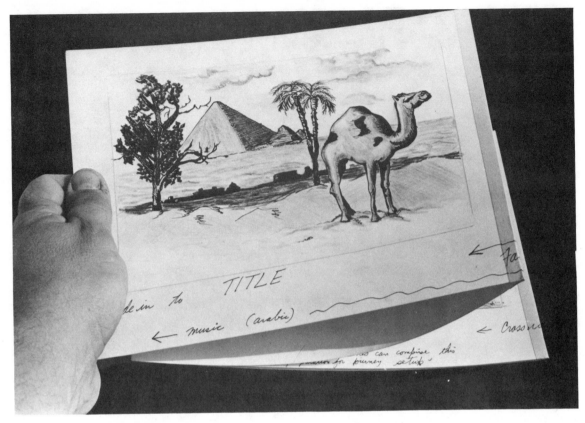

Fig. 8-2. A close-up of a storyboard segment.

well as 35mm slides. The borders also show 16mm/35mm relationship when these designated areas are used at magnifications marked to aid in positioning graphic elements on center within pre-scribed horizontal and vertical dimensions.

STANDARD BORDER LINES

Five standard border lines are indicated: The TV Safe Title Area; TV Safe Action Area: TV scanned area; 16mm Movie film area; 35mm slide area.

TV Safe Title Area

The inner border outlines the safe title area showing format and size for 16mm film or 35mm slides. The inside edge of the frame line indicates the 35mm slides. The inside edge of the frame line indicates the 35mm slide title area; the outer pe-

rimeter the 16mm movie film border line. Titles or artwork formulated along standard TV production artwork requirements will be accommodated within these areas and completely visible within the TV receiver screen area.

TV Save Action Area

The next (middle) grey frame border (also con-forming to 16mm and 35mm slide specs) indicates the area in which all artwork or video action will be visible on the TV monitor when material is prop-erly sized and prepared.

TV Scanned Area

This largest, designated grey bordered area indicates the image areas scanned (electronically) by the TV transmitting system. Image areas ex-tending past these border lines are not ordinarily

a part of the transmitted or received visual picture.

Film and Slide Formats

The last remaining (black line) bordered areas on the template conform to the 16mm motion picture projector apertures and the 35mm slide mount both of which display a common height on the template. This common height allows a more convenient evaluation of the other template dimensions allowing greater ease of template utilization.

When designing artwork and graphics for video reproduction it is easy and wise to rely on the TV Graphics Production template. Though designed for professional and commercial applications, the serious videophile will find the template will assist greatly in standardizing graphics reproduction and transmission.

HOME VIDEO PRODUCTION

The traditional home videos as we know them are for the most part dull, poorly planned and a chore to sit through (except for the older photographer who has photographed such personally valued subjects as Junior, wife, mom, dad, and family). They need not be, though, and with some forethought and planning can be, if not exciting, at least orderly and interesting. The most important aspect of home videos is a story line which most lack, emulating into a series of "record shots", one on top of the other. Even the simple home video should contain a complete story line. There must be a beginning and an end ultimately tied together with interesting interludes along the way. Pre-plan the shooting sequences and relative incidents involved and the story will fall easily into place. Make a listing of the sequences or scenes you wish to include in the home videotape, arranging all the scenes in proper and intelligent sequence. If you are shooting a birthday party, for instance, you can start with situations occurring before and working

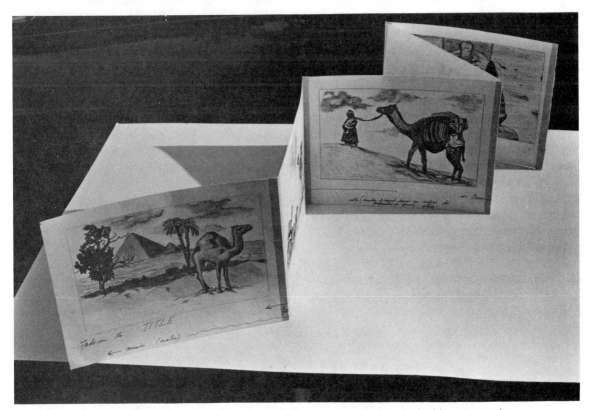

Fig. 8-3. After the script and shooting sequence is finalized, segments can be attached in proper order.

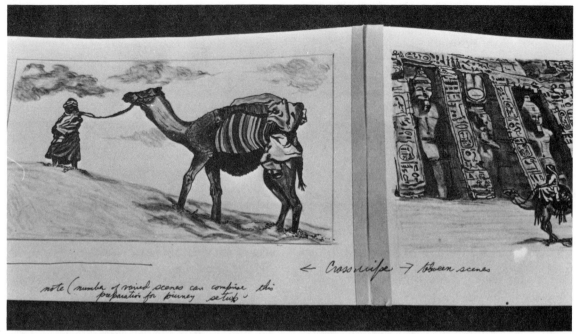

Fig. 8-4. Notes in the lower margin pertain to scene duration, dissolves or fades involved, music, narration, etc. to aid in final editing.

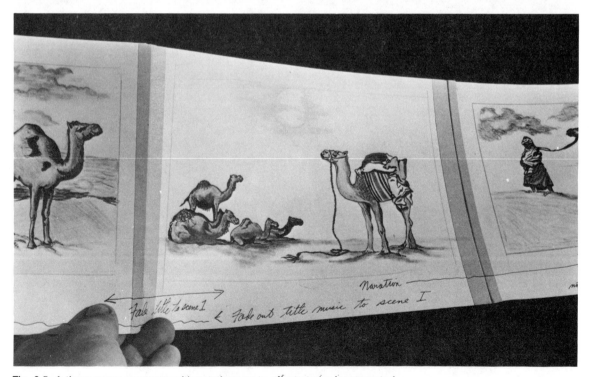

Fig. 8-5. A three-scene sequence with notations as to effects to be incorporated.

Fig. 8-6. The Television Graphics Production template.

up to the party itself. The same formula can be applied to visits, weddings, Bar Mitzvahs, and even vacation pictures. Story elements can be extended through the day (weekend, etc.) and with proper and selective titling, fades, editing, (all facets within the realm of the basic videophile), the story from start to finish can be interesting and aesthetically pleasing. Check and plan lighting availability or what auxiliary lighting must be implemented in order to attain maximum video quality. Master elements of good composition and posing; don't get involved with electronic technology and gimmicks. Keep home movie productions simple. Above all, know your camera so that integrated controls may be worked instinctively without much thought or bother involved.

INSTRUCTIONAL AND HOW-TO TAPES

Video is an ideal instructional media, and in-structional videotapes have a bright and prominent future in the homes of craft, hobby, and tinkering buffs. A video presentation of a construction or repair sequence will delineate in far better detail entire procedures involved from start to finish, while books offer sporadic pictures with the reader left to figure out what may transpire in between. How-to videotapes are destined to improve the dissemination of visual information in the future.

The prospective how-to videotape producer must understand, articulate and present the information designated in order to visually present to the viewer instructions as to how something is actually and precisely done. Before you commence shooting the how-to tape, you must have full knowledge of the operation presented.

Planning and story board layout is an essential part of how-to videotape production. Sequences must be categorized, indexed, and after sequence presentation is formulated, the producer must plan

and present the information to be conveyed. In complex situations, detailed step-by-step documentation will be necessary though entire procedures are not always required to be presented if fewer key steps will achieve the desired effect. The producer must use sound judgement and discretion in order for the presentation not to appear dull and redundant with oversimplification.

Closeups are very important in how-to sequences and it's wise for the videocameraman to have equipment containing zoom features and macro reproduction capability for close to extreme close up shooting if required. Editing in how-to videotaping is essential in order to present a concise instructional process. If you can edit, your shooting will be more flexible and manipulative. You can shoot takes out of sequence; you can edit or compress long takes and eliminate trivia con-

centrating on the key elements. You can compress time, squeezing a week long project down to an hour if that is all the time necessary to explain a point. It is wiser to overshoot in all cases; excess footage can always be edited down.

In some cases it may be necessary or feasible to transfer movie film to tape, particularly when you must utilize shooting capabilities only inherent in movie camera photography.

For time lapse and single frame consecutive photography, the movie camera is unequalled. Some special trick effects can only be realized with movie cameras, so if you are seriously contemplating how-to taping, consider the purchase or rental of 16mm camera equipment if a film-reproduction situation arises. The film can always be transferred to videotape; the procedure is presented in a special section in this book.

Chapter 9

Videocamera Techniques and Procedures

Good camera technique and good videotape production go hand in hand. In most instances the person behind the camera governs the quality of the production. He must combine good exposure with impeccable camera manipulation while considering the aesthetic aspects of video photography: color, composition, special effects.

In this chapter I cover the various aspects of video photography with an eye toward achieving pleasing as well as optimum results.

For camera work, particularly in the field, the portable VCR reigns supreme. It is light and can be easily transported by the cameraman offering unlimited shooting flexibility (Fig. 9-1). The small, battery operated VCR units can be battery powered and either worn on the shoulder or bracket mounted on special tripod VCR holders. Though table model VCR's can also be used (with minimal portability), they are not as efficient due to bulk, weight and power source availability: alternating current to operate them in virtually nonexistent in the field. Console VCR's should be confined to in-house or studio use. When shooting on location be prepared

by having enough battery power on hand plus a car cigarette lighter adapter cord should the need for emergency power arise.

EXPOSURE

Proper exposer is a key factor for good video reproduction. A perfectly balanced or composed scene or "take" will be invariably ruined if the exposure is not "right on." Improper exposure will affect color balance and picture clarity as well.

There are two approaches for obtaining perfect exposure: automatic white balance adjustment of the videocamera, and manual adjustment with the aid or an exposure water.

WHITE BALANCE

The human eye adjusts naturally to varying light conditions, but the iris of the videocamera must be electrically adjusted automatically or hand set. The human eye can also perceive a white object as white in color whether under sunlight or artificial light even though the color varies under the two varying light sources. The color camera cannot

Fig. 9-1. Portable VCRs such as the Quasar VP5435WQ are great for in-the-field or studio shooting.

° K. As color temperature increases, the color of light changes. White balance should always be adjusted for the light source which illuminates the subject or object. High temperature lighting tends to go bluish; low temperature lighting will impart a redder or warmer tonality to the subject. Activating the automatic white balance switch on the camera in the proper (daylight or incandescent) setting will properly calculate exposure while adjusting color balance.

WHITE-BALANCE ADJUSTMENT

When balancing for artificial light, set the illumination indicator switch to the artificial light position usually indicated at the switch (by a diagram of a bulb). Then automatic white balance can be set by pressing the proper button. When shooting in daylight, set the indicator to the natural light position (diagram indicated by a sun sign). Depressing the "Auto" button will adjust the white balance. Always check to see that the indicator switch is in the proper position relating to the type of illumination falling on the subject to be videotaped (Fig. 9-2).

To give you an indication of brightness values I have included the chart in Fig. 9-3A reproduced from the Quasar VK 747 camera manual (Courtesy: Quasar). Calibrations are in Lux and Footcandles which conform to videotaping standards.

In Fig. 9-3B I present a corresponding color temperature table (Courtesy: Sony).

Fog calculating on-the-nose exposure I prefer using an exposure meter for light calibration, followed by hand setting the iris or light aperture. This enables me to do some headwork. The proper use of the exposure meter for incident or reflected light readings is discussed in Chapter 5 "Lighting Equipment and Procedures."

adapt as readily to color temperature changes and records a white object according to the color temperature (degrees Kelvin) of the light source falling on the subject. In lieu of this it is necessary to pre-set or allow the camera to automatically adjust to the light source so that a white object will register as white without color shifting or imbalance. All cameras have two white balance settings: one to balance exposure for natural light, and one for balancing artificial (incandescent, flood, quarts, halogen) light.

COLOR TEMPERATURE

When a subject is heated (or lighted) it will in turn radiate light and heat. There is an inherent relationship between the color of the light reflected or radiated and the temperature of the object. The unit of measurement delegated to color temperature is known as degrees Kelvin, degrees K, or

FOCUSING

Automatic focusing controls are also built into most videocameras and they work quite well. In studios they are quite accurate for zeroing in on prominent objects. Outdoors the camera does not always zero in at the proper subject distance, especially if a number of objects are scattered varying

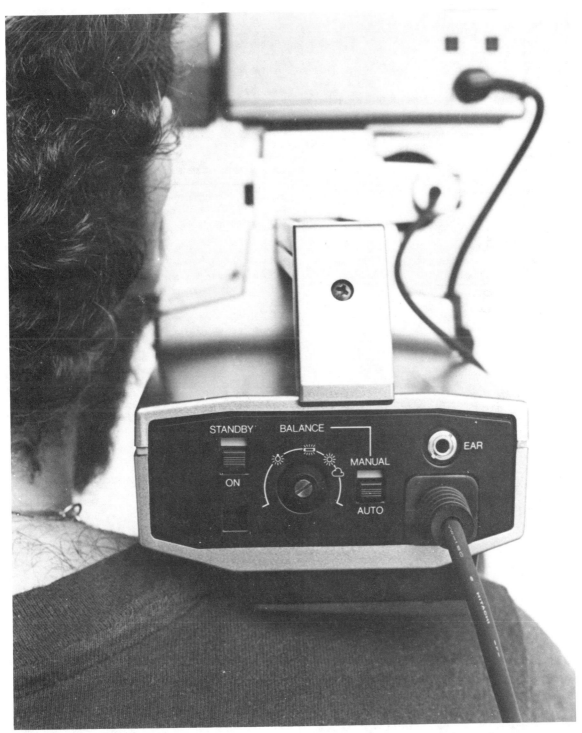

Fig. 9-2. Light compatability and white balance switches are usually located in close proximity on all cameras.

The figures in this table are approximate values for reference.

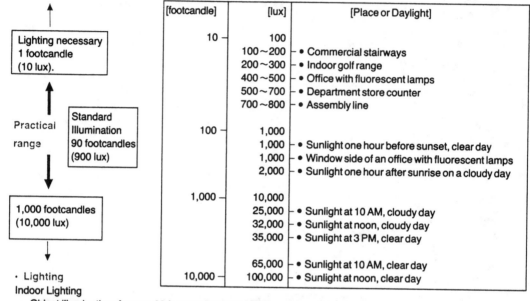

[footcandle]	[lux]	[Place or Daylight]
10	100	
	100~200	• Commercial stairways
	200~300	• Indoor golf range
	400~500	• Office with fluorescent lamps
	500~700	• Department store counter
	700~800	• Assembly line
100	1,000	
	1,000	• Sunlight one hour before sunset, clear day
	1,000	• Window side of an office with fluorescent lamps
	2,000	• Sunlight one hour after sunrise on a cloudy day
1,000	10,000	
	25,000	• Sunlight at 10 AM, cloudy day
	32,000	• Sunlight at noon, cloudy day
	35,000	• Sunlight at 3 PM, clear day
	65,000	• Sunlight at 10 AM, clear day
10,000	100,000	• Sunlight at noon, clear day

Lighting necessary 1 footcandle (10 lux).

Practical range

Standard Illumination 90 footcandles (900 lux)

1,000 footcandles (10,000 lux)

• Lighting

Indoor Lighting
- Object illumination: Approx. 90 footcandles (900 lux).
- Keep sufficient distance between the lights and the object to get uniform illumination.
- Maintain as much brightness as possible behind the object.
- Minimize object shadows.

These are the fundamentals for reducing the contrast ratio. To emphasize a three-dimensional effect or to add depth, use additional spot lights.

Fig. 9-3. (A) Value brightness scale. Courtesy Quasar.

distances within the len's depth of field. For superior results, I strongly urge the serious videocamera buff to rely on the eye and manual focusing in order to guarantee sharp subject definition (Fig. 9-4).

VIDEOCAMERA SHOOTING TECHNIQUES

The Tripod. A luxury for the still camera photographer, the tripod is a necessity for the videocameraman to be used both indoors and outdoors. The videocamera cannot be successfully or steadily hand held and some basic shooting procedures require the built-in control effects the tripod will provide. Figure 9-5 shows a functional and highly efficient camera tripod set up. Shown in the

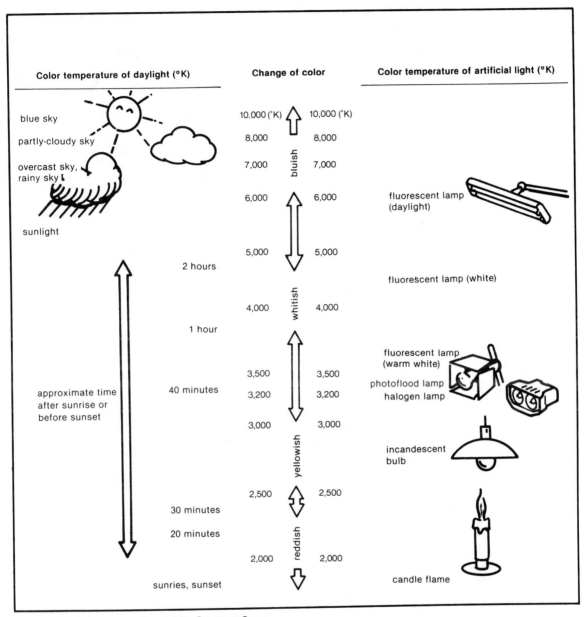

Color temperature of daylight (°K)

blue sky

partly-cloudy sky

overcast sky, rainy sky

sunlight

approximate time after sunrise or before sunset

2 hours

1 hour

40 minutes

30 minutes

20 minutes

sunries, sunset

Change of color

10,000 (°K)	bluish	10,000 (°K)
8,000		8,000
7,000		7,000
6,000		6,000
5,000		5,000
4,000	whitish	4,000
3,500		3,500
3,200		3,200
3,000	yellowish	3,000
2,500		2,500
2,000	reddish	2,000

Color temperature of artificial light (°K)

fluorescent lamp (daylight)

fluorescent lamp (white)

fluorescent lamp (warm white)

photoflood lamp
halogen lamp

incandescent bulb

candle flame

Fig. 9-3. (B) Color temperature table. Courtesy Sony.

illustration is the Bogen 3124 tripod with the Bogen Mini-Fluid head. This combo will afford the camera positive and fault free performance for panning, tilting, etc. and adds to camera work versatility. Handle options are also offered for individual application as preference.

Attaching a dolly (Fig. 9-6) will further increase the tripods versatility, allowing steadiness and freedom of tripod movement when the tripod must be used to follow action. When setting up the tripod, insure that the legs are tightened and equal in length. Individual leg length should only vary if you are shooting on an inclined ground plane.

The camera should always be securely attached

Fig. 9-4. Manual focusing provides reliable and optimum sharpness.

Fig. 9-5. Bogen tripod setups with Micro Fluid head units. Courtesy Bogen.

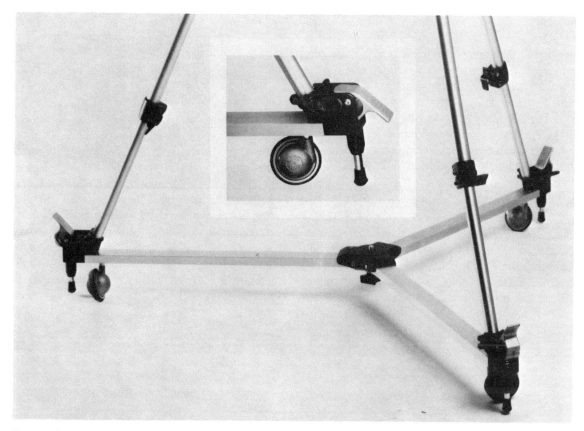

Fig. 9-6. Bogen Dolly System. Courtesy Bogen.

to the tripod plate-receptacle (Fig. 9-7). The securing screw should be turned into the camera's female tripod screw, fitting all the way and tightened. Make sure also that the tile-handle is also tight before moving away from the camera. If your tripod contains a dolly base and you don't intend to move camera and tripod, look down the wheels. Fluid head tripods are preferred for videocamera work. They rely on greased internal ball bearings for smooth tilt and pan operation. Fluid heads make camera jockeying effortless resulting in professional looking videotaped productions.

Panning. Panning is the art of side to side camera movement. It is used for camera scanning purposes, or for following action. Sophisticated tripods have both a pan and a tilt handle so that the two functions can be manipulated quickly utilizing both hands. However, the tilt handle will serve admirably for panning (as shown in Fig. 9-8).

Panning rhythm and technique are easily acquired with minimal practice. You should pan smoothly and evenly in a steady arc, avoiding jerky movement. The rule of thumb is to pan slowly for a more desirable effect. Fast panning movements only apply in fast action camera work.

Tilting. Tilt, or up-and-down effects, are realized with the tripod tilt handle. The handle is first loosened by turning it counter clockwise until the desired freedom of movement level is achieved, then manipulated up and down (Fig. 9-9). One must always retain a positive grip on the tilt handle to guard against camera tipping when tilt lock mechanism is loosened.

HAND-HELD CAMERA TECHNIQUES

Some video photography will warrant hand

holding the camera while shooting. In such situations the camera should be hand-secured as steadily as possible with body movement kept to the barest minimum. The camera body should rest on the shoulder, the pistol grip held firmly in the hand (Fig. 9-10). Further camera support should be provided with the second hand steadying the camera (Fig. 9-11). For low angle shooting further camera steadfastness is achieved by kneeling on one knee and resting the elbow on the other (Fig. 9-12).

Walking With The Camera

Occasionally one will need to walk with the camera to follow action or for special effect. Unfortunately when we walk normally we tend to bob up and down. This bobbing effect (Fig. 9-13) must be counteracted or minimized as much as possible. As the cameraman bobs, the picture bobs. When

walking while videotaping, keep the knees slightly bent and move with the camera parallel to the ground. Walk evenly, slowly, and steadily. The same rule applies when walking sideways (Fig. 9-14). Keep the eye on the viewfinder and concentrate on the subject.

ZOOMING

Zooming is the technique of moving in or away from your subject with the camera at a fixed position. This is made possible by the electronic zooming apparatus integrated in virtually all cameras today. In the early days of TV, the videocameraman had to rely on supplementary or accessory lenses to change the shooting angle or adjust from wide angle to telephoto effects. The zoom lens will do this electronically at the touch of a button. Zoom controls are usually contained in the pistol grip

Fig. 9-7. Securing camera to tripod.

Fig. 9-8. Tilt handle manipulation.

Fig. 9-9. Tilt functions in the more sophisticated tripods are freer.

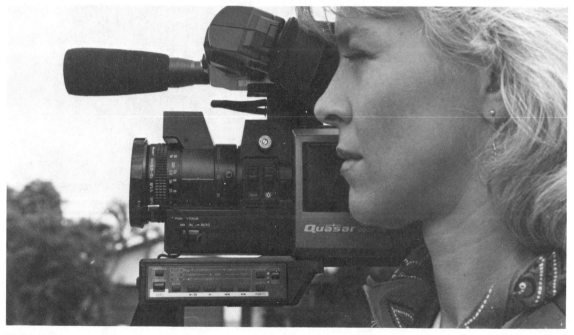

Fig. 9-10. Using the shoulder for steadying is possible if a tripod is not available.

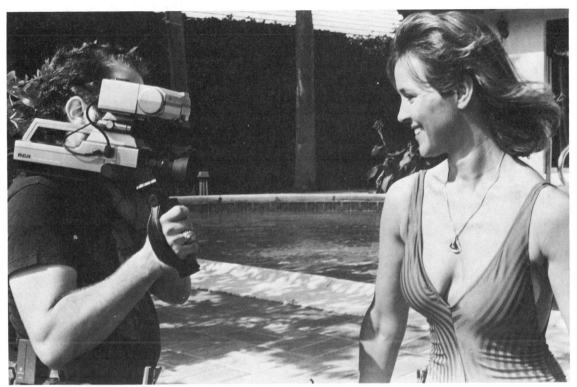

Fig. 9-11. Two hands and steady shoulder make off-tripod shooting feasible.

Fig. 9-12. An elbow and a knee can provide a steady rest.

Fig. 9-13. Walking forward.

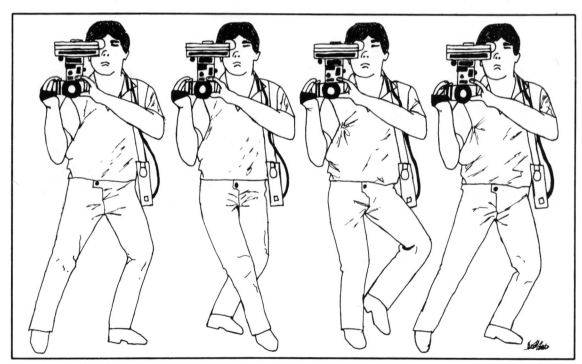

Fig. 9-14. Walking sideways.

Fig. 9-15. Zoom action is finger tip controlled.

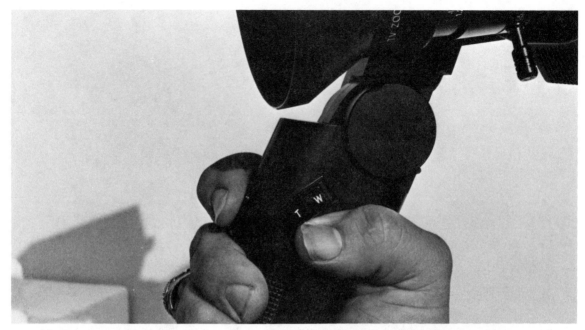

Fig. 9-16. Some cameras feature thumb-tip zoom; it is not as controllable as the forefinger type.

Fig. 9-17. Macro facilities hand-controlled allow "close-up" work.

handle either in front (Fig. 9-15) or on the side for thumb manipulation (Fig. 9-16). You can control zoom with one hand, and focus with the other. Manual zooming is also possible but not as controlled or steady as motorized zooming.

Neophyte camera operators tend to zoom in and out constantly, which can annoy viewers of taped sequences. Zoom should be used occasionally and for emphasizing certain objectives, and for varying framing angle from time to time just to maintain viewer interest. Proper focusing is mandatory prior to zooming. Move the zoom ring to its telephoto position and adjust for correct focus. Then you can successfully zoom to wide angle and back without losing sharpness. If you focus in wide angle position, then zoom to telephoto, you will zoom from sharp wide angle to out-of-focus telephoto.

MACRO VIDEO

Most videocamera lenses make provision for *macro*, which is extreme close-up (as close as 4mm) reproduction. Macro will allow insect, texture, etc., photography. To close in on the subject, the zoom lever is set at "wide" and the macro lever revolved (Fig. 9-17) in order to focus "up close." Most cameras will allow you to go from wide to macro, which can promote some wild effects. When zooming from macro to full wide, before placing the zoom ring in macro stage, adjust lens focus for distant subjects (with zoom lens in telephoto mode).

FILL IN LIGHTING

When shooting close subjects outdoors in sunlight it is advisable to use fill in lighting to open up shadows. This is particularly effective when videotaping people or models as it cuts down the contrast ratio. Always use a light source that balances with sunlight. In Fig. 9-18 we see an ideal supplementary lighting setup consisting of an Ambico V0200 12 volt 100w quartz iodide lamp mounted on the camera. Ambico belt power pack serves to power both Videocamera and lamp.

MULTI-CAMERA VIDEOTAPING

The occasion may arise when the serious

Fig. 9-18. Ambico V-0200 camera light and V-0806 belt power pack.

videophile may want to do multiple camera work, using two cameras in various positions or one for close-up or special effects. Most videocamera companies do not make provision for setups of this nature not the equipment to make it possible. One company, Sci-Tech, has, however, released a special electronic unit, the HS-2HIP, allowing the consumer multiple camera production plus special electronic effects.

The housing of the HS-2 is compact; the unit is simple to hook up and use. The HS-2 will work with most 10 pin color camera's, coordinating two cameras to work singly or in conjunction, feeding into a common VCR. Three push buttons on the unit select local, remote, and special effects. A rotary knob further controls the special effects circuitry. A slide switch controls "dissolves" and "wipe patterns" made possible by different, insertable special effects cartridges.

109

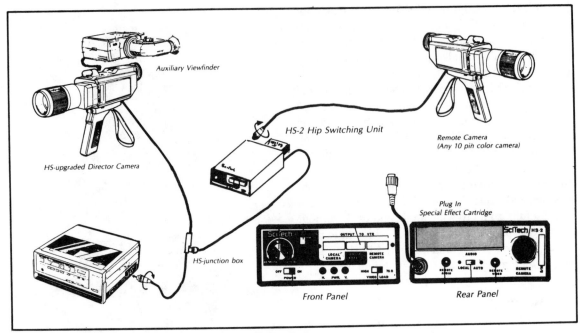

Fig. 9-19. The Sci-Tech HS-2 HIP Switcher. Courtesy Sci-Tech.

The HS-2HIP Switcher receives its power from the same source that activates the local camera and transfers it to the remote camera's cable. Sci-Tech also makes two camera upgrades available. The *Gen-Clock upgrade* will allow a camera to lock subcarrier and sync signals to an external source. The *H-S upgrade* also features genlocking, but has in addition an auxiliary viewfinder jack, LED indicator and viewfinder selector switch.

The Gen-Clock circuitry feature of HS-2 switcher reads subcarrier and sync signals from the remote camera, consecutively engaging the local camera into matched phasing and timing. It is *this* circuit that allows two cameras to work together so efficiently. The Gen-Clock circuitry will intro-duce controlled drift into the main camera's horizontal synchronization timing till both camera pulses match. After establishing horizontal sync, the Gen-Clock repeats the function with vertical synchronization inserting drift into the main camera (a line at a time) until a state of vertical coincidence is arrived at. One of the trickiest aspects of multi camera sync is automatically handled by the HS-2, eliminating the need for a waveform monitor or vectorscope. The HS-2 and connective set up is illustrated in Fig. 9-19.

This chapter has served to illustrate shooting techniques and integrated camera functions. Other sophisticated videotaping enhancing and trick effects are featured in the next two chapters.

Chapter 10

Electronic Special Effects

There are many special effects that can be achieved with video equipment. Effects achievable fall into basically two categories: *electronic* and *optical*. This chapter deals with electronic effects that can be realized with cameras, VCRs and special effects generators.

CAMERA EFFECTS

Camera special effects are generated by manipulating or adjusting built-in camera features in order to obtain creative or trick visual reproduction.

Fade

Fade is basically an editing feature that can be implemented when going from scene to scene. Fade controls are built into practically all cameras; the more sophisticated circuits offer varying fade-time durations. This built in effect works admirably well and is handy for creating scene to scene fades to break up the monotony of instantaneous scene change.

Color Balance Manipulation

For general videotaping, color should be balanced. However to create mood or color impact, the fine-color control settings on average videocameras can be manipulated for startling effects. Overall chromatic renderings in red, blue, green, etc., can be realized by changing fine color settings to suit particular moods or purposes. Experimenting with these settings will enable you to create your own specific color moods.

Negative Positive Reversal

Also contained in many cameras is a *positive negative reversal* switch. In normal operation or setting the camera will reproduce the scene videotaped in positive natural color. Flicking the switch, will reverse the image, making it appear as a color negative. This can be utilized as a trick effect. The scene can be taped normally and for special emphasis in a given portion can be switched to negative mode. This can be done at the end of a zoom in which the image is reversed and still framed for

added emphasis or impact. A number of combinations are possible, governed by the ingenuity of the cameraman. You can also copy a color film negative in positive full color using this reversal switch.

EFFECTS WITH VIDEOCASSETTE RECORDERS

There are some effects that can best be implemented using the video cassette recorder. In most cases two VCR's must be used: one to *create the effect*, the second *to reproduce it on tape*.

Freeze Frame

The newer four and five head design VCR's feature freeze frame capabilities. To inaugurate freeze frame, the effect producing machine plays the source material up to the freeze frame point. Then the freeze frame switch or button is pressed, throwing the machine into freeze-frame mode. The second machine connected to the output of the effect producing VCR then records the effect. The freeze-frame effect footage can be edited into the production tape in its appropriate place. Freeze-frame segments can also be introduced into a videotape production as the taping proceeds or at appropriate intervals. Camera work and VCR electronic effects methods can and should work hand in hand. Full stop-frame segments can also be transmitted from the "sending" VCR if only a static frame segment is preferred.

Freeze Zoom

This requires a bit more work. The zoom effect must be inaugurated by the camera first. Then the recorded zoom segment must be played on the sending machine till the point of freeze is reached and the transfer machine's freeze frame control is activated. As this takes place the second receiving machine records the transpiring effect.

Practice and familiarization with freeze frame efficiency of the signal sending VCR will enable the videocraftsman to master the two freeze effects until they can be manipulated exactly. Only the more sophisticated and efficient VCR's with superior multiple head design will provide effective freeze frame effects.

Time Lapse

Time lapse is also possible on the home front, but it is more advisable on industrial grade machinery that can segregate half and full frames exactingly. This can be done by a professional video reproduction outlet that can provide this service. Time lapse studies can also be shot frame by frame on 16mm film or with 35mm camera's then transferred to videotape.

Posterization

This is an effect that is usually attainable with professional electronic video equipment. A pseudo-posterization effect is possible by taking a videotaped segment and reduplicating it about four or five times (via VCR to VCR transfer). The original tape is copied, then each copy is consecutively copied until the final reproduction breaks down into a pseudo posterized effect.

COMPUTER EFFECTS

A number of novel graphic, design and titling effects are possible generating from computers. To transmit signals to the VCR the computer must interface properly with the VCR. Consult the computer manual or technical data that will delineate what connective devices and accessories must be implemented in order to transfer computer signals to VCR inputs.

SPECIAL EFFECTS GENERATORS

There are a few component additives that when introduced into camera or VCR signal circuits will promote special effects. The Sci Tech HPS-2 HIP switches mentioned in the previous chapter, in addition to serving as a multi camera linkage, will also generate special effects. A small slide switch on the control box will determine what type of effect will be generated: a dissolve, or a special wipe pattern. The special wipe patterns evolve from insertable cartridge modules which slide into a panel slot on the rear of the HS-2, like the cartridges in an Atari game.

The plug-in cartridge effects include horizontal, vertical, double vertical , and dual corner wipes. Sci Tech markets up to 20 special effects cartridges. In addition, they also make available a computer interface for transferring created digital- controlled effects emanating from computers. The cartridge effects systems worked excellently for us. Of particular interest is the horizontal-wipe module which forms true split screen images.

Most special effects generators will plug into the standard 10-pin camera connections on VCRs (Fig. 10-1). The utilization of special adaptor cords may be necessary in some situations.

AMBICO V-0303
SPECIAL-EFFECTS GENERATOR

This unit incorporates its own electronic control center, its own video camera (with zoom lens), copy stand, and special effects masks (Fig. 10-2).

Essentially the V-0303 is a creative tool, enabling the videotape producer to add images in seven color combinations, and to superimpose titles, masks, or images directly onto videotapes. The unit will also allow switching back and forth between superimposed and original material. In addition to video effects, the generator makes full provision for selective and controlled audio dubbing.

Integral switch controls on the control box panel provide a multitude of functions. A control combination selector selects both superimposed and background colors in seven combinations: white-black, orange-blue, green-blue, green-magenta, blue-red, blue-yellow, and magenta-green. There is a color base control for adjusting hue. Turning the hue control clockwise increases blue tonality; turning it counterclockwise increases red tonality.

The V-0303 is used in conjunction with a main color camera for superimposing images or titles. Manipulating the pattern selector switch will allow patterns picked up by the generator to be superimposed on the color image picked up by the main camera. In the "negative" switch position only the white or light portion of the image from the generator is superimposed. In the "positive" switch position, only the black portions of the transferred

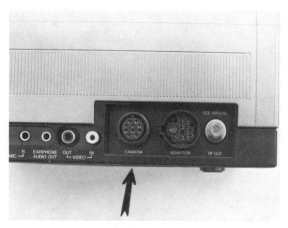

Fig. 10-1. Most electronic special-effect components have 10-pin cable setups for connection to a camera or VCR.

image are superimposed on the image taped in the main camera. A key level control serves to sharpen or diffuse graphics recorded by the generator. The Ambico V-0303 will connect either to a remote (or main) camera or directly to a VCR. Special fade controls for both video and audio are also incorporated into the generator's control box. This unit is a highly functional piece of electronic equipment and can be most beneficial to the discerning videocraftsman.

THE SONY HVS-2000

The HVS-2000 is a generator and dual camera selector similar to the Ambico, with the exception that it does not incorporate separate audio dub and fade functions. An excellent piece of graphics superimposing and titling equipment, the HVS-2000 (Fig. 10-3), can be used with Beta VHS formats. Figure 10-4 shows a typical HVS-2000 hookup in Sony Beta format.

Both Ambico and Sony effects generators rely on B&W camera units which in turn superimpose the special effects created into a second color camera or VCR. Special effects generators of this type tend to be a bit expensive, but for the purpose they are created for, they are unbeatable. Some of the finest titling and graphics sequences I have studied originated from special effects generators of this type.

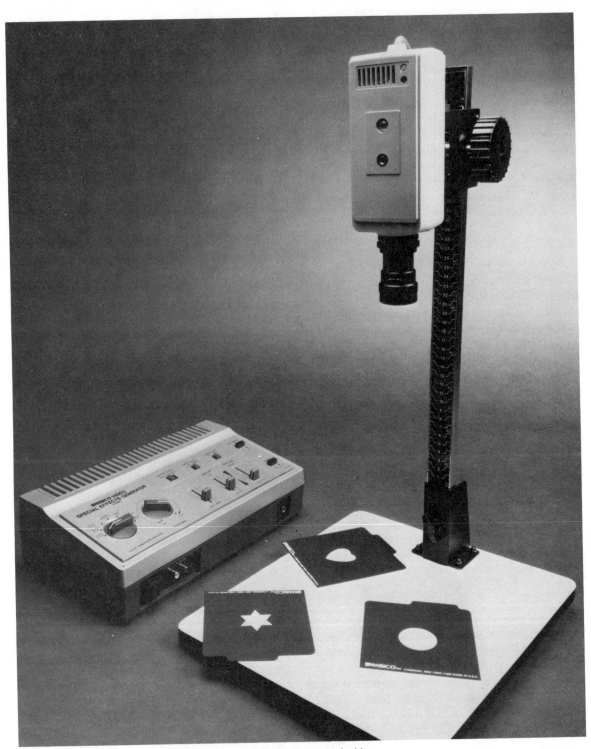

Fig. 10-2. The Ambico V-0303 Special Effects generator. Courtesy Ambico.

Fig. 10-3. Sony HVS-2000 Special Effects Selector. Courtesy Sony.

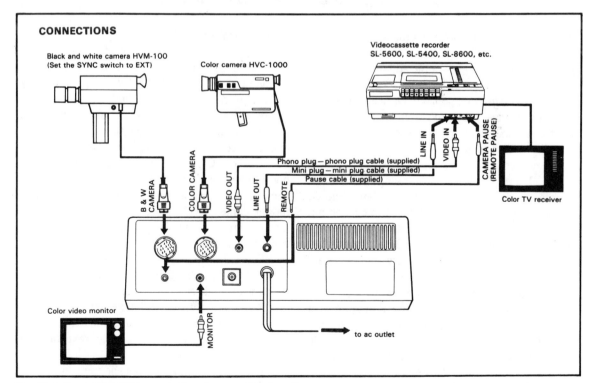

Fig. 10-4. Sony HVS-2000 connection diagram. Courtesy Sony.

Chapter 11

Lenses and Filters for Special Effects

There are numerous special effects that can be easily and effectively achieved by using auxiliary lenses and filters. These simple add on accessories are not only readily available at most camera stores, they are relatively inexpensive. Optical special effects accessories are much, much cheaper than electric special effects units. They are also easier and less tedious to use.

In most accessory lens and filter situations, you will be able to purchase adapter rings and thread mounts for your particular camera's lens. Should an exact filter size not be available, you may obtain special step-up or step-down adapters that will surely make the filter unit and lens compatible. Step-up or step-down rings will allow an attachment size of 55mm to adapt up to 58mm or down to 52mm. Although most video cameras contain fixed lenses, they will all accept universal adapters. In fact, filters and accessory lenses are one of the few additive accessories that are truly interchangeable in the videocamera field. Videocameras usually feature the following lens diameters (in millimeter): 49mm; 52mm; 55mm; 58mm.

AUXILIARY LENSES

Auxiliary lenses for various effects are becoming more common in still photography but they are not as favorably accepted for video photography. This is probably due to the fact that virtually all videocameras feature "zoom" lenses which will run the gamut from wide angle to extreme macro, making auxiliary field effect lenses useless. For the buff who has C-mount (threaded mount in camera body to accept C-mount lenses) capabilities in his camera, auxiliary lenses may be a boon. The C-mount camera will also allow the application of many 35mm camera lenses to videocameras via special adapters.

The only auxiliary lenses the videobuff may care to include in his gadget bag is a fish-eye or extreme wide angle auxiliary lens; extreme wide angle effects are not always attainable with lenses. The fish-eye feature provides an extreme, distorted wide angle optical effect, and hence is only desired for special trick effects.

The wise thing to do when shopping around for auxiliary lenses is to try them on for size to study

Table 11-1. Auxiliary Lenses.

Manufacturer/Model#	Type	Accessories
AMBICO V-0311	macro/wide-angle (2-part lens converts from macro to wide-angle, .7X)	adapter rings
AMBICO V-0314	fish-eye (extreme wide-angle, .4X)	adapter rings
AMBICO V-0314	macro	adapter rings
AMBICO V-0312	telephoto, 1.5X	adapter rings
CANON C-8	wide-angle, .6X	direct mount
CANON C-8	telephoto, 1.4X	
CURTIS MATHES 14B370-462	lens kit: wide angle, .7X neutral density optical lens cap	adapter ring
JVC GL-CO6-58U	wide-angle, .6X	adapter ring
JVC GL-C15-58U	telephoto, 1.5X	adapter ring
PANASONIC PK-L078	lens kit: telephoto, 1.5X macro, multi-image, neutral density, optical lens cap	direct mount
QUASAR VF-93WE	lens kit: wide-angle, .7X, neutral density, optical lens cap	adapter ring
RCA LX-152	telephoto, 1.5X	direct mount
RCA WAL-01	wide-angle, .6X	direct mount
SONY VCL-0758WA	wide-angle, .7X (lightweight acrylic lens)	direct mount
SONY VCL-1558A	telephoto, 1.5X	direct mount
SONY VCL-0758A	wide-angle, .7X	direct mount
SONY VCL-4058	high-power telephoto, 4X	direct mount

what they will do and see if you require the effects offered. Also keep in mind that the longer the lens, the greater the magnification of telephoto effect; the shorter the lens, the greater the wide angle effect. Shown in Fig. 11-1 are two popular auxiliary lenses distributed by Ambico. These lenses will adapt to all video cameras and provide excellent wide angle and "trick" fish eye effects.

On the preceding page is a listing of currently available auxiliary lenses and their mounting capabilities. In cases where manufacturers provide direct mounting for their specific brand of camera, adapters may be purchased separately at photo shops for possible mounting on a differing brand model.

FILTER TYPES AND CATEGORIES

Hundreds of filters and filter types are available to photographers, and with the aid of adapt-

ers, consequently available to video camera buffs. They range from corrective, to enhancement, to special "wild effects" filters.

Corrective or one-color filters are almost useless in videowork; the camera itself has internal color corrective functions that will afford identical effects.

The enhancement filter category features color vignette, diffusion, polarizing, half tone (color graduated) and "foggilizer" and soft spot filters.

The more radical special effects filters encompass rainbow, diffraction grating, split image, bi and tri-color, and star grids.

A special Slip-on Filter system guide is presented in Fig. 11-2. (Courtesy: Marumi Filters), showing all currently available filter types and configurations.

Space alottment for filter effects and techniques would far exceed that necessary to cover all the

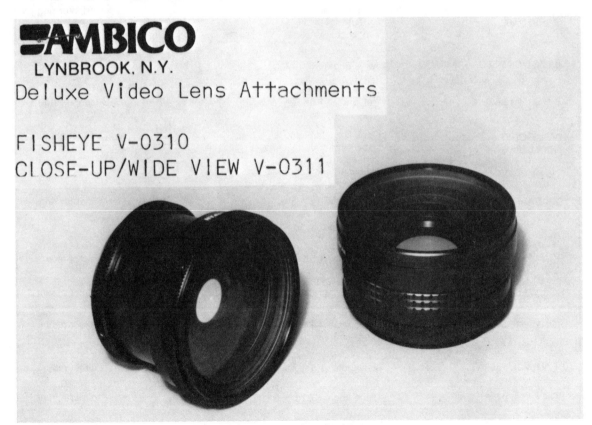

Fig. 11-1. Ambico accessory wide angle lenses. The fisheye (left) V-0310 and close-up/wide V-0311.

Fig. 11-2. Marumi Slip-on Filter guide. Courtesy Marumi.

"trick" variables possible; so we have chosen to feature some filters that are most applicable to creative videotaping. For those readers who wish an in-depth and enlightening background on filter types and application, I recommend three good, authoritative manuals (Fig. 11-3) that may be obtained in most camera shops. The excellent "Slip-on Creative Filter System" guide made available by Marumi may be obtained by writing to:

Marumi Filter Systems
369 Central Street
Foxboro, MA 02035

FILTER KITS

A number of accessory manufacturers package special effects filter kits. The most unique, well-conceived one is the V-0319 Special Effects Kit marketed by Ambico. This compact kit features a multi-imager with which the cameraman can make a tri-image revolvable by control arm rotation, a rainbow effect filter for spectrum color bursts, a starburst grid, plus an optical glass cover lens. The V-0319 kit comes complete with carrying case and adapters for all videocamera lenses. This is a good basic special effects kit recommended for both beginner and advanced videocraftsman.

VIDEO SPECIAL-EFFECTS FILTERS

The nicest thing about special effects filters is that (in addition to being inexpensive) they can be purchased singly or as required. They store

Fig. 11-3. Three good manuals for trick effects with opticals: Kodak's "Filters and Lens Attachments," "How to Use Filters," an Alfred Handy guide, and Marumi SL Filter guide.

easily and compactly, and can be placed in filter files without fear of mix-up as most filters have a number and name type listed on the edge of each filter ring (Fig. 11-4).

Filters are most readily obtainable at camera stores; most shops will stock such complete filter lines as Marumi. If you can find a local camera shop that stocks the Marumi line of filters, you can rest assured you will have at hand a source of every filter type conceivable. There are other filter lines of merit also such as Tiffen and Vivitar, but the Marumi line is more complete and of high quality hence most applicable to TV camera work.

Following is a listing of special filters that are desirable and suitable for videocamera special effects.

Polarizing Filter

The *polarizing filter* is a compensating filter that will allow you to shoot through glass and eliminate annoying reflections emitted by shiny or glassy objects. On bright sunny days a polarizer will help reduce glare and atmospheric haze. The polarizing filter is a revolving filter that must be revolved in position to maximize or minimize its specific properties. At the proper position, the polarizer reduces or eliminates reflective glare by blocking polarized light, while transmitting nonpolarized light. The polarizer "polarizes" light passing through it by transmitting light which vibrates in a single plane. As nonpolarized light which enters the polarized vibrates in all directions, only part of the light will pass through the filter (the part vibrating in the path allowed by the filter). Polarized light traversing the filter will pass through only if vibrating in the correct direction; if not the light is blocked. In this manner, the polarizer serves to block out or minimize reflection and glare.

To witness this effect one need only look through the filter as it faces a glare or reflection. The revolving portion of the filter is rotated until glare or reflection decreases or increases, a phenomenon that can be studied or "set" with the naked eye. A polarizing filter will achieve its maximum blocking effect when the cameraman stands at the *same* angle to the reflective surface as the source of light falling upon it.

When calculating exposures with polarizing filters, first set the polarizer in the desired position, then set your automatic white balance. Since polarizers only transmit a portion of the light admitted, exposure increase may be required.

Polarizers are also highly effective in sky color and haze control. Polarizers are capable of darkening sky effects without altering other colors within the picture. As well as darkening the sky area, the polarizer will assist in reducing unwanted reflections in the picture. Rotation of the polarizing element will control the sky darkening effect or the reflection reduction effects, thus improving scenic photography. Polarizing filters may also be used in pairs in order to achieve more striking and dramatic effects.

Multiple Image Prism Lenses

Actually neither filters or lenses, these units are basically prismatic glass, attached to the videocamera lens in the same fashion as a filter. There are basically three types of prism lenses: *parallel*, *triangular*, and *radial*.

The *parallel prisms* will break the image into side by side segments according to the number of segregated facets within the lens. In the *triangle prism*, a triple image effect is produced, one image above or below the other two. *Radial prisms* are comprised of five or six prismatic segments creating a multiple image pattern around a central focal image. In Fig. 11-5 we can study a typical prism lens. The one pair of eyeglasses the lens is concentrated on is broken-up into three images.

Most multiple image prism lenses are double ring mounted to allow rotation of the lens within the ring-adapter unit. Rotating the prism lens will allow image rotation or placement as desired. Prism lenses achieve their most effective results when the lens is placed at normal focal length. Prismatic lenses are not effective at focal ranges greater than 100mm. Extreme wide angle lenses also minimize the effect. The lesser the focal length of the lens, the greater the angle of view and hence the lesser the "imaging" effect. Prismatic lenses should also be used with small iris apertures to guarantee sharp images. Prism lenses should mount as *close to the main lens's front element* as possible in order to pro-

Fig. 11-4. Filters are usually ring labeled on the side for identification.

Fig. 11-5. The Ambico Tri-image prism filter.

vide most effective results.

Rainbow Filters (Diffraction Gratings)

Rainbow or diffraction filters have the capacity to break up beams of light producing flares of color when aimed at a light source. Different rainbow filters produce varying flare patterns. The variances in color, intensity, and pattern of flare depends on the angling and spacing of thousands of minute lines which are etched into the rainbow filter. These lines interact forming miniature prisms which in turn diffract the light, causing flare to form across the lines.

To benefit the wide range of effects achievable with diffraction filters, it is wise to try a few types to see which will offer the most desirable effect. Diffraction filters fall into one of five groups; each group gives off a different or distinct type of effect.

Diffracting Type

☐ *Linear:* With this diffraction filter, repeti-

tive, singular direction patterns are produced along a straight line on two sides of a point light source.

☐ *Radial:* Three spectral flares are usually created in a spokelike pattern emanating from the point light source.

☐ *Circular:* In this pattern the point light source is surrounded by rings of solid colors.

☐ *Rainbow:* Here point light source is broken up into a surrounding starburst pattern with varied spectra. Some rainbow gratings have a clear center spot for producing a softer effect.

☐ *Nebula:* This type creates a multistreak spray pattern starting at the point light source graduating to a circular pattern. More pronounced than the standard radial effect, the nebula filter can be converted to a more vivid effect with rotation during videotaping.

In Fig. 11-6 we see a normal reproduction of a chandelier on a dark background.

Five point light sources are contained in the

122

Fig. 11-6. Photograph without a trick filter.

Fig. 11-7. Same view shot through the Ambico rainbow filter.

123

chandelier. In Fig. 11-7, the identical subject is photographed at the identical distance, but this time we apply a rainbow filter over the lens. Note the dramatic spectral effect which in color is even more vibrant and exciting.

Most diffraction filters produce their prominent effects best at large lens (iris) apertures. Since overall intensity of spectral diffraction will diminish as the lens is stopped down, it is advised that prior to shooting the effect is predetermined and studied by viewing through the videocamera lens or monitoring.

Half-Color Filters

These filters are usually designed with a graduated color tone on half of the filter. These filters can be used to partially tint a picture or scene area. This filter is good for enhancing sky effects. For instance: a half pink filter will create a sunset effect in natural daylight.

Star Filters

Star filters, by means of an engraved screen (Fig. 11-8), create star like images whenever aimed at a point light source, promoted by causing the "point" rays to flare into lines of light. Star filters are clear and require no exposure adjustment. The stronger the point source of light, the more intense the flare and the greater the flare or star line. Figure 11-9 shows the effect realized using a four point star filter when photographing automobile and street lights which provide very fine point light sources.

In addition to four-point star filters there are six and eight points types, the differing point effects caused by additional parallel lines laid at angled intervals to the otherwise simpler square-grid pattern. Always experiment with varying star effect patterns before determining which one is best suited for a special situation. Star filters can be com-

Fig. 11-8. Starburst filter showing grid pattern. Filter by Ambico.

Fig. 11-9. Starburst effect.

bined for varied effects, but it wiser to choose the proper grid pattern for the desired effect.

Star filters are capable of the most striking effects when used against a black or dark background. There should not be an overabundance of point light sources in the picture as the profusion of star effects may promote visual distraction. Shooting at sunlight through star grids will create brilliant flare lines, but I would advise against this as the videocamera pick up tube can be seriously ruined or damaged. Star filters are particularly effective when videotaping jewelry, glass, candlelight and arrayed single point light sources. Rotating the star filters while videotaping will also produce spin flare effect.

Diffusion Filters

Diffusion filters create soft images not always conductive to special video effects, since the video image is somewhat soft itself. For fantasy-like or intense diffusion, diffusing filters of varying intensity will provide various levels of diffusion. An alternate which is much cheaper: the use of cello-

Fig. 11-10. The motorized Marumi V-1 Filter housing and control pack.

Fig. 11-11. The Filter Housing.

phane over the lens or set into a filter holder. Nylon mesh across the lens will serve the same purpose as will a light coat of vaseline on a skylight filter. If you require diffusion, go the home-brew routes which will provide adequate results at lesser expenditure.

Closeup Filters

There are a bunch of closeup lenses available but with most videocamera lenses possessing their own macro facilities, closeup or Proxmar lenses are a waste of time. In macro mode, most of the current videocamera lenses will focus down to inch increments; you can't ask for a more discerning macro range.

It was previously mentioned in this chapter that some isolated special effects filters rely on "rotating" to heighten or expand their special effects facilities. This would usually necessitate revolving the ring manually or intermittently not always a smooth or even method of manipulation.

Marumi, the quality filter manufacturer, has

Fig. 11-12. The speed-setting knob controls the filter rotation speed.

Fig. 11-13. Battery pack and control box.

recently released what is considered a most essential filter carrier called the Marumi V-1 (Fig. 11-10). The filter carrier of the Marumi V-1 is a motorized component (Fig. 11-11) that both houses and revolves the filter while also serving to mount the filter unit to the camera lens by means of a threaded adapter. The V-1 is adaptable to *all* camera lenses and is a most welcome piece of accessory equipment that should prove universally popular since it is so efficient and reliable. The V-1 will revolve continuously or in finger controlled time durations in either direction. The speed can be pre-set manually (Fig. 11-12) so that the unit will allow slow or fast filter-turning speeds. The motor is self contained in the filter housing and is battery powered by small photo batteries (Fig. 11-13) housed in the hand control console which also contains speed setting knob and motor switch. This motorized filter, true "state-of-the-art" unit is probably one of the most warranted and essential accessory items to hit the videocamera market. For the video buff who wishes to do trick optical effects with polarizing, starburst, and diffraction filters, it's the ultimate way to go. the Marumi V-1 filter holder will accept all Marumi SL filters and similar sized filters of other manufacture.

Chapter 12

Film-to-Tape Transfer

There will come a time when the serious videophile will want or have need to transfer movie film to tape. This may be for filing or reference (as in home movies), for including or interjecting material that may only be available on film, or for special effects. The versatility of videotape and VCR media make it possible and practical, and due to the varied transfer accessories on the market, simple and feasible. With the benefits of video equipment, you can also correct over and under exposure (on color and slide film); color balance, zoom in or out to crop, or create special effects with operative camera options or filters.

There are two options for film to tape transfer: using commercial services, or doing it yourself. The negative factor with using the commercial services is cost. For what you would normally pay out to reproduce about a thousand feet of film, you can enjoy ownership of your own transfer equipment which after a few hours' of usage has paid for itself. Then you can continue to convert all the film you want down the road for no extra cost save for purchasing videotape to transfer the film to. In addi-

tion, when you transfer yourself, you have complete creative control over the project giving you ample room to aesthetically control tape production.

The advantage of commercial duplication is *flicker-free* reproduction, which can be minimized or circumvented on the home front if proper projection techniques are utilized. "Flickering" can (and in most cases will) occur for the simple reason that silent film footage is shot at 18 frames per second and sound footage at 24 frames per second. Videotape (camera, VCRs) reproduce at 30 frames per second. All these frame rates are in opposition to each other so compensating factors must be adhered to (unless the flickering factor is inconsequential to the operator). Commercial and professional equipment contains special shutter components that automatically compensate with selective frame repetition until a harmonizing 30 frame per second rate is arrived at properly balancing Flicker rate until the flicker is visually not apparent.

If you take the do-it-yourself approach, make sure you have or obtain a projector with a variable speed control. This way, you can increase film

speed to assist in minimizing flicker. Counteracting flicker is easy with silent film; with sound film additional compensation must be made for the sound track; in many instances (as in narration) speeded up sound distortion can be minimal or negligible.

Transferring slides is more simplified both in terms of necessary equipment and reproduction. There is no frame rate problem; you are simply taping a static frame evenly lit.

CONVERTERS

The procedures for utilizing a do-it-yourself converter are basic as well as economically logical. Telecine converters range in price from $50 to $200—from basic to sophisticated. The more expensive models incorporate additional features which are most desirable and recommendable.

The Telescreen No. 620 by Hudson Photographic Industries is the least inexpensive (about $40) converter and is a small book sized basic unit. It opens up into a 45 angled mirror and projection screen. The 8 × 8 inch screen offers full viewing of 35mm slides in vertical or horizontal format.

Manipulation of the Videocamera's zoom lens will regulate cropping. This unit is effective with 35mm, 8 mm, or 16mm projectors as the visual source.

Ambico, another progressive accessory distributor, also provides the budget minded with a compact cine-converter unit. (Model V-1610) Transfer by means of a high contrast, rear projection screen allows its use with all 8/16mm movie projectors or 35mm slide projectors.

Another excellent converter is the Ambico Model V-0327 Teleslide converter (Fig. 12-1), strictly for use as a 35mm slide converter. The V-0327 attaches directly to the videocamera lens. The 2 × 2 slide slips into the accommodating frame which also serves for centering and alignment. This unit is so simplified that no additional formal projection equipment is required. One simply faces the camera into a daylight, incident or reflected (artificial) light source and shots. Color correction or enhancement can be administered by videocamera color controls. Color negative (Kodacolor, ektracolor) negatives can also be utilized and converted to a positive color image by using reversal

Fig. 12-1. Ambico V-0327 slide converter. Courtesy Ambico.

features contained in most videocameras. Similar slide converter units may also be obtained from Canon, Quasar, and some other leading video-camera accessory component manufacturers.

The most sophisticated of the tele-cine converters is the Quasar VE 590VA Film/tape converter. This is the epitome of film tape conversion units utilized for this chapter and used and recommended emphatically for its quality, ease of operation and guaranteed, refined, results. The VE 590UA will accurately reproduce any film format to videotape. The unit with integrated components will also allow you to add or superimpose graphics and titles during or in addition to transfer, necessary as well as desired options.

HOW TO SET UP THE CONVERTER

Setting up the Quasar converter is even simpler than setting up a videocamera. The unit out of the box is mounted on a flat plane (table is ade-

quate) and the main body of the converter is swung around on its pedestal 90° till the circular lens faces the camera mount plate. The converter is universally adaptable to most cameras; for the Canon and Quasar cameras it is tailor made. An optional mount bracket to increase heightening/lowering range is also included and a required accessory when using the Quasar 747. The 747 is then mounted in place as shown (Fig. 12-2). Pistol grip cameras will mount directly to the telescopic base eliminating the need for the elevating bracket. All necessary components for the conversion operation should be set up and connected (see Fig. 12-3).

Once the camera is mounted, the height adjustment screw on the converter box is loosened, and the scissor type mechanism is raised and adjusted till the camera lens and converter lens are in exact alignment. The Camera Lens focus should be set at Infinity.

The projector is next lined up: brought close

Fig. 12-2. Mounting the Quasar 747 on the Quasar Cine-Converter. The camera is slid up close to the converter, the lens set in macro mode with the camera lens in close proximity (almost touching) the converter lens.

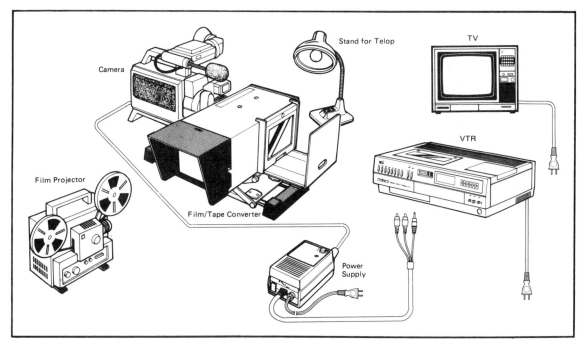

Fig. 12-3. Setting up components for film in tape transfer. Courtesy Quasar.

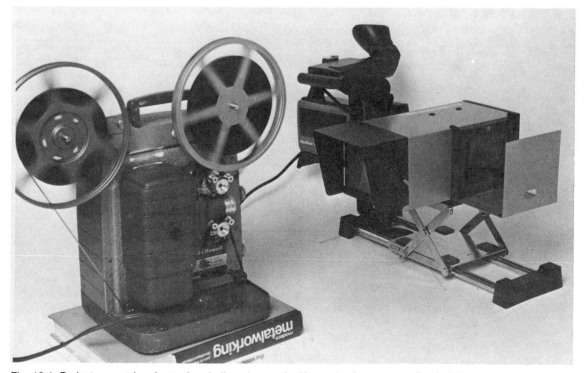

Fig. 12-4. Projector must be elevated and aligned properly. Here a book serves to align height.

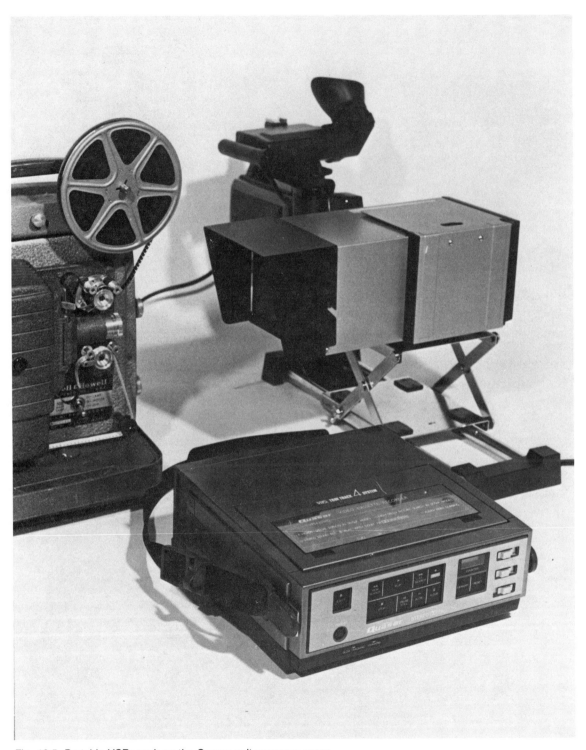

Fig. 12-5. Portable VCRs such as the Quasar unit conserve space.

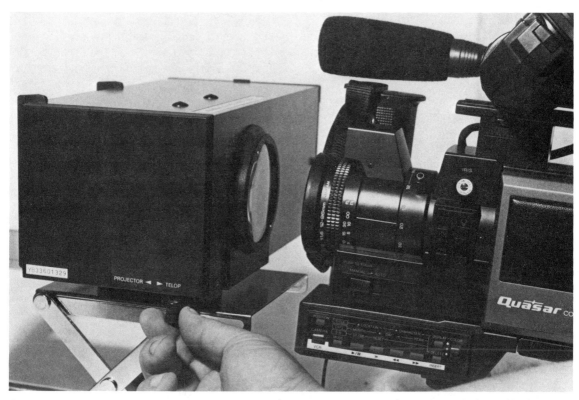

Fig. 12-6. The lever is set for projection reproduction by moving it forward to the projector position as designated by the arrow.

enough to the screen (Fig. 12-4) to fill it fully when sharply focused. Some film footage should be run to check for frame alignment and focus. After all the preliminaries are finalized, the recorder is hooked up and transferral may commence (Fig. 12-5). The portable Quasar VP 5435WQ was found to be ideally suited to this type of operation as are most portables. Prior to taping, the telop-projector lever is set at the "projector" position (Fig. 12-6).

To insert Titles or Graphics into the transfer, the telop card and holder option facilitates the operation and set up as shown in Fig. 12-7. When focusing or viewing title or graphic alignment, the viewfinder (adjustable) should be turned up so that one can look down into the finder easily rather than laying the head horizontally on the table in order to simplify viewing (Fig. 12-8). This eyepiece up position is advisable when using the film converter for focusing, frame alignment, etc.

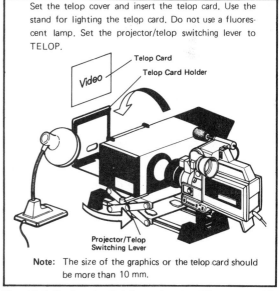

Set the telop cover and insert the telop card. Use the stand for lighting the telop card. Do not use a fluorescent lamp. Set the projector/telop switching lever to TELOP.

Telop Card
Telop Card Holder
Video

Projector/Telop
Switching Lever

Note: The size of the graphics or the telop card should be more than 10 mm.

Fig. 12-7. Setting the Tel-Op option for titling or graphic reproduction. Courtesy Quasar.

FILM TRANSFER PROCEDURES

With all the basics down pat, we can run through the typical procedures and how to best consider and apply the factors involved.

It is always sound practice to use good, well exposed film as source material. The better the source, the better the tape reproduction.

A word about automatic exposure: automatic exposure setting (automatic white balance setting) is good if implemented before final transfer using a common or normally lit scene source which will be of average density. Once a happy medium is realized the transfer may commence, but the camera diaphragm should be then set to *manual focus*. If not, the following may transpire: an occurring night or dark scene will cause the diaphragm (if set on automatic) to open up throughout the dark segment projection. Consequently, if a light or bright consecutive scene suddenly appears, a momentary "burning" will occur in the tape transfer promulgated by the automatic diaphragms startling jump down to compensate for the brighter reading. Besides, the diaphragm can be manually adjusted while monitoring the transfer and one will quickly discover that with practice, the hand can be as quick as the (automatic) eye. Dry-running and prechecking exposure variances will also assist in obtaining setting guidelines. It has been found that once a happy exposure medium has been reached, overall reproduction exposure quality will prevail. When transferring film to tape, turn out the lights in order to ensure optimum picture reproduction quality (Fig. 12-9). If the picture exhibits noticeable "flickering," speed up the projector speed until the syndrome diminishes or disappears.

SOUND FILM REPRODUCTION

When transferring films with sound tracks, (if

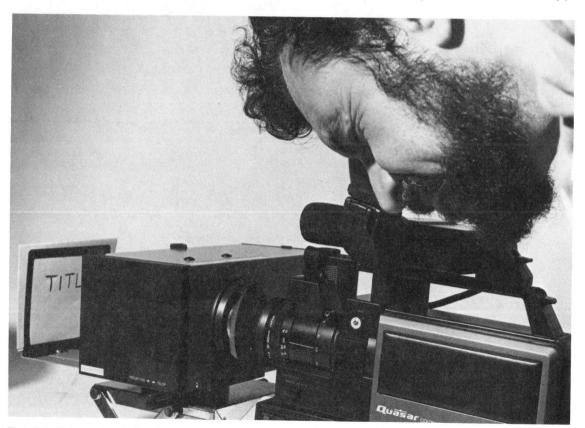

Fig. 12-8. The eyepiece is faced up for easy access.

Fig. 12-9. Turning out room lights will afford better reproduction clarity and eliminate intruding reflections on the glass screen.

sound track reproduction is relevant), it is preferable that wires be run from the audio output of the projector to the audio input of the recorder. This will provide optimum sound clarity and quality. Using the Video cameras microphone is of no value; sound quality will be stilted and ex-

traneous sound (like projector noise) will find its way onto the Videotape's audio track.

Following the guidelines laid down within this chapter will enable even the neophyte audiophile to produce excellent film-to-tape transfers.

Chapter 13

Titling

Titling is one of the most important aspects of video production. It is necessary to have titling, subtitling, and captions in all video, be it a home movie, how-to or travelogue.

Shooting titles is relatively simple, and it has been simplified with marketed accessory items geared to put sophisticated titling within the realm of even the neophyte.

CHARACTER GENERATORS

The most simplified approach to titling is via character generators. High level cameras have them built in (Fig. 13-1) and they will insert titles or captions as the camera records. The generators produce characters in varied colors and can insert them at programmed intervals in varied time durations. The only drawback with character generated lettering is that it is of the digital type. No real aesthetic lettering creativity is allowed with this method.

For those who can be content with character generated lettering but have no provisions for such in their cameras, a number of accessory character generator units are marketed. A most formidable one is the Model PK-G900, produced by Panasonic. The Panasonic unit compatible with Panasonic and various Matsushita made cameras and portables will insert characters, titles and captions in red, white, or green. Titles and captions are composed on the PK-G900's pressure sensitive keypad then transferred onto VCR or camera videotaped productions. Characters or titles may also be stored in the unit's 16 page memory bank (60 characters comprise one page). Another interesting feature of the PK-G900 is a built-in time lapse function from one to 59 seconds, to allow tapers time to get from behind the camera and into the picture.

Another excellent piece of electronic equipment which affords professional video titling effects is the Sony HVS-2000 described in Chapter 10. This unit is primarily designed for titling effects. For electronic titling effects it is unexcelled.

Superimposition of title effects can be realized when cameras and VCR's are interconnected according to the HVS-2000 set up diagram presented in Chapter 10. The HVS-2000 can also be used to

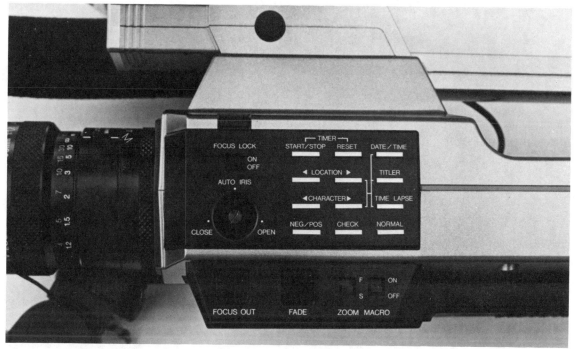

Fig. 13-1. Character generator built into higher level cameras can serve to compose simple digital titling.

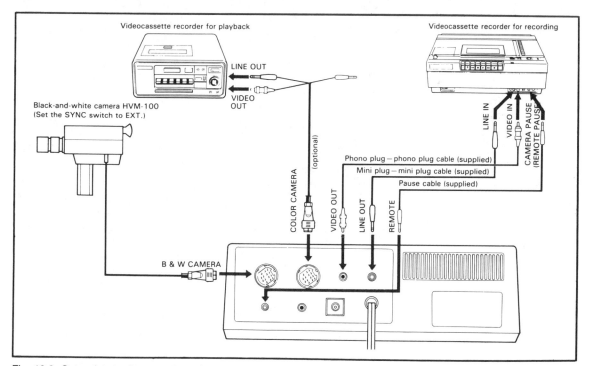

Fig. 13-2. Setup for the Sony HVS-2000 for use in titling. Courtesy Sony.

Fig. 13-3. Titling with the Quasar VE 590UA.

Fig. 13-4. Transfer Lettering is professional looking, easy to use, and inexpensive.

superimpose titles on pre-recorded tape programs using the arrangement shown in Fig. 13-2. A similar accessory unit, the Ambico V-0303 (see Chapter 10) will also provide controlled superimposition of titles and characters.

The Quasar Film to tape converter VE 59OUA is another manually set up piece of equipment that can be set up for visually creating titles. The converter is set up with the transfer mirror lever set in "title" position. The camera is mounted in "taking" position, the title card is inserted and then videotaped (see Fig. 13-3). This method allows the producer to visually and artistically design his own creative titles, hand drawn or assembled with press on transfer lettering.

CREATIVE TITLING

The aforementioned equipment may be too sophisticated for the average videophile. This does not mean that good, professional titling effects are out of the realm of the basic videophile. The

Fig. 13-5. Lettering is aligned and then transferred with the aid of a pencil tip or stylus.

Fig. 13-6. Novel titling approach.

Fig. 13-7. Quasar VF 792WE; 35mm-to-tape conversion unit.

Fig. 13-8. Polaroid Polachrome 35mm film and processing pack.

average individual who is not artistically inclined may produce titles simply, efficiently and perfectly. Transfer lettering provides the means. Transfer lettering is available in all art supply facilities (Fig. 13-4). The lettering is transferred to cards, board or drawing paper by means of rubbing the face of the letter sheet with a pencil or stylus tip (Fig. 13-5). The letter will then become permanently affixed to the title card. Guides on the letter sheet will aid the artist in letter alignment. With this method anyone can design perfect and pleasing titles. Novel and unique effects may be obtained by titling photos, drawings, diagrams, etc. which can serve as attractive title backgrounds. A typical example is shown in Fig. 13-6. Press-on lettering was placed on the object held by the model in the photo. The entire picture serves as a novel, unique title; far more effective than simple type on a monochromatic background and much more interest arresting.

TITLING ON FILM

An excellent way to create creative and artistic titling is with 35mm film and cameras. In this way titles can be planned and picture and filter effects together with type can be included in the videotape. Color transparencies can be transferred to videotape by means of a film to tape transfer unit.

Titles can be prepared and photographed much more easily on 35mm color film. What's more, the titles can be stored and used or re-used at will. Transferring slides to tape does not necessarily rely on expensive equipment. Shown in Fig. 13-7 is the Quasar VF-792 slide to tape conversion unit. This inexpensive accessory can be fitted to the front of the camera lens in the same manner as auxiliary filters. Adapter rings are provided for mounting onto standard threaded videolens flanges. After the mounting carrier piece is attached the slide housing is added. The Quasar VF792 will also accept 35 strips or single frame film cuts. Though the Quasar adapter is most versatile and adaptable, a number of other slide-to-video adapters are marketed by various manufacturers and you can check on what is available through your video accessory dealer.

For those of you desiring instant slide production, you may want to check the Polaroid Polachrome system. This system (Fig. 13-8) provides transparencies in a minute, a once unheard of miracle similar to the Polaroid "Pictures-in-a-minute" concept. The special 35mm polachrome film comes with its own processing pack; each film roll utilizes its own chemical pack

Fig. 13-9. Complete equipment for 35mm slides "In a Minute."

Fig. 13-10. Film is inserted and threaded following instructions in the processor.

Fig. 13-11. As film cranks through, it develops all within a time lapse of 60 seconds.

for development. (Fig. 13-9). Also necessary is the Polaroid Autoprocessor allowing daylight processing in 60 seconds. The polachrome film is shot just like regular 35mm color film but instead processed on the spot if necessary by the photographer.

After photographing, the film and the processing chemical pack included with each rod of 35mm Polachrome is inserted into the processor (Fig. 13-10) and loaded following the instructions and guide Arrows. The cover is closed down and the processing crank slowly revolved until the whole roll of film is developed internally in the processor in about 60 seconds (Fig. 13-11). The film can then be removed from the processing unit and cut down into individual frames for mounting.

Though not as perfect as regular 35mm color films, Polachrome will afford you excellent working transparencies quickly for transferral to videotape. This method can prove handy for instant, on the spot titling.

Chapter 14

Editing Videotapes

After video photography, editing is the most important and critical aspect of videotape production. Editing is the major and most tedious part of production assembly and the serious video buff should be aware of the techniques available in both basic or more sophisticated procedures.

BASIC EDITING

For basic editing will need at least *two* VCR's; one for playing and one for dubbing. Optional editing accessories and components are chosen according to the videophiles needs and budget. You will also need *two video cables* and *two audio cables* (four audio if you are dubbing in stereo sound). Using standard TV coaxial cables from VCR to VCR is not advised as you have more editing controllability when you are working audio and video separately during the editing process. Connect the video and audio outputs on the "play" VCR to their respective inputs on the "recording" or dubbing VCR. These connections are indicated on all VCR's which standardize these connections on RCA cable connectors

(Fig. 14-1). A monitor or TV is handy to check material before and after dubbing (Fig. 14-2). The more compact, the better for table-top editing. The hot setup uses two monitors, one for the "play" and one for the "record" VCR, but one will suffice as it can be switched from one VCR to the other for checking recorded or dubbed material. Dubbing and editing in SP or fast speed is strongly advised in order to attain optimum reproduction quality. In all cases you will lose some sharpness, while gaining some noise and interference. Noise gain and picture loss can be kept down to a minimum (in some cases circumvented) by using accessory component enhancers and dubbing equipment containing negative noise amps. This specialized equipment is listed in Chapter 17.

ASSEMBLY EDITING

Without sophisticated additive editing equipment you will suffer some noticeable "glitching," particularly with older model VCR's that do not possess positive pause control functions such as

Fig. 14-1. Separate audio/video output-input connections should be used when dubbing for maximum quality in reproduction.

those integrated into the more refined VCR units of today. To avoid or minimize glitching when editing tapes, you can try the following: connect a video camera to the playback VCR, then turn it on. The VCR turner switch should be placed in "Camera" mode. Put the camera lens cap in place, then place a blank tape in the record VCR and start running it for your estimated segment dub recording time with a few minutes overlap added. In this way you will record a black video signal on this selected section of the tape. In the aftermath, when you edit your segments over the prerecorded black video band, if the machine does not precisely overlap segments automatically to avoid glitches, there will exist some control track pulses and "black" video which will assist in hiding the glitches.

To obtain a good edit progression in this manner, rewind the tape after you have recorded your black track. Isolate a segment you then wish to dub on the "play" VCR. Run about 30 seconds of lead tape on the "record" VCR; then hit the pause button. Start the "play" VCR and just before you reach the point where you want the dub to commence, then release the pause control on the "record" VCR, letting both VCR units run until a few seconds beyond the end point of the dub. Stop both recorders and rewind the recording VCR in order to play back and study the dubbed segment.

The next segment to be dubbed in after the first is then cued up on the "play" VCR, running it back about 10 to 15 seconds, then stopping, as in the initial dub setting procedure. As the first dubbed segment is played back, run it about a half a second beyond the exact edit and point, hit the pause switch, then the play and record switch, allowing the videotape to back up automatically in order to be aligned, and commence recording again, with minimal glitching at the edit point.

MODEL UP1315XQ

Fig. 14-2. A compact TV makes an excellent video monitor, as exemplified by this Quasar UP 1315xq. Courtesy Quasar.

The aforementioned sequences should be followed for each added on edit segment of the videocopy procedure. End-to-end editing of this type is known as *assemby editing*. on most consumer VCR's the amount of glitching at edit points varies depending on versatility and feature contents of the recording VCR.

INSERT EDITING

A second form of video editing is known as *insert editing*. In insert editing, pieces of programmed or isolated material are inserted within an existing program. Consumer VCR's cannot handle insert editing with ease since they erase tape throughout the recording process. Since the erase head is also activated as the VCR goes into "record" mode and it is located ahead of the recording head in the path of the tape, a small amount of tape always idly remains between the erase and recording heads. The beginning of an insert edit can be fairly clean, since it begins like an assemble edit but when the machine is stopped at the finish of the insert, the amount of tape between the record and erase heads is automatically erased and nothing recorded in its place. In playback, after the insert segment has played, the empty gap in the tape runs over the playback head, resulting in a noise band (snow) which descends horizontally over the picture. Since the control track pulses in the tape have also been erased, the machine goes out of pulse sync, causing a horrendous visual and noise pattern. Insert editing is not totally feasible when editing VCR to VCR.

ELECTRONIC EDITING DEVICES

If you are seriously considering insert editing

Fig. 14-3. A Matsushita (Quasar) editing controller set up for editing and dubbing between two VCRs.

Fig. 14-4. Selector switch is set to "PLAYER."

at their disposal the Matsushita editor controller sold under various brand names. The Quasar unit shown here (the VE-582UQ) (Fig. 14-3) will link between two similar Matsushita made VCR types through provisional cables and receptacles. This remarkable, new, highly efficient editing controller will provide glitch-free editing (with compatible equipment) combined audio/video dubbing or audio or video alone dubbing.The controller will also enable assembly editing. As shown in the photo, the editor has two cords; one goes to the "Play" VCR, the other to the "Record" VCR.

in addition to assembly editing, you should think about some of the new, refined electronic editing devices for use in conjunction with Consumer VCRS. Owners of high level Panasonic, Quasar, Canon and other Matsushita produced VCR's have

The video/audio editing procedure with the VE-582UQ is simple. Playing and dubbing should be done at the same speed to simplify editing. If the playing VCR tape has been recorded at a speed differing from that of the recording VCR, then log counters or numerical timing devices will not synchronize.

Fig. 14-5. Program beginning and end points are located with the SEARCH button.

Fig. 14-6. Tape is rewound to before the beginning point and played.

Fig. 14-7. The pause button at the start of the edit is pressed for still-picture playback.

Fig. 14-8. The selector switch is switched to RECORDER.

Editing with the Quasar VE-582UQ

The first step is to set the Player/Recorder switch on the Editor to "Player" (Fig. 14-4). Push the "Play" button, then check out the counter numbers designating the beginning and end of the segment you wish to dub or insert. The "Search" (Fig. 14-5) buttons (forward or reverse) will aid greatly here. Whenever possible start with the counter at "0" and the tape at the beginning of the cassette to facilitate operations. Rewind the tape after preliminary scanning to a point somewhat preceding the starting point of the material to be dubbed. Then depress the "Play" button (Fig. 14-6). Press the Pause/Still button at the beginning of the edit segment to provide still picture playback (Fig. 14-7). Slip the player/recorder selector to "recoder" (Fig. 14-8). Search the counter numbers for edit point locations on the VCR, then rewind the tape stopping just before the edit point on the tape (Fig. 14-9). Pressing the Pause/Still button at the start

edit point will allow still picture playback (Fig. 14-10).

To commence audio/video dubbing, press the audio/video dub button (Fig. 14-11). If you wish to

Fig. 14-9. Search digital counter numbers for beginning and end of editing on the recording VCR using FAST FORWARD and REWIND buttons.

Fig. 14-10. After rewind, tape somewhat before the edit point is played. Then the PAUSE/STILL button is pressed for still picture.

dub only the video portion, press the upper video dub button. Pressing the dub-end button at the desired point finalizes dubbing operation. Indicator lights will go on as dubbing commences and go out as it ceases.

The Quasar and similar editing controllers perform perfect edit functions if no changes are made in the "out" point of a previously recorded segment. The controller is excellent, particularly for assemble editing. As the dub-end button is pressed, the recording machine will stop, then back up the proper frame interval, insuring proper spacing and merging with the consecutively edited segment. With the Matsushita made controllers, each new edit can be precisely timed to the edit point of the previously edited segment. Monitoring will assist greatly in editing, at least one to scan edited material as the dubbed material is assembled.

Hitachi

A great aid to editing is the excellent new Recorder/Monitor recently marketed by Hitachi. Having a monitor built into a VCR is a great asset. The Hitachi Model VT-680 MA VCR/Monitor also provides wireless remote control for scanning, frame advance, slow-motion and freeze-frame functions. Virtually any camera or playback VCR can

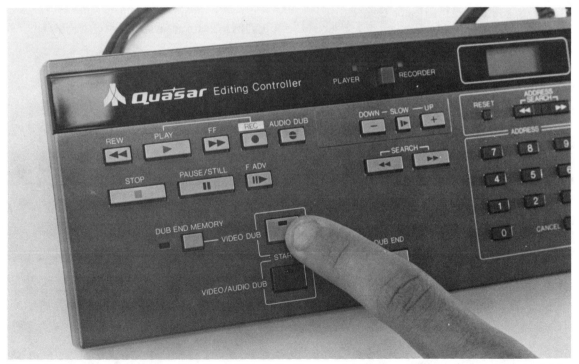

Fig. 14-11. Press the desired dub button; the dubbing light will go on as dubbing commences. At a predetermined dub-end point press the dub-end button.

Fig. 14-12. The hybrid-8. Courtesy Video Interface Products.

be hooked up to this Hitachi unit which will work off either ac or dc power sources. The Hitachi VT-680 MA can be further studied in chapter Two of this book.

The Hybrid-8 Special Effects Generator

The hybrid-8 (Fig. 14-12) though not specifi-

cally marketed as an editor, performs some excellent fault free as well as "trick" editing. The hybrid-8 will provide fades in timed durations and fadeouts in conjunction with a wide array of wipe patterns. It can perform editing type functions quite diversified and unique. Ideally suited to both Beta and VHS formats as an auxiliary electronic editing

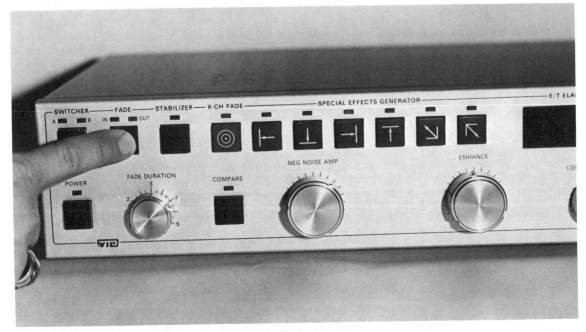

Fig. 14-13. Fade and fade duration in hybrid-8 is controllable.

Fig. 14-14. Vertical wipe button. Hybrid-8.

Fig. 14-15. Diagonal wipe button.

accessory, the hybrid-8 includes video, audio and cross channel fading. Fade time can be adjusted by a fade duration switch, and fades can be introduced at beginning and end of edited segments at the touch of a button (Fig. 14-13). The special effects generator of the hybrid-8 system is an optional item; the unit may be purchased with or without this feature. Since this optional feature is the crowning glory of this unit, no hybrid should be considered without this internal feature which only adds about $60 to the base price of the unit. The special effects generator creates four basic wipe patterns, each governed by singularly controlled wipe buttons (see Figs. 14-14 and Fig. 14-15). A total of 16 combinations of wipe patterns are possible by multiple button utilization (Fig. 14-16). Figure 14-17 visually presents some of the basic wipe patterns provided by the special effects generator section of the hybrid-8. This sophisticated unit will also dub three copies in unison while providing three sets of video/audio inputs and outputs.

The hybrid-8 works especially well in the field coupled to a videocamera for editing at camera level. The varied fade and wipe functions can be

Fig. 14-16. Combinations of buttons pressed in unison promote even more wipeout effects.

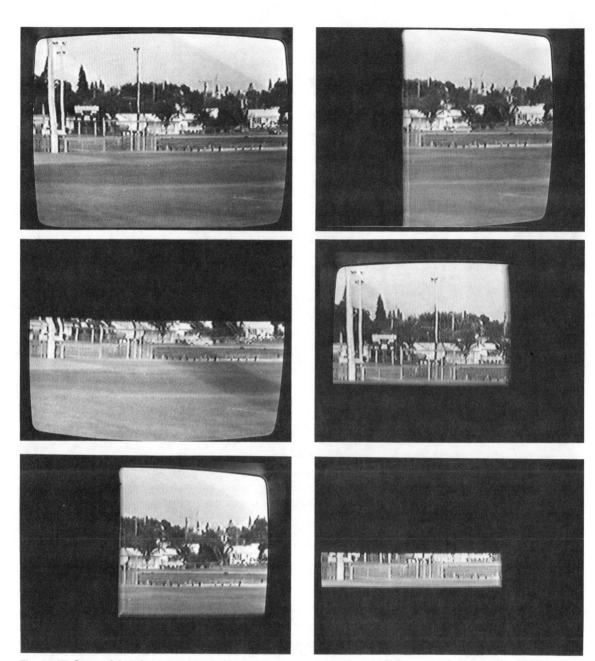

Fig. 14-17. Some of the wipe patterns possible with the hybrid-8. Top left: complete picture prior to wipe and fade; Top Right: Left horizontal wipe; Middle left: Vertical Down wipe; Middle Right: Left diagonal upper wipe; Bottom left: Upper right diagonal; Bottom Right: Combination wipe (see Fig. 14-16).

directly applied as camera work transpires, lessening the need for after editing on the VCR workbench. The internal negative noise amp section of the hybrid reduces snow in transmitted signals and a built in enhancer does much to assist in balancing color and picture transmission. Fig. 14-18 shows a typical camera/hybrid—8 hookup for editing, fading and wiping at camera level as the

videotape is shot. The camera is first connected to its own camera power and adapter box, which is then connected to the inputs of the hybrid-8. To create the wipe effect once it has been selected, the "Fade" button is first activated wherein the videotaped image fades to black; duration length of the fade is preset. The "In" LED indicator adjacent to the fader control will go out and the "Out" LED will blink until the picture fades out totally. Pressing the fade button a second time fades the picture back in; duration is also controllable within a one to five second range. As the picture is faded out, wipe pattern may be switched. You can fade out (or in) with one pattern and in (or out) with another. The switcher circuit can work independently or in unison with fading and special wipe patterns. If no special effect pattern is selected, the switch-

er will internally activate the Vertical Interval switch to change to another input immediately. As a pattern is selected, that pattern is utilized for fadeout as the fade function switch is pressed. At full fadeout a second pattern may be chosen then faded in. Some very creative editing can be accomplished with a unit like the hybrid-8.

To nullify glitching in fade-to-fade transition when editing and assembling, the hybrid-8 provides vertical interval switch circuitry to eliminate roll and rip glitches as the two video signals are switched. Both forms of glitching occur since the sync pulses of the two signals are not identically timed. Vertical roll is promoted by vertical sync out of time; horizontal rip promulgated by out of sync horizontal timing.

The vertical switch does nothing in terms of

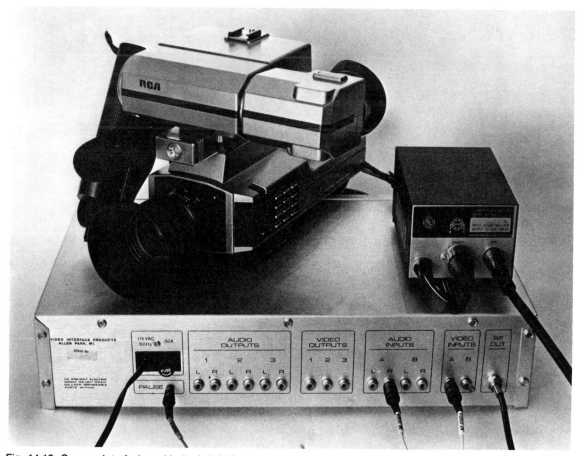

Fig. 14-18. Camera Interfacing with the hybrid-8.

If your splitter has more than two outputs, one may be ran to VCR-B to allow recording broadcast programs on either machine through the Hybrid-8.

The Hybrid-8 input switch (switcher) determines which VCR is being used as the master. This machine must not be in the recording mode.

If VCR-A does not have a switch labelled TUNER/CAMERA, it will be necessary to remove the cables from its video, audio inputs to use its RF input.

The third set of outputs on the Hybrid-8 may also be ran to a stereo system if the signal is treated as line level (not phono).

The above setup gives the most flexibility with the Hybrid-8 without a switcher.

Fig. 14-19. Typical hybrid hookup for dubbing.

Fig. 14-20. Commercial editing facilities offer dubbing services and qualified technicians to assist.

aligning the synchronization of the two signals. Instead, it conceals the "rip" in the portion of the picture not seen by switching during the vertical interval of the signal its switching from. There is a possibility of a single vertical roll unless the signals are timed together. The internal, integrated vertical interval switch circuit (which doesn't require the attention of the operator) provides the most efficient Glitch-free switching possible without sync generation of frame synchronization. Figure 14-19 shows a typical hybrid-8 hookup for editing between two VCRS.

COMMERCIAL EDITING

Commercial editing facilities are becoming very popular and are generating much acclaim as they spring up across the country.

A typical example is the Video Workshop located in Fort Lauderdale, Florida. Conceived and operated by David Bawarsky, The Video Workshop is a professional type editing center, allowing do-it-yourself videotape production facilities. You need not be an editing expert to avail yourself of industrial quality facilities provided in a workshop situation. The Video Workshop and other similar to-it-yourself services will also provide a special training course teaching the essentials of professional editing (Fig. 14-20).

The Video Workshop provides private video editing booths and audio recording rooms for editing of videotapes in both VHS and Beta formats with certain booths designated to each format. Designed for both beginner or more knowledgeable videophiles, workshop facilities, available on an hourly rental basis, offer highly sophisticated electronic equipment financially out of reach of the average videophile, with qualified technicians are always on hand to lend assistance.

The Video Workshop of Ft. Lauderdale provides an outstanding example of a workshop facility. Each room or booth contains complete electronic equipment for all phases of editing, dubbing, and reproduction. The equipment includes two monitors, two industrial type VCR's and editing controller and cassette tape deck for audio neatly arrayed ready to use in private booths (Fig. 14-21). The Panasonic NV 8500 Recorders (VCRS) offer finer quality transferral than standard consumer grade VCRS (even state-of-the-art units). They are infinitely controllable and will allow frame-by-frame and even half frame editing, plus slow motion, freeze frame, etc. effects.

Monitors are the Panasonic CT-1010 units set up to monitor each VCR during the editing operation (Fig. 14-22). The editing and dubbings set up includes the Panasonic NV-A500, a professional editing controller which allows exacting and faultless assemble editing and insert editing. The NV-A500 is similar to the Quasar consumer editor shown and mentioned previously, but is much more efficient and sophisticated (Fig. 14-23). Sound can also be dubbed in on one or two channels with individual fading. A special fader controller unit is also incorporated into the system to allow controlled video fading at will.

Basic workshop fees for editing purposes are $12.50 per hour for the consumer; if one wishes a technician's assistance for editing material, the fee goes up to $25 per hour. Either way the fees are

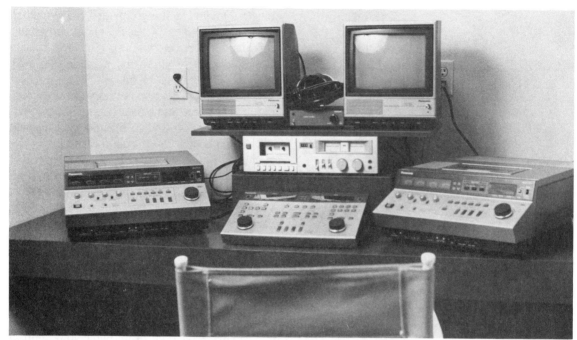

Fig. 14-21. The Video Workshop of Ft. Lauderdale, Florida offers highly sophisticated, industrial-grade editing equipment and private booths.

Fig. 14-22. Dual Monitors make editing a most refined procedure.

Fig. 14-23. The A500 Panasonic Editor is technically advance but simple to operate.

Fig. 14-24. Panasonic Industrial grade VCRs. The best units for VCR editing offering almost no loss in picture transfer.

most reasonable considering the quality of machinery at one's disposal and the exacting, flawless editing that can be achieved on machinery that pricewise would be unattainable for the average videophile (Fig. 14-24).

For optimum quality coupled with low expenditure (great for the part-time editor) an Video Workshop alternative is highly recommended.

SOPHISTICATED MAGIC BOXES

There are a number of sophisticated consumer film editing assembly units that are also used professionally which enable the user to attain professional quality editing and trick effects. Following

is a listing of the more formidable ones, tested by me and found to be highly recommendable to the serious videophile.

Sansui AV-77

This unit is considered one of the best video/audio processors (Fig. 14-25), is reasonably priced, and offers a lot of handy options for the video buff. The AV-77 will permit dubbing or editing between two VCR's and recording of any video input into either or both VCR units. This magic box enables you to fade in-fade out scenes, interjects a new audio track with intermixed mike/music signals, enhances and improves detail and sharpness

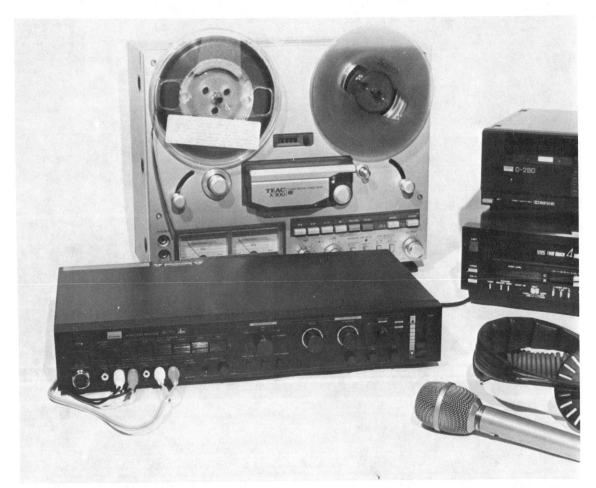

Fig. 14-25. The amazing yet reasonably priced Sansui AV-77 is a great processing unit and more sophisticated than competitive units.

Fig. 14-26. An out-of-synch dual signal aberration.

in dubbing. Separate "art" control functions enable you to vary color effects and even create posterization effects of the standard video image. The AV-77 also serves as a camera adapter and its 10-pin receptacle accepts virtually all VHS cameras allowing inter editing between camera and a second VCR signal.

As an audio processor, the AV-77 allows options between two audio sources with mono and stereo enhancement. The audio circuitry also includes DBX noise reduction which can be introduced into the videotape audio channel to suppress and eradicate tape hiss, noise, etc.

Special Effects Generators

The most sophisticated special effects generators offer signal mixing and synchronization between two cameras to attain fancy wipes dissolves and overlaps.

To properly inaugurate these effects with no glitching or signal disturbance, one of the two cameras used in videographing must be genlocked.

Genlocking is the synchronization of the two signals (one from each camera) coordinating the two in order to circumvent tearing, glitching and rolling that can occur when switching from one camera to another. These signal aberrations will manifest themselves when the cameras do not have compatible horizontal and vertical frame synchronization. Such a typical manifestation can be studied in Fig. 14-26.

Before a two camera set up can successfully be implemented for use in conjunction with a true special effects generator, one of the cameras must be genlocked. Some factory cameras come from the manufacturer genlock capable but this minority group only features the Sony DXC-1800, the JVC KY-1900 and S-1000, JVC GX-N8OU and the Mag-

161

Fig. 14-27. Sony editing components.

navox VR 8282BK, VR 8283BK models. Any camera can, however, be easily genlocked by modification to the camera's synch generator circuit; most special effect generator manufacturers supply this modification for a nominal fee.

Some basic special effects generator kits such as the Sony HVS-120K or Ambico V-0303 provide a second camera that genlocks within the control box of the kit. These kits are limited to producing only such effects as superimposition of design over

Fig. 14-28. The multiple input-output panel of the GS-164 allows four-camera intermixing.

picture, design framing, color-key alteration, black and white reversal,and titling. Shown in Fig. 14-27 is the Sony HVS-120K effects kit in addition to the Trinicon HVC-2500 camera and HVT- 3000 video photolab adapter.

Gemtronics-"Gem Star" GS164 Switcher

The GS-164 (Figs. 14-28; 14-29) easily hooks into a genlock modified camera by means of the standard 10-pin connector which carries the genlock signals (in pins 7 & 8). With the Sony 14 pin connector format the recorder/earphone pins act as genlock signal carriers. Gemstar provides a special interface genlock board that they will install in any camera making it genlock acceptable. Offered in the Gem Star GS-164 console package are a number of wipe patterns, fancy dissolves and 2 camera split screen effects, as well as intermixing of up to four camera signal sources.

The Sci-Tech SEG-21

The most innovative, versatile, most exacting and professionally designed special effects generator for the serious videographer is the SEG-21. Basically a professional unit, the SEG-21 was scaled down (price and sizewise) for portability as well as ease of use for the videophile. This compact unit is unequaled for special multicamera effects such as dissolves, fades, wipes and cuts. Twenty wipe patterns are made possible with all patterns im-

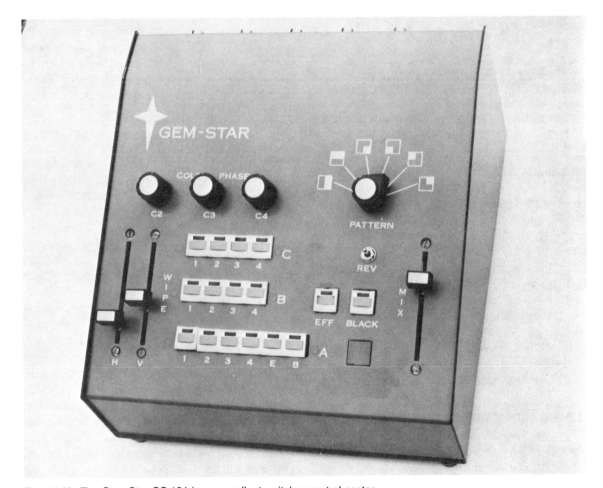

Fig. 14-29. The Gem Star GS-164 is an excellent switcher control center.

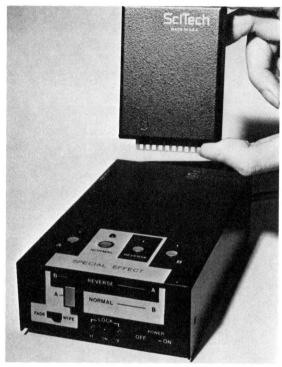

Fig. 14-30. The Sci-Tech SEG-21 and one of the plug-in wipe modules.

aginable instituted by plug-in modules (Fig. 14-30) which slip into an accommodating receptacle at the rear of the control unit.

A special accessory expansion unit plug-in cartridge module is also marketed to accommodate three plug in wipe pattern cartridges, effects of which can be intermixed during videography.

Shown in Figs. 14-31, 32, are some typical wipe patterns made possible with the S.E.G.-21. Sci-Tech also manufactures a professional switcher, the S.E.G. 31 which can accommodate three cameras. The S.E.G. 21 however will provide the same special effect functions and is more within the budget of the average videophile.

TIME-BASE CORRECTORS

The *Time Base Corrector* (TBC) is a bit too esorteric for average and most pro buffs, but must be mentioned because of its importance to true video editing.

The average editing videographer today must live with the generation loss (in quality) when dubbing or editing tapes. The only way to obtain no-loss reproduction is by introducing a TBC between master VCR and dubbing VCR for controlling signal stability and genlocking multiple VCR signals in order to realize faultless edit points and aberration free special effects (fades, wipes, etc.). As of now, the TBC is out of reach of the basic and even many video pros who prefer to rent a TBC since the price can be so exorbitant.

In summary, a *TBC* is a computerized electronic piece of equipment monitoring all existing facets of a video signal. Circuits within the TBC can compensate out of place lines, serving to implement dead accurate synchronization of multiple video signals guaranteeing video signal stability. According to today's true editing standards, one must incorporate 2 TBCs into an editing suite, one for each signal source being intermixed. The necessity for two standard units, plus the sophisticated refined circuitry involved can put one in the budget neighborhood of from 15 to 30 thousand dollars (and more).

A recent and most welcome breakthrough which will revolutionize the video market as well has been instituted by Sci-Tech, manufacturer of the SEG-21 special effects generator. President Juan DeLa Cierva of Sci-Tech has created and consolidated a professional quality TBC which as a single compact unit will perform all the functions of two TBC units. Designated the Tibec 8000, the rack mountable TBC (Fig. 14-33) currently marketed in the professional video field, contains specially formulated chips and components devised by DeLa Cierva which serve to incorporate the functions and bulk of multi unit TBC setups into a much more compact entity.

Mainly available to the professional videophile, the Tibec 8000 can be utilized in home video applications and at a fraction of the cost of standard TBC offerings. Even at its lower price tag it will be out of reach of the average consumer, but creator DeLa Cierva confidently asserts that in the near future he will be able to market a comparable unit that will retail for no more than $2,000. At that

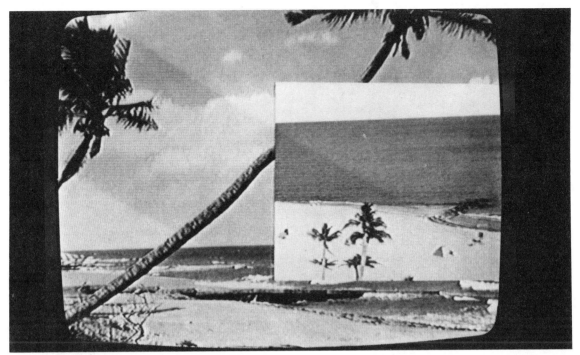

Fig. 14-31. Rectangular wipe.

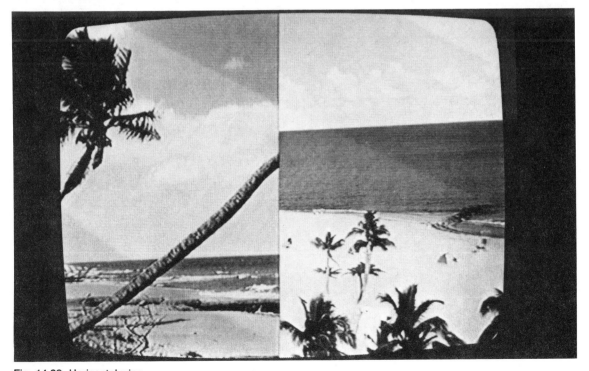

Fig. 14-32. Horizontal wipe.

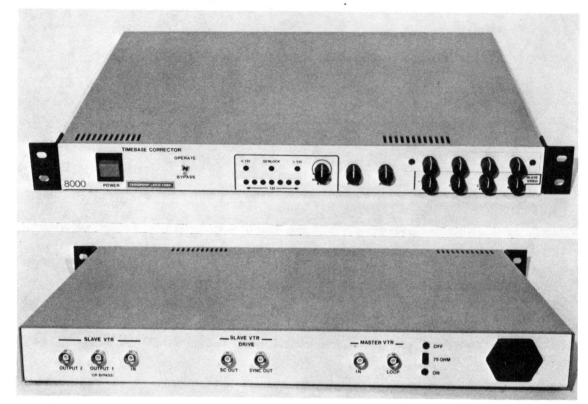

Fig. 14-33. The Revolutionary Tibec 8000 TBC by Sci-Tech. Front view (top) and rear view.

point, the everyday serious videophile can have at his disposal a highly esoteric piece of equipment that will greatly expand and improve standard VCR tape production.

I have had the opportunity to test and evaluate the Tibec 8000 and can unequivocally state that it is the greatest breakthrough in the pro/consumer video field and is a most sophisticated, exacting and functional as well as a remarkable piece of equipment.

Chapter 15

Audio Dubbing

Audio dubbing is the procedure by which sound is added to video productions. It can be simple or complex, depending on what manner of sound source material must be integrated into the video production. Sources may be live (voice, music, sound effects) or commercial (records, tapes, FM etc.)

The *wild track* method is most appropriate for adding audio to video. *Wild tracking* is the process by which the sound track is added after the video portion of the tape has been constructed and edited. An individual sound track can later be separately inserted and synchronized to the visual material. The sound track must be precisely timed and edited so that it will coincide with the video aspects of the production.

Sound tracks usually consist of narration, music, sound effects and generally a combination of all three. Narration is usually applied on the spot for the most part via combined audio/video taping, or added and dubbed in later as formal editing and assembly takes place. Music is added or interjected from prepared source material and can be also combined with microphone narration. When narration

is a crucial part of the video production, it should be inserted with proper microphones during the audio editing process. Music and background effects may be transferred from pre-recorded commercial sources. In circumstances where the narrator is in the picture, it is best to implement combined video and audio recording (built into all cameras) so no lip-syncing problems will arise. At all times, one should use quality microphones (which will adapt to most auxiliary mike inputs (at the camera) for optimum voice clarity.

MICROPHONES

Microphones produced and marketed are too numerous and diversified brandwise to mention. They come in all shapes, types, and price ranges, and should be selected for the most part for their reproductional clarity not price.

There are three basic types of microphones applicable to video-audio taping: the *omnidirectional*, the *super- cardioid*, and the *cardioid*. An *omnidirectional mike* will pick up all sound direct and ambient; it does not "pin-point." The *super-cardioid* is

a more directional mike. Noises behind super cardioids are depleted with pickup elements concentrating on direct, frontal sound sources. The *cardioid* is similar to the super cardioid but with a "heart-shaped" response pattern, allowing sound from the right and left sides of the mike to be recorded in addition to sound in front of it.

Three very commendable mikes for audio reproduction are the ME-50, the ME-80 and the ME-120, all distributed by the Teac Corporation (Fig. 15-1). These "TASCAM" series microphones are studio quality, compact and affordable. The most refined in the line is the ME-120, recommended for its performance excellence in soundtrack work. A professional quality mike, the ME-120 contains interchangeable omnidirectional and cardioid elements which serve to increase the efficiency and versatility of this unit.

TAPE RECORDERS AND DECKS

A good tape recorder is a necessity for proper audio dubbing; it is essential for recording and coordinating sound tracks for audio track assembly. Both cassette or reel-to-reel decks are suitable for composing and editing audio master material for consecutive insertion in videotape productions. Reel-to-reel tape decks offer the most editing flexibility (as demonstrated later in this chapter). Cassette decks, though a shade less flexible, will also provide proper functions for adequate video dubbing. An example of a functional cassette deck is presented in Fig. 15-2. This unit features visible VU meters (for sound level setting), three-way bias equalization, and simplified operational controls. this Teac 3RX model provides quality and efficiency at a reasonable price.

The more discerning audio/videophile will opt for a reel-to-reel unit, superior in sound editing versatility to the cassette deck. The Teac X-300 (Fig. 15-3) is an excellent basic state-of-the-art recorder, very functional and reasonably priced. For optimum dubbing versatility, the implementation of *two* audio

Fig. 15-1. Teac Tascam series mikes.

Fig. 15-2. The Teac C-3RX is a good dubbing cassette deck.

Fig. 15-3. Teac X-300.

decks will afford unlimited sound track assembly editing necessary to serious videophiles. Multiple decks can also provide multiple sound sources for interweaving and mixing. A useful junction box such as the QED (Fig. 15-4) will allow three recorders to be interconnected for sound transferral and reproduction. The box makes possible tape-to-tape audio insert editing (dubbing) between three recorders in varied combinations of the three, all at the touch of one or two buttons. One may record material from one deck or two at once in various back and forth combinations (Fig. 15-5). If even more sound sources are to be combined and utilized (recorders, turntable, digital disc, FM etc.) for video sound track production, professional type studio mixing components are available to the consumer for this purpose (Fig. 15-6). Versatile mixers available from ADC or Radio Shack will enable mixing of up to six different sound sources complete with separate fade controls for each of the six channels.

Once a sound track is composed and assembled, it may be transferred to the videotape. The audio track assembled on a recorder or deck can be transmitted or dubbed to the production VCR by connecting to the video recorders audio dub input. All the newer, sophisticated VCR's provide separate audio dub inputs, specifically for audio transferral to videotape. Some VCR manufacturers even build in selectable stereo-mono inputs for isolated channel or combined channel dubbing (see Fig. 15-7).

EQUALIZERS

Sound equalizers are professional electronic components used to balance, enhance or improve sound source material. Equalizers will compensate for sonic deficiencies, sound abberations, and even

Fig. 15-4. Switching unit will tie in three decks for interdubbing.

170

Fig. 15-5. Deck interchangeability at the touch of a button.

Fig. 15-6. Mixers provide multitrack mixing.

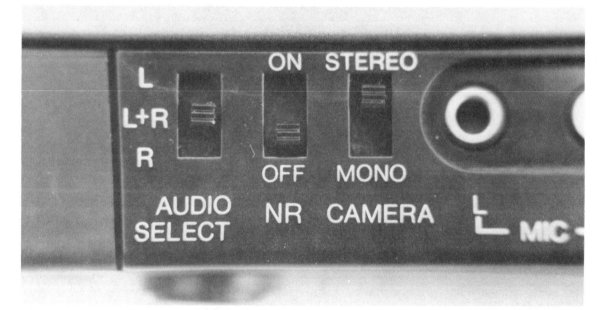

Fig. 15-7. Some manufacturers provide stereo-mono options.

sound track inconsistencies. While basic tone output controls in better tape decks can make overall improvements in bass and treble response, they usually do so affecting both channels (in stereo) simultaneously. If one channel requires a boost (or cut) it can not be readily isolated from the other channel and modified without affecting the entire audio spectrum of both. Equalizers manipulate about ten bands of the audio spectrum, allowing boost enhancement of all or isolated bands, each band controlled by a separate slide switch. With the aid of an equalizer, different musical instruments or voice values can be heightened or minimized for added effect. "Presence" can be added to individual sonic tones and voices by individual adjustment of the segregated bands of the tonal spectrum. Equalizers are standard hi-fi items available universally. Though luxury additives, they can do much to improve or "color" frequency response of dubbed material, creating special and unusual effects. Equalizers are interconnected between an audio sound source and the dubbing deck. Modification of tone value is finalized as the "doctored up" signal is recorded. Poorly mastered sound sources (lp records, etc.) can also be improved with equalization which can also correct sonic imbalances (see Fig. 15-8).

AUDIO TAPE EDITING

Audio tracks, like video tracks, require some editing. In most video productions it is almost mandatory. Sound segments must be inserted properly timed and spaced. In videotape production, the video portion is usually adjusted first, followed by interjection of the sound track. It is advised that the sound track be completely composed individually (conforming to visual aspects of the production) then added in its perspective place. This

Fig. 15-8. Equalizer unit (top).

Fig. 15-9. Edit-All Block.

is not difficult; an audio edit job is far simpler than its video counterpart in terms of assembly, insertion and alignment. Whereas video editing entails specialized electronic manipulation, total sound track editing is comprised basically of physical splicing or sound transfer (audio deck to audio deck) in order to assemble a well coordinated sound track. Some audio tracks may consist of music tracks butted up against narration tracks or narrational with sound fading in and out for background. Feasible sound tracks can be worked out on either cassette or reel-to-reel decks for later transferral to video tape. Select segments of tape can be joined together to form a clean audio track if patience and care are exercised. For audio track assembly the reel-to-reel deck excels; it affords optimum splicing versatility.

SPLICING AUDIO TAPE

The Edit-all splice block is the most exacting audio tape splicer marketed, and is used universally by both neophytes and professionals alike (Fig. 15-9). Two separate segments of tape can be connected with this handy tool as follows: first, the lead

Fig. 15-10. Tape is placed in the block.

174

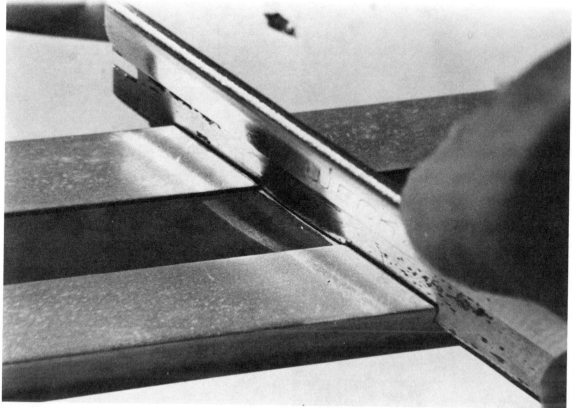

Fig. 15-11. Tape ends are cut.

of one tape segment is inserted in the Edit-all block as shown in Fig. 15-10. The lead from the second segment to adjoin to the first is then placed in the block over the first. Both tape segments are held in secure alignment in the recessed groove of the block. The overlapping ends are then cut on a bias using the diagonal cut on the block as a guide (Fig. 15-11).

A single edge industrial razor blade serves best for cutting audio tape cleanly and precisely. Excess tape cuttings are discarded, leaving the major tape segments properly butted and aligned (Fig. 15-12). Splicing (adhesive) tape is then affixed over the two ends, allowing about one-half inch adhesive tape overlap (for maximum splice strength) (Fig. 15-13). It should be noted that the "splicing" tape must be affixed *only* to the rear or backing of the Audio tape. No gaps must be left between the spliced tapes at the adjoining point. If gaps occur (Fig. 15-14)

audible pops or dropouts will be noticeable in playback. "Start" and "Finish" sound edit points on tape segments to be joined are determined by playing the sound material of each segment prior to cutting. These points may also be physically indicated

Fig: 15-12. Ends are aligned.

Fig. 15-13. Tape is joined.

Fig. 15-15. Cassette tapes.

on the tapes by marking the back side of the tape with a magic marker; these can serve as "cue" points. These cue points are so placed so as they will correspond in location to the "playback" heads on the recorder. Recorded or sound segment should begin as the mark aligns with the tape head. Cassette tapes may also be spliced (Fig. 15-15) but since this tape is not as accessible as reel tape it must

Fig. 15-14. Gaps should not be left between joins.

Fig. 15-16. Alignment marks are placed.

Fig. 15-17. Counters aid in timing for dubbing.

be pulled out from the housing before splicing takes place. Alignment points for cassette tape can be placed on housing and tape (Fig. 15-16).

Once a complete soundtrack is constructed, it can be dubbed into the video tape adjacent to the video track (in synchronization). Timer (VCR and audio recorder) and physical markings will aid in aligning sound and video tracks (Fig. 15-17). Here's a good way to do it. First, set the timer of the video VCR on zero, and then run the tape until video commences. Note the timer number. At the point you wish to align and commence the soundtrack, start the audio dub procedure (at the predetermined sound start point). Audio recorder output must be directly connected to the Audio Dub input of the VCR.

With the proper coordination of dubbing and timing, audio and visual tracks can correlate precisely.

Audio dubbing is not difficult, but it requires a little work; it is precision work which can be facilitated by the numerous editing controls and components at the disposal of every videophile.

Chapter 16

Animation

Animation is a select as well as most entertaining aspect of movie and TV production. Translated, animation means "give life to" stemming from the latin "Anima," which means spirit or soul. In movie and video work animation is the term given to cartoon type action and character depiction which is comprised of a series of drawings done in stages to illustrate progressive movement. Each individual illustration is photographed frame by frame, and when each frame is assembled, interjected into a film strip, and then projected onto a screen, the quick flashing of each consecutive frame in rapid succession gives the illusion of movement or animation.

Animation such as the Walt Disney type involves elaborate equipment as well as artwork; we do not intend to approach home animation along these lines. Instead we will feature some simplified approaches to basic animation that even the neophyte can attempt to tackle.

There are a number of basic approaches to animation; some are simple and some are complex. These approaches encompass the various types of animation categories. A great many of these techniques are adaptable to videotape animation production, specifically the techniques that utilize limited movement.

CLAY ANIMATION

This is a very simple form of animation material that can depict excellent object movement, while easy to sculpt and change shape. The flexible aspect of clay itself lends itself to small change manipulations necessary for stop motion animation. With clay, the original figure or object can be changed by hand to create movement sequence that can be shot frame by frame. This is an excellent experimental medium for videophiles who wish to start with a basic and simple animation approach. As each movement change is sculpted (or clay segment moved) it is single-frame shot to build up the animation sequence. Later on in this chapter I will clue the readers in on a very basic still frame shooting technique evolved for animation transfer to video. This still frame shooting technique can be applied to any production animation approach.

PHOTOKINESIS

Another simple technique, this one is based on multiple photography of a single piece of artwork or various different views of a single object ganged together in frame sequence to provide an illusion of movement. Photos, collages, comics, magazine pictures, etc.; all will serve for creating this type of pseudo-animation effect. Objects or images can also be cut out and pasted onto cels, then superimposed on a background and juxtapositioned to create a "movement" effect. Figure 16-1 is an example of a photokinesis approach to animating the fantasy dragon. In Fig. 16-1 we show the artwork in its entirety. This would be the first step or frame in the photokinetic sequence. In Fig. 16-2 we move or zoom up a little closer, making the dragon a bit more ominous. This would be the second frame or timed segment. In Fig. 16-3 we zero in on the ferocity of the dragon by a frame shot showing the

fierce head. In Fig. 16-4 we jump to the eyes and teeth, which serve to heighten the demonic impact. A sequence like this is more effective than the overall first shot shown singly; an illusion of some movement is also imparted. Photokinesis is usually implemented when it would be difficult to animate a static piece of artwork with single pictorial representation.

THREE-DIMENSIONAL ANIMATION

Stop motion animation of three dimensional objects or figures is simple but can be used effectively to emulate live action situations. Dimensional characters can also be placed in sets or shot outdoors in various terrain or simulated set situations (Fig. 16-5). As each movement change is made (by manipulating the figure), and stop-frame photography captures each change, motion is created. Three dimensional stop-motion video photography

Fig. 16-1. This picture animation technique shows the entire illustration.

Fig. 16-2. Move in to achieve the effect of the dragon moving closer.

is a form of motion creation by which action is created by movement of the figure (see Figs. 16-6 through 16-8). Before attempting this approach, the videophile should study and understand how people or objects move to guarantee authenticity. In three dimensional animation, the subject is photographed (still frame), moved slightly for the next frame, and so-on. Several hours may be involved in shooting animation of this nature, but the results are well worth the effort. This is a good basic animation approach for the basic videophile who does not want to concern himself with elaborate artistic rendering as in cel animation which we will also study in this chapter.

Puppet Animation

Puppet Animation is related to object animation as it consists of frame by frame filming of dimensional figures (usually with joints). The joints

may be flexed or moved in small increments, so that when still frame shots are coordinated in unison, the movement illusion is created. Puppet animation is popular for recognizable character or animal motion sequences. Puppet animation has also been extensively used for creating monster and monster effects in live action fiction films as the puppet figures are interjected into live action scenarios.

Object Animation

Object animation is akin to puppet animation except that the object is mostly inanimate and only animated or allowed to "move" for effect. The viewer always relates the object as inanimate whereas in puppet animation the subject is perceived as a "character." Dimensional object animation involves similar videotaping techniques utilized in puppet animation. Almost any object may be animated by the videocameraman that is knowl-

edgeable, imaginative, and well versed in animation concepts.

CUTOUT ANIMATION

Cutout animation relies on small paper or cardboard jointed figures carefully placed under the camera and juxtapositioned and manipulated to create motion. Limb joints on the cutout figures may be constructed using string, wire or paper fasteners. Figures can be fine detailed or "shape" rendered. Different sizes of each specific character can be used to further illusions of close and long shots and various drawn heads substituted to create changes of expression. Cutout animation must also be still frame photographed to achieve the illusion of movement.

PIXILATION

This technique relates closely to live action videotaping. In pixilation, props, subjects or characters are photographed frame-by-frame, the frames butted together in sequence to create the motion illusion. This technique is unsurpassed for creating crazy, unreal, speeded-up, jerky motion effects that can be comical as well as expressive.

CEL ANIMATION

The epitome of excellence, Cel animation is the most effective and refined; the roots of artistic animated cartooning. It is the accepted classic method used to create high level cartooning and hand rendered animation situations. Cel animation derives its name from the method used to achieve

Fig. 16-3. Zero in on the head.

Fig. 16-4. Then close in on the eyes and teeth.

the finished effect. In Cel animation each figure and key movement is drawn out in ink on acetate sheets (after the story line and scenario has been calculated) (Fig. 16-9). The first drawing is followed by a second with slight movement changes (Fig. 16-10) which then are followed by a third and so forth. When each cel is stop-frame photographed in sequence, consequent projection of the segments in quick succession after the other will serve to bring life and movement to the sequentially arranged individual cel renderings. After the cel images are inked, they are colored in on the back of the cels in opaque gouache or watercolor.

In Fig. 16-11 we see a progression of three cels showing progressive key movements. Each progressive cel should be checked against the preceding one to check the degree of movement and expression changes required. The artist must then take the completed cel overlays and coordinate

them juxtapositioning them over a painted background to further heighten illusions of background and depth giving the animated subject an appropriate setting (Fig. 16-12). In Fig. 16-12 the background consists of a woodsy scene with some basic sporadic foreground elements. The main foreground element (animated figure) is placed directly over the scene so that the character will motivate or move in front of the background. Each progressive cel is placed a few inches to the side of the preceding one and is individually photographed. With this approach the figure moves while progressing across the background increasing the movement or "animation" effect.

In addition to being an artist, the animator must have some knowledge of subject anatomy in relation to movement. The animator must be cognizant of physical aspects of movement as well as subject personality traits that make the individual charac-

Fig. 16-5. Puppet or figure subjects can be effectively placed using the outdoors or foliage for a setting.

Fig. 16-7. In the next frame, the figure is moved slightly.

ter respond in its own unique fashion. The animator must work these facets out on a drawing board prior to cel production, with consideration also to dialogue and soundtrack. Since every motion in an animated feature is created from a series of progressive cels, the animator must check and collate each drawing flipping each over and over correspondingly until he is content with the smoothness

Fig. 16-6. Animation realized by doll manipulation and stop-frame shooting. Here's one frame.

Fig. 16-8. Running each frame and movement in sequence gives the animation effect.

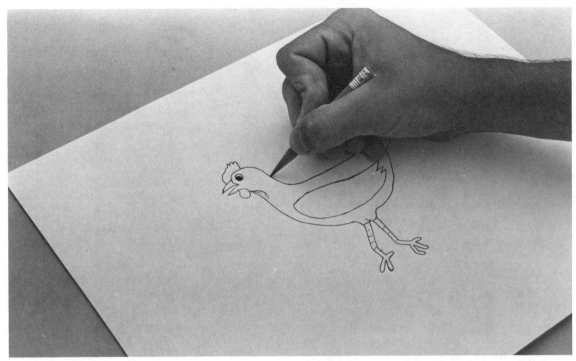

Fig. 16-9. First the figure is hand drawn.

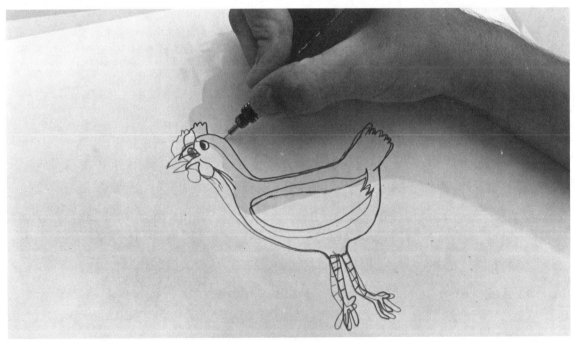

Fig. 16-10. Each figure to depict movement changes is india inked on separate cels, using the previously drawn cel for reference.

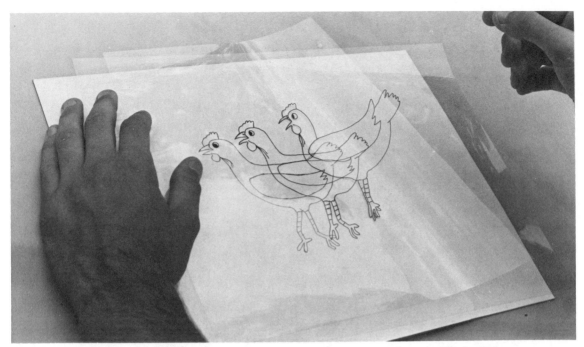

Fig. 16-11. Three sequential cels. Each one incorporates a slight movement and expression change.

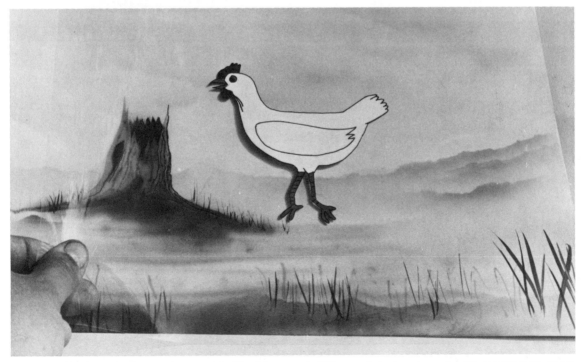

Fig. 16-12. Cels are superimposed over painted backdrops and still frame shot, changing cels while moving them along prescribed intervals along the background artwork.

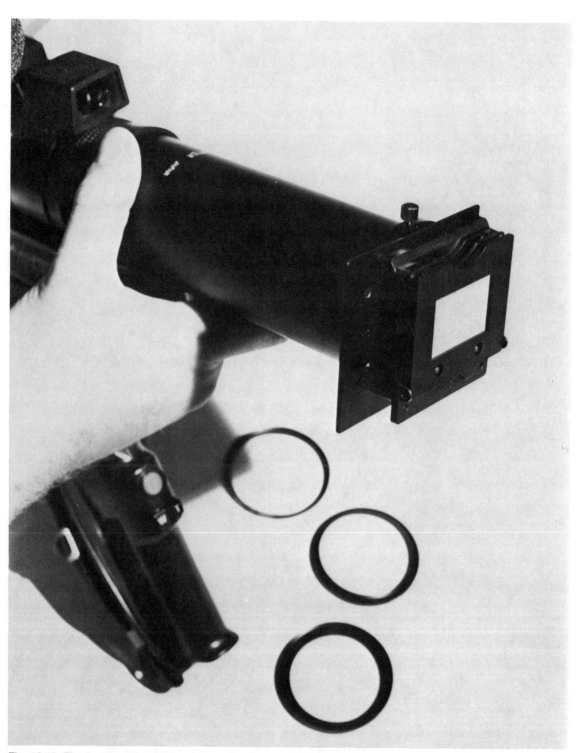

Fig. 16-13. The Ambico 35mm slide adapter will adapt to all videocameras.

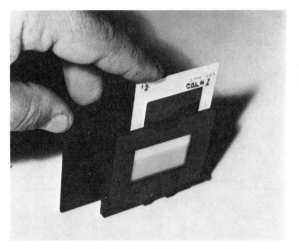

Fig. 16-14. The slide is slipped into a frame, which retains and centers slide.

Fig. 16-15. The frame front will extend forward so that strip films can also be used.

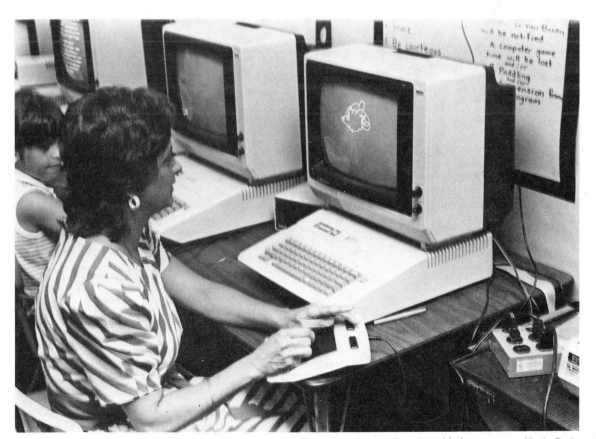

Fig. 16-16. Rose Botting works out an animation sequence on the Apple II in conjunction with the accessory Koala Pad.

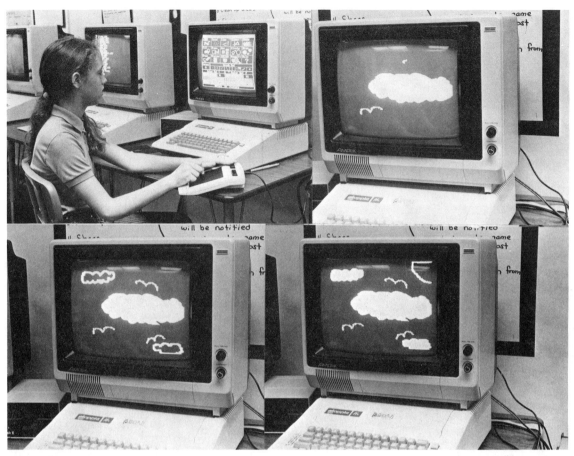

Fig. 16-17. An example of an animation step-by-step sequence. Sequence is hand composed utilizing the Koala Pad. Formulating the command pattern & sequence is Jennifer Goddard of Coral Springs Elementary School.

and accuracy of movement. The extremes and rate of movement to be performed must also be considered. When the cel production procedure is finalized, the drawings are shot in proper sequence on film, shooting and moving each cel over the background as required.

Animation is usually shot with 16mm or 35mm movie film in stop frame mode commercially. Since this type of equipment is not easily accessible or too complex and expensive for the average videophile, we present a feasible and highly efficient alternate made possible by a camera accessory item, the Ambico V-0327 tele-slide converter which can be attached to the lenses of all videocameras with proper adapters (Fig. 16-13).

Each individual cel frame is first photographed

with a 35mm still camera on color transparency film. After the film has been developed and mounted in 2 × 2 slide mounts, the individual cel reproduction slides are placed into the frame retainer in the forward portion of the tele-slide converter (Fig. 16-14). Each still picture is then videotaped in short time increments in consecutive order. Playing back the videotape after the process is finalized will create the animation or movement effect which can be most accurate and convincing. Strip 35mm film may also be utilized as the adapter allows mounting provision for strip films by opening the front baffle (Fig. 16-15) then placing it back over the film strip which centers and secures each individual frame as required. When videocopying 35mm transparency film, use a good reflected

light source; not *direct,* as it can harm the video pickup tube. Facing a light source against a large white surface will work well; the camera lens is then directed at this bounceback surface and white balance exposure is set and videocopying can commence.

COMPUTER ANIMATION

Computers can be most effective for creating abstract art and pseudo-animation effects that can be most novel and impressive when interjected into an animation type sequence. With computers, abstract patterns may be made to move or to build up in progressive stages. A correctly programmed computer can generate patterns in sequences quickly and effortlessly, consequently transferring them to the VCR using proper cables or interfacing accessories. In Fig. 16-16 we see a set-up of this type using the Apple II computer in conjunction with a Koala Pad, which formulates the basic hand animation. The Apple II will effectively provide basic animation and titling with a Koala-Pad setup with proper interfacing to the VCR which will record the sequence. A special rf adapter must be

connected between computer and recording device which raises the computer signal output to channel 3 or 4 when coupled directly to the VCR antenna input. With this setup you can record on videotape in the same manner as recording a TV program. Adwar Video makes a proper interface adapter compatible with the Apple II, Apple *II*e, Apple II+ and Franklin Ace 100 computers. Showtime Video Ventures also markets an interface accessory unit that can be used with the Commodore VIC-20.

Most home computers contain a five pin jack for outputting video as well as audio signals. Pin arrangement may vary from computer to computer, but proper connection can be evaluated by checking the computer owner manual. Once the proper pin connection has been calculated, one need only purchase a "Monitor" cable with five pin adapter available at most computer or Radio Shack facilities. The opposite end of the five-pin connector cable will consist of four or five individual RCA plugs which will easily connect to VCR rf inputs. In Fig. 16-17 we can study a typical progressive computer animation sequence with the Apple II and Koala Pad.

Chapter 17

Miscellaneous Equipment and Accessories

The home video accessory market abounds in items of all types for specified purposes. Listed in this chapter are a number of formidable accessories that will be of interest to the creative videophile.

LENSES AND FILTERS

The Perispheric Super wide angle, Macro Auxiliary lens from Photo and Video Electronics Service will provide the average camera lens with distortion free wide angle capability. It will screw onto an existing lens via the proper step-up or step-down adapter. It is a welcome auxiliary lens for the videophile who wishes to expand his wide angle and Macro perspective.

The Ambico Model V-0312 Tele-converter lens (Fig. 17-1) is also a screw-on additive lens that turns the existing camera lens into an extreme telephoto for those up close impact shots. The Ambico Tele kit comes complete with adapter rings for all lens mounts.

Sony Camera owners should look into the Sony line of lens converters and filters. The Sony VCL-1558A Tele-converter lens extends the focal length of the video camera about 50 percent. It will convert the average 6:1 ratio zoom lens into a 9:1.5 ratio lens. The Sony VCL-0758A wide conversion lens increases the average field of view approximately 70 percent and is great for extreme wide angle reproduction. Sony also provides a VF-105A special effects filter kit containing a cross pattern rainbow filter, center spot focus filter, a multiple five image filter plus a multicoated protective camera lens filter.

Smith Victor, the light people, also market C-mount adapters for video cameras. These adapters allow maximum versatility and flexibility enabling all 35mm still cameras to be mounted on all video cameras with removable C-mounting. All existing 35mm lenses can be adapted by the simple converter at a fraction of the cost of high priced video lenses. To use, one simply unscrews an existing C-mount video lens and affixes the appropriate Smith-Victor converter in its place. Adapters are available to fit the following 35mm lens mounts:

Fig. 17-1. Ambico Tele-Converter lens. Courtesy Ambico.

Canon mount	640300
Nikon mount	640301
Pentax K mount	640302
Pentax S mount	640303
Minolta mount	640304
Yashica mount	640305
Olympus mount	640306

EQUIPMENT CASES

Cases are far too numerous to mention, but two are highly recommended, not only for their versatility but for their protective power second to none. The two cases in point are the Bogen LC and LF series TSE Cases. The TSE LC series cases measure 9 1/4 inches wide by 14 inches long and come in three height options: 4 inch; 5 inch; 6 inch. The TSE LF series cases measure 14 inches wide by 21 inches long also in three height sizes: four-, five-, and six-inch. The LF series cases are for larger format equipment. The TSE cases feature hi impact Lexon construction and interior foam padding for optimum protection of video equipment (see Fig. 17-2).

AUDIO-MICROPHONES

Professional minded videophiles will appreciate the Tascam PE-250 pro mike from Teac (Fig. 17-3). Not cheap, the Tascam PE-250 offers ruggedness, needs no additive power source, and offers extremely high sound pressure pickup without overload. A four position integrated switch offers three high pass filter settings for lowering bass response

Fig. 17-2. Bogen LF and LC series heavy-duty cases. Courtesy Bogen.

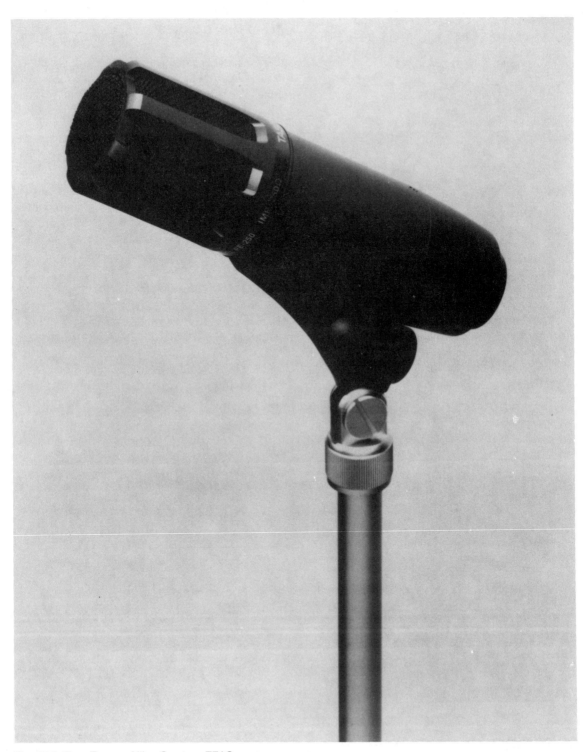

Fig. 17-3. Teac Tascam Mike. Courtesy TEAC.

when the PE-250 is placed close or for creative effect control. The PE-250 comes with a mic holder and carrying case.

VIDEO CONTROLLERS

A number of video controllers are available which serve to make component interfacing simple and reliable. The versatility of these all in one control boxes enable varied combinations of inputs and outputs allowing the videophile to tape or record from such rf sources as TV, VCR, Videodisc, games and even computers. A typical Video Controller that is most functional in all the aforementioned respects is the Quasar VE 581VN (Fig. 17-4).

STABILIZERS, PROCESSORS, ENHANCERS

A number of specialized VCR additive component manufacturers markets excellent "electronic box" additives that serve to boost, enhance, improve or modify signals for creative and foolproof videotape reproduction or transferral. The following quality components and component type availability will be listed according to manufacturer.

Kramer

Kramer produces the Model VS2E Active Video Enhancer Splitter and the Model VS-10 Video-Audio processing unit (Fig. 17-5).

The VS2E is a multifunctional processor for recording and playback. The VS2E serves as an enhancer with integrated noise limiting circuitry and color processor controlling color saturation and balance. It also functions as a video amplifier/fader for luminance control and editing. The VS2E also contains a three output video distribution amp an audio mixing center and four output audio distribution.

The VS-10 combines high resolution video enhancement with full sync retention and a video stabilizer with multi-system stabilization. Also included in the VS-10 video functions are:

☐ Video color processor with color correction, color burst phase and chroma regulation.

☐ Full by-pass switching in each video section.

☐ Rf video and audio conversion.

☐ Digital three-input video switcher with three separate video outputs.

Fig. 17-4. Quasar VE 581. Courtesy Quasar.

Fig. 17-5. Kramer VS2E (top) and VS-10 (bottom). Courtesy Kramer.

Audio features of the VS-10 include a five band equalizer, audio level and amplification with overload detection, five input audio mixer with line and mike inputs and four audio outputs. The VS10-EX model has a built in stereo synthesizer circuit allowing conversion of mono videotapes for stereo recording and VCR playback through home hi fi systems.

MFJ

MFJ is another manufacturer of enhancement equipment tailored for video work.

The MFJ-1445 is their deluxe color processor/Enhancer/stabilizer combining a stereo synthesizer, audio noise reduction system, electronic Video/stereo switcher, cross channel and auto/manual fader, distribution amp, audio video mute, rf modulator and four video/stereo outputs. The color tint and color intensity controls assist in adjusting and enriching color saturation for natural or modified color effects. An excellent built-in split screen enhancer makes soft video pictures sharper and crisper while also increasing contrast.

Audio noise reduction as well as video noise facilities are also incorporated into the unit.

The MFJ 1450 is a less expensive, standard version of the MFJ 1445. Featured in this model are fade-in, fade-out control, split screen enhancement, automatic stabilizer to control roll and jitter, three video-audio outputs and built in rf modulator for TV viewing.

Recoton

Recoton, who is into a really wide array of cables, accessories, control and connection boxes, also markets a line of basic video improvement products (Fig. 17-6).

The V600 A minimizes or eliminates picture distortion and roll improving vertical, horizontal and contrast control. A built in LED indicator lights up when maximum stabilization is achieved. With this unit one can stabilize and improve reproductional quality from TV to VCR or VCR to VCR. One video and one audio output is included as well as two video, two audio and one rf outputs. The Recoton model V601-A "box" is an image en-

hancer with rf conversion. It upgrades contrast and sharpness while refining color tone. Specially designed for re-recording videotapes, the V601-A also includes bypass mode for instant comparison. The internal rf converter changes VCR audio and video outputs to a standard rf TV signal allowing the viewer to install the V601-A in line between one VCR and a TV. Inputs and outputs are the same as in the V600-A.

The Recoton V604 unit is a stabilizer/enhancer/rf converter and the top of the line box in the "Producer" series. For the more discerning videophile, this unit combines three functions into one box increasing its versatility. The stabilizer section eliminates roll and distortion as does the V600-A with a stabilizer lock that illuminates when stabilization is at maximum. The enhancer circuitry refines color and contrast with a bypass comparison mode. Separate detail and gain controls ensure best possible re-recording. Input and output facilities are the same as in the prementioned Recoton mini models.

Vidicraft

Vidicraft is seriously into video enhancement components with nine boxes in their line from basic to complex. Three units are especially worthy of mention to the serious videophile.

The sophisticated Vidicraft IVE-100 (Fig. 17-7) is an integrated Video Enhancer unit that improves picture reproduction and clarity even at slower videotape speeds. Exclusive internal processing controls "snow" and other low level visual noise effects. The stabilizing circuit controls roll and jitter while reducing the probability of picture break-up due to tape mis-tracking and dropouts. A built-in rf modulator allows the IV-100 direct connection between a VCR and TV. An auxiliary audio/video input will accept a separate component or player. Switchable interfacing for two VCRs is also provided.

The Vidicraft Proc-Amp (Fig. 17-8) is a video processing unit expressly for correcting color and contrast errors. The Proc-Amp can also be utilized to create fade-ins and fade-outs or remove color completely from a picture. Chroma gain and phase controls adjust color level and tint, while the luminance gain control affects contrast and brightness. Luminance gain control can be monitored on a built-in level meter to check adjustment accuracy. The Proc-Amp can also be implemented for balancing one camera to another in multiple camera shooting situations.

The Vidicraft Stereo Synthesizer (Fig. 17-9) is geared toward sound track manipulation or dubbing processes. With this unit, a monaural signal can be

Fig. 17-6. Recoton Enhancement Components. Courtesy Recoton.

Fig. 17-7. Vidicraft IVE-100. Courtesy Vidicraft.

Fig. 17-8. Vidicraft Proc-Amp. Courtesy Vidicraft.

Fig. 17-9. Vidicraft Stereo Synthesizer. Courtesy Vidicraft.

enhanced and processed to stimulate the body and direction of stereo sound. The incoming mono audio signal is separated into five bands which when distributed to left and right channels produce steady directional sound with low and high frequencies transmitted to each channel somewhat like a stereo recording. Audio hiss is suppressed by means of DNR noise reduction. This unit will provide synthesized stereo from monaural sources or enable stereo recording synthesization with stereo compatible VCRs.

Showtime Video Ventures

A camera color processor is a leading offering of this company, offering a wide range of picture control not seen in many non-industrial electronic video processing devices. Small and compact, the Showtime VV-770PP Camera Color processor hooks up directly to a portable VCR's camera jack. The unit is marketed with either 10 pin connectors for VHS or 14 pin connectors for Beta. Connectors are male and female so "backward" connection is impossible. Controls of the 770 are on the top panel or face arranged in a line. A switch on the face selects record or playback mode. In playback mode, the boxes circuitry is disengaged so that recorded material can be played back and displayed in the camera's viewfinder monitor.

The controls in the VV-770PP separately manipulate Video gain (contrast) color tint, flesh tone, color saturation and color reverse. A pushbutton is also included that allows comparisons between processed and unprocessed signals. Unless you have an RCA or Hitachi camera with a color viewfinder, you can't get proper use of this unit in the field without a color monitor to check color setting. The VV-770PP is a sophisticated piece of equipment made to state-of-the-art standards. It offers much in wide range color control and is indispensable for accurate and controlled color rendering at camera level.

EDITORS

In the chapter on video editing we featured the most formidable offerings to date. Though there is no proliferation of electronic editing equipment in

"F" to "F" Cables
Used as connectors between VCR and TV, in line between amplifiers and switching devices, as a connecting cable to a signal splitter etc.

RCA to RCA Cables
Most commonly used for dubbing between VHS Systems.

RCA to Mini Cables
Most commonly used for dubbing between VHS and Beta formats.

V450	3'	"F" to "F" Plugs
V451	6'	"F" to "F" Plugs
V452	15'	"F" to "F" Plugs
V453	25'	"F" to "F" Plugs
V454	6'	RCA to RCA Plugs
V455	10'	RCA to RCA Plugs
V456	6'	"F" to Motorola Plugs
V457	10'	BNC to BNC Plugs
V458	10'	RCA to BNC Plugs
V459	10'	RCA to UHF Plugs

Motorola to "F" Cables
Used to connect from wall plate master antenna outlets to VCR, TV, Disc, etc.

"F" to RCA Cables
Used to connect enhancers or stabilizers to your VHS recorder.

Mini to Mini Cables
Used for tape dubbing with Beta type VCR's.

V460	3'	Right Angle Quick Connect "F" to "F" Plugs
V461	6'	Right Angle Quick Connect "F" to "F" Plugs
V462	10'	2 RCA to 2 RCA Plugs
V463	6'	"F" to RCA Plugs
V464	6'	RCA Plug to 3.5 mm Mini Plug
V465	10'	RCA Plug to 3.5 mm Mini Plug
V466	6'	Mini Plug to Mini Plug NEW
V467	6'	Quick Connect "F" to "F" Plug NEW

Fig. 17-10. Recoton Connection Cables. Drawing courtesy Recoton.

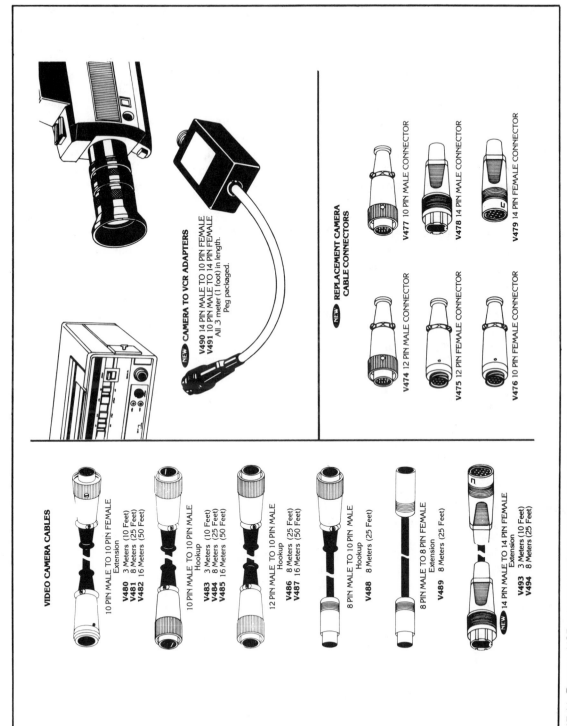

VIDEO CAMERA CABLES

10 PIN MALE TO 10 PIN FEMALE
Extension

V480 3 Meters (10 Feet)
V481 8 Meters (25 Feet)
V482 16 Meters (50 Feet)

10 PIN MALE TO 10 PIN MALE
Hookup

V483 3 Meters (10 Feet)
V484 8 Meters (25 Feet)
V485 16 Meters (50 Feet)

12 PIN MALE TO 10 PIN MALE
Hookup

V486 8 Meters (25 Feet)
V487 16 Meters (50 Feet)

8 PIN MALE TO 10 PIN MALE
Hookup

V488 8 Meters (25 Feet)

8 PIN MALE TO 8 PIN FEMALE
Extension

V489 8 Meters (25 Feet)

NEW 14 PIN MALE TO 14 PIN FEMALE
Extension

V493 3 Meters (10 Feet)
V494 8 Meters (25 Feet)

NEW **CAMERA TO VCR ADAPTERS**

V490 14 PIN MALE TO 10 PIN FEMALE
V491 10 PIN MALE TO 14 PIN FEMALE
All 3 meter (1 foot) in length.
Peg packaged.

NEW **REPLACEMENT CAMERA
CABLE CONNECTORS**

V477 10 PIN MALE CONNECTOR

V478 14 PIN MALE CONNECTOR

V479 14 PIN FEMALE CONNECTOR

V474 12 PIN MALE CONNECTOR

V475 12 PIN FEMALE CONNECTOR

V476 10 PIN FEMALE CONNECTOR

Fig. 17-11. Recoton VCR adapters and connectors. Courtesy Recoton.

the video market there are a few others available.

Chalange Editor 1000

Another editor worthy of merit is the Chalange developed and marketed by two electronic engineers Bruce and Ron Wright. Simply styled, the 1000 is accurate though not overly expensive which adds to its popularity. It will do effective scene-by-scene and general editing. Establishment, keying and recording in all edit locations can be performed with one VCR and the editor; however, when all segments have been keyed on the tape, a second VCR will have to be implemented for transferring the edited version. The Chalange 1000 will interface with all VCR's either in Beta or VHS format. Portable VCRs are highly recommended over table types since the portables usually contain superior editing, keying and pause functions affording cleaner edits. The 1000 is not recommended for non-stereo VCR's since in standard mono VCRs the existing soundtrack can be damaged during edit dubbing. A stereo VCR will allow the dubber sound retention on one track while the edit tones can be alternately put on the second track. The Chalange 1000 will work and operate most effectively when used with two VCR's (one to play, one to dub).

This basically simple editing unit is also very easy to hook up with all the jacks neatly arrayed and labeled on the back of the unit. The panel contains jacks for record and dub, VCR camera pause, power Audio in, Audio out, remote ET and audio out monitoring.

Once the unit is hooked between the two VCRs editing functions can transpire with the utmost ease. To edit out a section, simply press down on the proper switch the length of the segment then release the switch. Edits can be studied and viewed on a monitor to coordinate material prior to the actual dubbing. After edit points have been keyed in a final dub can be made onto the second VCR.

Chalange 1200

This upgraded model of the 1000 will perform the identical functions, but in addition will automatically process single scenes and also varied scene segments in any continuous length. In order to connect the Chalange 1000 or 1200 units to a dubbing VCR a control cable with comparative plug is required which may be obtained at any videophile specialty or accessory shop.

CAMERA AND VCR CABLES AND CONNECTORS

Proper cabling and connection between components is important; when non-compatible brands are interconnected special cables must be utilized or constructed. A full line of all purpose cables is made available by Recoton (Fig. 17-10). The video "Gold" series shown here offer all current forms of adaptability.

Camera cables, camera to VCR adapters and replacement camera cable connectors are items all videophiles will require at one time or another. Recoton has again the widest array of items of this type available (Fig. 17-11).

ACCESSORY SOURCES AND MANUFACTURERS

Recoton Corp.
46-23 Crane St.
Long Island City, NY 11101

Bogen Photo Corp.
100 S. Van Brunt St.
Englewood, NJ 07631

Vidicraft
0704 S.W. Bancroft St.
Portland, OR 97201

Ambico, Inc.
101 Horton Ave.
Lynbrook, NY 11563

Chalange
Box 31086
St. Louis, MO 63131

Kramer Electronics, Ltd.
48 Urban Avenue
Westbury, NY 11590

TEAC
7733 Telegraph Rd.
Montebello, CA 90640

<h1 style="text-align:center">Chapter 18</h1>

Abberations, Troubleshooting, and Maintenance

VCR's are not much more complex or harder to operate than standard Hi-Fi equipment; Video cameras as opposed to still cameras require more attention in operation and maintenance.

Inherent operational problems can best be avoided and circumvented by studying and absorbing fully all the material presented in instruction manuals provided by the manufacturers.

VCRs require little maintenance outside of head cleaning, while cameras must be checked frequently and babied so that their internal functions and facilities are always kept in top working condition.

Certain precautionary measures should be exercised with VCR's or any recorder type electronic unit. Figure 18-1 shows a listing of precautionary measures (courtesy Quasar) that will apply to the care and preservation of all standard VCR's currently produced.

With videocameras, it should be particularly stressed that they be handled with kid gloves throughout operation as well as in general consumer servicing.

It is imperative that every camera owner has an efficient and sturdy case for his videocamera. Unfortunately the case is considered an accessory item, and the more sturdy the case, the more expensive it tends to be. I would recommend a good aluminum or Lexan case with enough volumetric efficiency to house the camera plus adequate foam rubber padding around it. Some camera manufacturers feature and supply cases specifically designed for their cameras, reasonably priced, but I have found that their efficiency factor is one of portability rather than protection. A list of camera precautionary measures that should be strictly adhered to by all videocamera owners is presented in Fig. 18-2.

In my estimation, servicing if necessary should be undertaken by only qualified personnel. VCRs can be complex, videocameras equally so. If a problem arises with the VCR, it should be taken to an authorized station unless it is a simple maintenance problem. The basic problems arising in VCRs are usually due to dirty heads (which can affect picture quality), or misfunction or hang-up of cassette ejec-

AVOID SUDDEN CHANGES IN TEMPERATURE

If the RECORDER is suddenly moved from a cold place to a warm place, moisture may form on the tape and inside the RECORDER. In this case, the DEW Indicator will flash and the power will shut off automatically.

HUMIDITY AND DUST

Avoid places where there is high humidity or dust, which may cause damage to internal parts.

DON'T OBSTRUCT THE VENTILATION HOLES

The ventilation holes prevent overheating. Do not block or cover these holes. Especially avoid soft materials such as cloth or paper.

KEEP AWAY FROM HIGH TEMPERATURE

Keep the unit away from extreme heat such as direct sunlight, heat radiators, or closed vehicles.

KEEP MAGNETS AWAY

Never bring a magnet or magnetized object near the unit because it will adversely affect the performance of the unit.

NO FINGERS OR OTHER OBJECTS INSIDE

It is dangerous, and may cause damage to the unit, to touch the internal parts of this unit. Do not attempt to disassemble the unit. There are no user serviceable parts inside.

KEEP WATER AWAY

Keep the unit away from flower vases, tubs, sinks, etc. If you use the unit outdoors on a rainy day, take care that it does not become wet.

CAUTION:

If any liquids should spill into the unit, serious damage could occur. In that case, please consult qualified service personnel.

CLEANING THE UNIT

Wipe the unit with a clean, dry cloth. Never use cleaning fluid, or similar chemicals. Do not spray any cleaner or wax directly on the unit or use forced air to remove dust.

THUNDERSTORMS

If lightning occurs while recording outdoors, particularly in a wide open field, stop recording immediately.

STACKING

Use the RECORDER in a horizontal or vertical position and do not place anything heavy on it.

REFER ANY NEEDED SERVICING TO QUALIFIED SERVICE PERSONNEL

Fig. 18-1. Precautions for Video Cassette Recorders. Courtesy Quasar.

x Do not attempt to disassemble the camera or power supply. In order to prevent electric shock, do not remove screws or covers.
There are no user-serviceable parts inside.

x Do not abuse the camera. Avoid striking, shaking etc. The camera contains a sensitive pick-up tube which could be damaged by improper handling or storage.

x Do not let the lens remain uncapped when the camera is not in use.

x Do not touch the surface of the lens with your hand.

x Do not use strong or abrasive detergents when cleaning the camera body.

x Do not leave the camera in a position that exposes the viewfinder eyepiece to direct sunlight. The sunlight concentrated by the eyepiece lens can cause damage to the viewfinder.

x Do not aim the camera toward the sun or other extremely bright objects, whether it is turned on or not. This action could permanently damage the pick-up tube.

x Do not expose the camera or power supply to rain or moisture, or try to operate it in wet areas. Do not operate the camera or power supply if it becomes wet.

x Do not use the camera in an extreme environment where high temperature or high humidity exist.

x Do not try to operate the camera and power supply on power line voltages other than 120V AC at 60Hz.

x Do not leave the camera and power supply turned on when not in use.
Do not turn the power on and off repeatedly without use.
Do not block the ventilation slots.

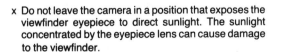

x Do not store the camera under conditions where temperatures are over 149°F (65°C).

Fig. 18-2. Precautions with Video Cameras. Courtesy Quasar.

tion and insertion mechanisms. The dirty head problem can be readily remedied by the owner as shown further on in this chapter; mechanical misfunctions should be left to the qualified serviceman. Outside of these areas VCRs will give unlimited, faultless operation.

BASIC PROBLEMS

Videocameras tend to promote more problems, but these are usually operational in nature due to unfamiliarity with cameras, some of which can be complex in operation and manipulation. Before running back to the dealer or service station, the neophyte videophile should diagnose the following basic problems if they should arise and try to remedy them with the suggested procedures.

No Picture (on viewfinder or monitor)

First check your power supply connection and see to it that all connectors are firmly seated. Make sure that your "standby" switch is in "operate" position. At the same time, also check that the VCR is powered and the switch in "on" position. In the case of portable VCR camera recorders, check the battery capacity to see if it contains a full or at least working charge. Naturally, you must make sure that the lens cap is off the camera.

Color

If you are achieving improper color balance in your picture, first check to see that the color balance controls on the camera are in a neutral or balanced state. Check light intensity and color temperature. Readjust white balance if necessary or even better take meter readings with a good accessory video meter. Also check out the color temperature correction switch. With natural light it should be at its daylight setting; with incandescent or quartz lights (auxiliary studio lighting) make sure you use the tungsten setting. If you are using auxiliary lighting for fill in outdoors, again check to see that the artificial and natural light sources harmonize. If not, filter the auxiliary light source by using a proper gelatin filter that will balance the artificial light to the daylight. In all instances make sure you are working in light conditions sufficient

for your particular camera. Insufficient lighting can also have an effect on color rendition.

Fuzzy Focus

Occasionally you may experience a deviation in sharpness. One very basic reason may be dirt or dust or moisture film on the lens. To avoid this common occurrence, clean lenses constantly, especially prior to camera use. Good photographic lens tissue and soft cotton cloth are the most ideal cleaning materials to use. Avoid liquid cleaners at all costs as they may affect the coated camera lens.

Another prime cause of bad focus is improper lens focus setting. Manual focus is the most effective way to set lens sharpness with the auto focus switch a second best alternate. Other minor incidents may transpire if functions are not properly coordinated. An upside down viewfinder picture is due to the picture turning switch in the wrong mode. The camera power should be turned off and the picture-turn switch set at the opposite mode, righting the image. At times the VCR will not pause immediately after the camera trigger is squeezed. This will occur if the fader switch is left in the "on" position. If the recorder does not commence operation when the camera trigger is pressed (when home video recorder is used) check to see if pause cable is properly connected. Also check to see that the camera cable to the VCR is properly connected and matched.

PICTURE ABERATIONS

White Noise Bars (Across Screen). This type of visual noise pattern occurs with mis-tracking of a recorded videotape. It is a minor occurrence and usually prevails when a tape is recorded on a VCR other than the one it is played back on. It is easily remedied by adjusting the "tracking" knob or lever found on all VCR's both portable and tabletop. The knob is manipulated till noise bars are completely eliminated.

Glitches. The ubiquitous glitch; soon to become a part of consumer video history as VCR's and cameras offer more sophisticated stop and go functions and corrective circuitry (Fig. 18-3). Glitches such as the one illustrated occur when the

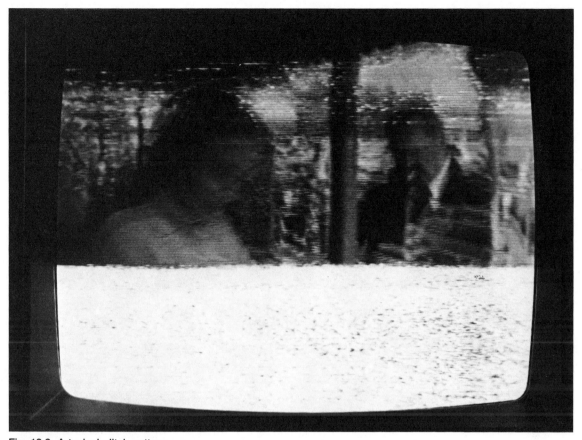

Fig. 18-3. A typical glitch pattern.

stop and start functions are activated in the VCR. On the newer VCR's, this is minimized by using the pause control when starting and stopping for assembly taping or assembly editing. The newer four and five head VCR units are glitch free overcoming this annoying fault which was more prevalent in earlier VCR models. For positive, segment to segment recording, always rely on the pause control for good segment-to-segment glitch free continuity.

Dropouts. Dropouts (Fig. 18-4) are continually turning up on cassette videotape, particularly at the beginning and end footage of the cassette. Dropouts can be caused by imperfections in the oxide coatings of the tape, heat damaged tape, dirty tape or even more common dirty heads on the VCR. Cheap tape is most prone to dropout so one sure way to minimize your dropout count is to use hi grade video tape for all your recording.

Above all, always keep the tape (drum) heads clean. They should be cleaned after 30 to 40 hours of use.

MAINTENANCE

The only maintenance that need be applied by the consumer is head cleaning. After long playing intervals, dirt and oxide can build up on the rotating drum area which will inhibit good, clean playback. Ideally the VCR cover should be removed for maximum access, but this is not recommended and simple cleaning with accessory cleaning units or swabs will suffice. In Fig. 18-5 we can see a cleanup procedure in which a cleaner laden Q-tip is run across the drum surface. The surface area should be liberally swabbed with head cleaning fluid, the excess fluid then wiped away with a clean dry Q-tip or cotton swag. The reason Q-tips work well here is that many drums are inaccessible by hand,

Fig. 18-4. Dropout noise in the form of white, meteorlike streaks.

whereas the long thin cotton tipped sticks can reach into confined spaces. The soft cotton tips will also enable you to spin or turn the drum without scratching the surface so you will have accessibility to all sides of the drum for thorough and complete cleaning. Specially formulated liquid VCR head cleaner solutions may be purchased at all Video accessory shops or Radio Shack outlets. They are necessary to have and relatively cheap; a few ounces will go a long way.

Most people prefer commercial cartridge type VCR cleaners for their versatility and ease of operation. Commercial cartridge cleaners are housed in a cassette similar to a videotape cartridge and are inserted into the VCR in the same manner. As the cartridge is run in the VCR play mode, a cleaning band is pressed against the recorder mechanism which also cleans all the surfaces in the tape's path. One must be wary when selecting cartridge cleaners; some are wet, some are dry cleaner units. The dry types tend to be too abrasive and will promote wear on drum surfaces with excessive use. Prepare to spend a bit more dollars on the cartridge units; some go up to thirty dollars. Check your monthly videomags for honest evaluations when considering the purchase of a cartridge cleaner. Dealers tend to lie and promote the products they have on hand with little knowledge or concern over the shortcomings of cartridge cleaners. The cotton Q-tip method is still the cheapest and a most adequate method.

If cartridge cleaners turn you on, you will be able to find some practical units in the video marketplace. One unit recommended highly and

Fig. 18-5. Cleaning a head on a Quasar Portable VCR. Portable VCR heads are usually more accessible than tabletop types. The Q-Tip laden with cleaner swabs the drum.

Fig. 18-6. Allsop 3 provides cartridge cleaning mechanism and cleaning solution.

found to be extremely efficient is the Allsop 3. Periodic cleaning cycles with the Allsop 3 (Fig. 18-6) will prevent and eliminate oxide particle and dirt buildup on VCR heads, capstans and pinch rollers. The Allsop should be used after 30 to 50 hours of VCR playback use. The cleaning element of the Allsop 3 is a chamois type cleaning strip, durable yet soft so that it cannot harm sensitive mechanism surfaces (Fig. 18-7). Prior to use, the felt pads and chamois strip are wet (but not over saturated) with the provided Allsop cleaning solution (Fig. 18-8). Usually fifteen to twenty drops will suffice. As soon as the cleaning strips are cleaner laden, the entire cleaning cartridge is placed into the VCR label side up (Fig. 18-9). The playback button on the VCR is pressed; the VCR activated with the cleaning process in full operation. The cassette will terminate the cleaning cycle automatically. A number of consecutive insertions may be necessary to thoroughly clean the internal contact surfaces particularly if a heavy dirt or oxide buildup prevails. After removing the cleaning cartridge from the VCR, allow a five minute drying period before viewing or recording a video cassette.

If your VCR fails to shut off automatically after the few second cleaning cycle, it may be because some late model machines have an internal sensory feature that senses the absence of tape in the tape path. In this case the VCR cannot be turned off without removing the electrical supply. If this proves to be a problem you can simply shut off the mechanism by hitting the cassette eject button which will also in turn eject the cleaning cassette. If the machine does not begin its cleaning cycle when the play button is depressed or if jamming occurs, remove the cleaning cartridge and manually rotate its sprockets one quarter of a turn.

The normal cleansing cycle of the Allsop 3 is three to five seconds. In case the cleaning cycle of your VCR is shorter, insert the provided rectangular label in the Allsop kit over the small hole located on the left side of the cartridge. The

Fig. 18-7. Cleaning chamois of the Allsop 3.

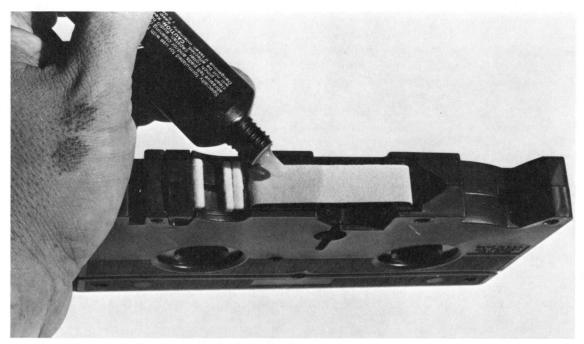

Fig. 18-8. The cleaning strip and pads are wet but not overly saturated.

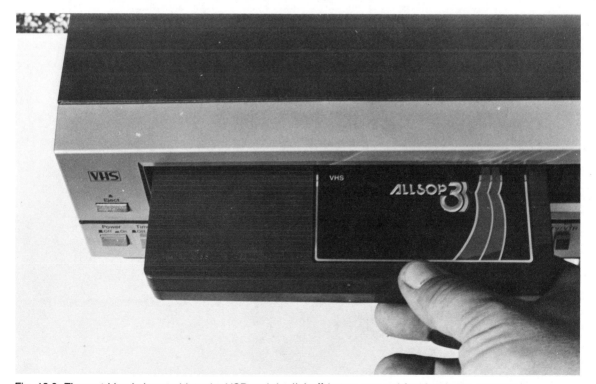

Fig. 18-9. The cartridge is inserted into the VCR and the "play" button pressed for cleaning to commence.

placement of this label will override the automatic shut off safety feature of the Allsop cartridge giving unlimited cleaning time. After five to ten seconds, the cleaning cycle should be terminated by hitting the stop button on the VCR.

Cleaning is the only maintenance for the layman or video neophyte; all operational problems should be left to qualified experts.

Chapter 19

VHS Principles of Operation and the Newvicon Tube

Videophiles who are technically minded might want to study the in-depth data on VHS recorders and the Newvicon tube, considered the hearts of videotape electronic systems most popular today.

The data is reproduced from Quasar Manuals in their original context courtesy of Quasar Company, Franklin Park, Illinois. All material is copyrighted by Matsushita Electric Corporation of America.

BASIC VIDEOTAPE RECORDING

To understand the VHS format, it is wise to first review the basic principles of videotape recording.

Like audio tape recording, video information is stored on magnetic tape by means of a small electromagnet, or head. The two poles of the head are brought very close together but they do not touch. This creates magnetic flux to entend across the separation (gap), as shown in Fig. 19-1.

If an ac signal is applied to the coil of the head, the field of flux will expand and collapse according to the rise and fall of the ac signal. When the

ac signal reverses polarity, the field of flux will be oriented in the opposite direction and will also expand and collapse. This changing field of flux is what accomplishes the magnetic recording. If this flux is brought near a magnetic material, it will become magnetized according to the intensity and orientation of the field of flux. The magnetic material used is oxide coated (magnetic) tape.

Using audio tape recording as an example, if the tape is not moved across the head, just one spot on the tape will be magnetized and will be continually re-magnetized. If the tape is moved across the tape, specific areas of the tape will be magnetized according to the field of flux at any specific moment. A length of recorded tape will therefore have on it areas of magnetization representing the direction and intensity of the field of flux. For instance: The tape will have differently magnetized regions, which can be called North (N) and South (S), according to the ac signal. When the polarity of the ac signal changes, so does the direction of magnetization on the tape, as shown by one cycle on the ac signal (see Fig. 2). If the recorded tape

211

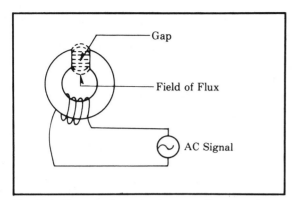

Fig. 19-1. Magnetic flux extends across the separation.

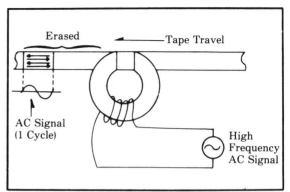

Fig. 19-3. Changing polarity of the high frequency ac signal.

is then moved past a head whose coil is connected to an amplifier, the regions of magnetization on the tape will set up flux across the head gap which will in turn induce a voltage in the coil to be amplified. The output of the amplifier, then is the same as the original ac signal. This is essentially what is done in audio recording, with other methods for improvement like bias and equalization.

There are some inherent limitations in the tape recording process which do effect videotape recording, so they will be examined now. As shown in Fig. 19-2, the tape has North and South magnetic fields which change according to the polarity of the ac signal. What if the frequency of the ac signal were to greatly increase?

If the speed of the tape past the head (head to tape speed) is kept the same, the changing polarity of the high frequency ac signal would not be faithfully recorded on the tape, as shown in Fig. 19-3.

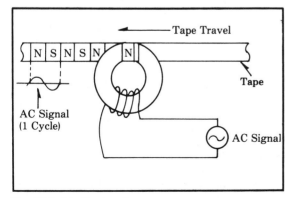

Fig. 19-2. Ac signal cycle.

As the high frequency ac signal starts to go positive, the tape will start to be magnetized in one direction. But the ac signal will very quickly change its polarity, and this will be recorded on much of *the same portion of* the tape, so North magnetic regions will be covered by South magnetic regions and vice versa. This results in zero signal on the tape, or self-erasing. To keep the North and South regions separate, the head to tape speed must be increased. (See Fig. 19-3.)

When recording video, frequencies in excess of 4 MHz may be encountered. Through experience, it is found that the head to tape speed must be in the region of 10 meters per second in order to record video signals.

The figure of 10 meters per second was also influenced by the size of the head gap. Clearly, the lower the head to tape speed, the easier it is to control that speed. If changes in head gap size were not made, the necessary head to tape speed would have been considerably higher. How the gap size influences this can be explained by Fig. 19-4.

Assume a signal is already recorded on the tape. The distance on the tape required to record one full ac signal cycle is called the *Recorded Wavelength* or λ. Head A has a gap width equal to λ. Here there is both North and South oriented magnetization across the gap.

This produces a net output of zero since North and South cancel. Head B and C have a maximum output because there is just one magnetic orientation across their gaps.

Maximum output occurs in heads B and C

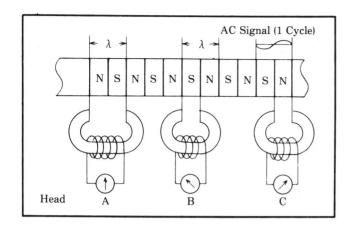

AC Signal (1 Cycle)

Fig. 19-4. Influence of gap size.

therefore, because their gap width is 1/2λ. (Heads B and C would also work if their gap width is less than 1/2λ.) The same is also true for recording. The maximum useable (no self-erasing) transfer of magnetic energy to the tape occurs when the gap width, G, can be expressed as.

$$G < \frac{\lambda}{2}$$

The *Recording Wavelength,* can be expressed as:

$$\lambda = \frac{V}{f}$$

where V is the head to tape speed and f is the frequencies to be recorded.

$$G < \frac{V}{2f}$$

So, as V increases, G is allowed to increase for the same MAXIMUM frequency. Conversely if G is made very small, V is allowed to be reduced.

In practice, G can be made as small as (and smaller than) 1μm (1×10^{-6} meters) and this puts V in the area of 10 meters per second. A head to tape speed of 10 meters per second is a very high speed, too high in fact to be handled accurately by a reel to reel tape machine of reasonable size. Also, tape consumption on a high speed reel to reel machine is tremendous.

The method employed in video recording is to move the video heads as well as the tape. If the heads are made to move fast, across the tape, the linear tape speed can be kept very low.

In 2-head helical video recording (the only format which will be discussed here) the video heads are mounted in a rotating drum or cylinder, and the tape is wrapped around the cylinder. This way, the heads can scan the tape as it moves. When a head scans the tape, it is said to have made a TRACK. This can be seen in Fig. 19-5.

In 2-head helical format, each head, as it scans across the tape will record one TV field, or 262.5 horizontal lines. Therefore, each head must scan the tape 30 times per second to give a field rate of 60 fields per second.

The tape is shown as a screen wrapped around the head cylinder to make it easy to see the video head. There is a second video head 180° from the head shown in front. Because the wraps around the cylinder in the shape of a helix (helica) the video tracks are made as a series of slanted lines. Of course, the tracks are invisible, but it is easier to visualize them as line. The two heads "A" and "B" make alternate scans of the tape.

Refer to Fig. 19-6. The Video tracks are the areas of the tape where video recording actually takes place. The guard bands are blank areas between tracks, preventing the adjacent track's crosstalk from appearing on the track where the video head is tracking.

There is one more point about video recording which will be discussed here. Magnetic heads have

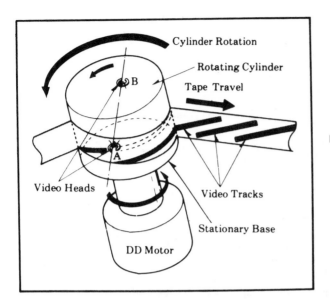

Fig. 19-5. One track.

the characteristic of increased output level as the frequency increases. Then, as determined by the gap width, the maximum output occurs at

$$approximately \ G \ = \ \frac{V}{2f}$$

In practice, the lower frequency output of the heads is boosted in level to equal the level of the higher frequencies. This process, as also used in audio applications, is called equalization.

Video frequencies span from dc to about 4 MHz. This represents a frequency range of about 18 octaves. 18 octaves is too far a spread to be handled in one system (one machine). For instance, heads designed for operation at a maximum frequency of 4 MHz will have very low output at low frequencies. Since there is 6 dB/octave attenuation, $18 \times 6 = 108$ dB difference appears. In practice this difference is too great to be adequately equalized. To get around this, the video signal is applied to an FM modulator during recording. This modulator will change its frequency according to the instantaneous level of the video signal.

The energy of the FM signal lies chiefly in the area from about 1 MHz to 8 MHz, just three octaves. Heads designed for use at 8 MHz, can still be used at 1 MHz, because the output signal can

be equalized. Actually speaking, heads are designed for use up to about 5 MHz. Therefore, some FM energy is lacked but it does not affect the playback video signal, because it is resumed in the playback process.

Upon playback, the recovered FM signal must be equalized then demodulated to obtain the video signal.

CONVERTED SUBCARRIER DIRECT RECORDING METHOD

The one method of color video recording that will be discussed here is the converted subcarrier method. In order to avoid visible beats in the pic-

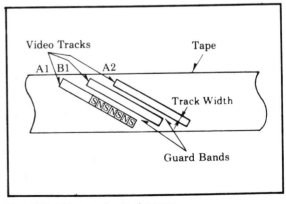

Fig. 19-6. Video tracks on the tape.

ture caused by the interaction of the color (chrominance) and brightness (luminance) signals, the first step in the converted subcarrier method is to separate the chrominance and luminance portions of the video signal to be recorded. The *luminance signal*, containing frequencies from dc to about 4 MHz, is then FM recorded, as previously described. The *chrominance portion*, containing frequencies in the area of 3.58 MHz is down-converted in frequency in the area of 629 kHz. Since there is not a large shift from the center frequency of 629 kHz, this converted chrominance signal is able to be recorded directly on the tape. Also note that the frequencies in the area of 629 kHz are still high enough to allow equalized playback. In practice, the *Converted Chrominance* signal and the FM signal are mixed and then simultaneously applied to the tape. Upon playback, FM and converted chrominance signals are separated. The FM is demodulated into a luminance signal again. The converted chrominance signal is reconverted back up in frequency area of 3.58 MHz. The chrominance and luminance signals are combined which reproduces the original video signal.

VIDEO HEAD
The Need for New Video Heads

We have already discussed the reduced track width. This reduction requires the use of a smaller, video head. Just making them smaller does not make them better. With less of actual head material to work with, the magnetic properties of the head suffers. To offset this a change in the head material is in order. Because the VHS recorder is designed to be small, a reduction in the size of the head cylinder was called for. A reduction in the size (diameter) of the head cylinder changes the head to tape speed. Remember, the head to tape speed affects the high frequency recording capability of the head.

To offset this problem, the head gap size was reduced.

As is well-known, Azimuth Recording is utilized in VHS. The heart of the Azimuth Recording process is in the video heads themselves. This requires still another change in head design.

Head Gap
1. Width

As explained, the need for smaller head gap size became apparent. In VHS, the video heads have gap widths of a mere 0.3 μm (0.3 \times 10^{-6} meters). This is quite a contrast with ordinary video heads used in other helical applications whose gap widths are typically in the area of 1 μm.

2. Azimuth

Azimuth is the term used to define the left to right tilt of the gap if the head could be viewed straight on. In previous VTR applications the azimuth was always set to be perpendicular to the direction of the head travel across the tape, or more simply, the video track. Figure 19-7 helps explain this.

In VHS, the video heads have a gap azimuth other than 0°. And more, one head has a different azimuth from the other. The 2 values used in VHS are azimuth of +6° and −6°. Refer to Fig. 19-8 and Fig. 19-9.

These heads make the VHS format different from most other VTR formats. Exactly how the azimuths of ±6° helps to keep out adjacent track interference is explained next.

AZIMUTH RECORDING

Azimuth Recording is used in VHS to elimi-

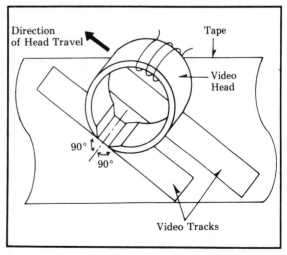

Fig. 19-7. Azimuth is set perpendicular to the direction of the head travel across the video track.

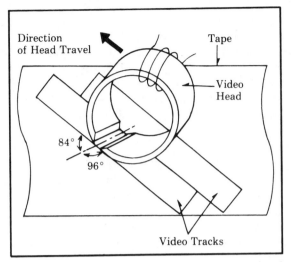

Fig. 19-8. Two values used in VHS are azimuth of +6° and −6°.

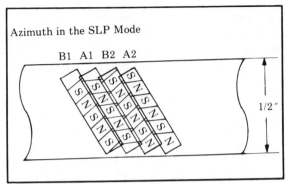

Fig. 19-10. VHS/SLP video tracks with N and S regions not perpendicular.

nate the interference or crosstalk picked up by a video head. Again, because adjacent video tracks touch, or crosstalk, a video head when scanning a track will pick up some information from the adjacent track. The azimuths of the head gaps assure that video head "A" will only give an output when scanning across a track made by head "A". Head "B", therefore, only gives an output when scanning across a track made by head "B". Because of the azimuth effect, a particular video head will not pick up any crosstalk from an adjacent track. Let's examine this more closely.

In Fig. 19-10, we can see the VHS/SLP for example, video tracks with not-to-scale North and South magnetized regions on them.

It can also be seen that these N or S regions are not perpendicular to the track, they have −6° azimuth in tracks A1, A2; and +6° azimuth in tracks B1, B2.

If we take track A1 and darken the N regions, it becomes easier to see. Refer to Fig. 19-11.

In Fig. 19-12, we see the information on track A, made by head "A". Imagine now that head "A" is going to play back this track, by superimposing the head over the track. Clearly, the gap fits exactly over the N and S regions, so that at any moment there is either an N region or an S region or an N to S (or S to V) transition across the gap. This produces maximum output in head "A".

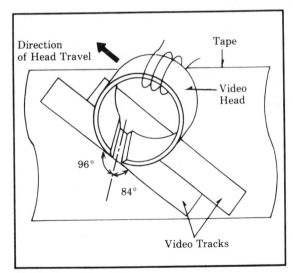

Fig. 19-9. Change of azimuth value.

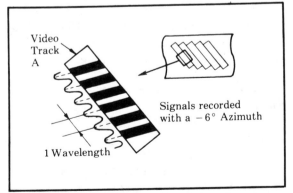

Fig. 19-11. Track A1 with N regions darkened.

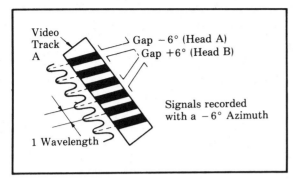

Fig. 19-12. Information on track A, made by Head A.

Now, visually superimpose the "B" head over the track. Here there are N and S regions across the gap at the same time, at any given moment. Remember that simultaneous N and S regions across the gap cause cancellation, and therefore no output. Looking at Fig. 19-9, we can see that the gap width is equal to 1/2 the recorded wavelength. Recall that this occurs at the highest frequency which is to be recorded.

So therefore, the azimuth effect works at these high frequencies.

But what happens at lower frequencies? In Fig. 19-13, we see a diagram similar to Fig.19-12, except the recorded wavelength is longer, which represents a lower frequency.

Again, visually superimpose the heads over the track. Head "A" is the same as before. But look at head "B". There is much less cancellation across the gap, and its output is close to that of head "A". Therefore, we see where the azimuth effect is de-

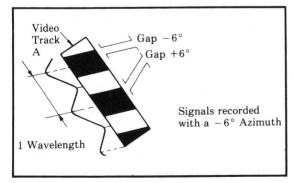

Fig. 19-13. Recorded wavelength is longer than in Fig. 19-12, representing a lower frequency.

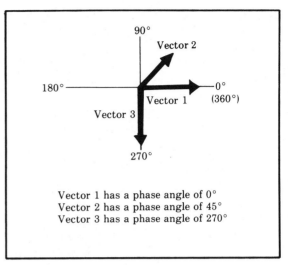

Vector 1 has a phase angle of 0°
Vector 2 has a phase angle of 45°
Vector 3 has a phase angle of 270°

Fig. 19-14. Vectors.

pendent on frequency. The higher the frequency, the better the azimuth effect. The lower the frequency, the lower the separation by azimuth effect.

VHS COLOR RECORDING SYSTEM

Because there is insignificant azimuth effect at lower frequencies, a new color recording system must be adopted.

The fact that crosstalk occurs at lower frequencies cannot be changed, this happens right at the tape during playback. The method adopted processes the crosstalk component signals from the heads so that they are eliminated. It is important to realize that the crosstalk *Does Still Occur*. It is the recording/playback circuitry that performs the elimination.

In ordinary Helical VTR's using converted sub-carrier direct recording, the phase of the chrominance signal is untouched, recorded directly onto the tape. The chrominance signal and its phase can be represented by vectors. Vectors graphically represent the amplitude and phase of ONE frequency. In this discussion, we will consider (for simplicity) the chrominance signal to be of one frequency. As an example of vectors, see Fig. 19-14. The length of any vector represents its amplitude.

We know that the azimuth effect will not work at the lower frequencies. And since the color in-

formation in VHS is recorded at low-converted frequencies, a new method of color recording was adopted.

Vector Rotation in Recording is actually a phase shift process that occurs at a horizontal rate, 15,734 Hz.

The chrominance signal can be represented by a vector, showing amplitude and phase. (＼).

In ordinary Helical Scan VTR's the vector is of the same phase for every horizontal line, on every track as shown in Fig. 19-15.

In VHS, we still convert the 3.58 MHz down to a lower frequency, namely 629 kHz, but the new color method used in VHS format is a process of vector rotation. During recording the CHROMINANCE phase of each horizontal line is shifted by 90°. For head "A" (CHANNEL 1) we ADVANCE the CHROMINANCE phase by 90° per horizontal line (H).

For head "B" (CHANNEL 2) we DELAY the chrominance phase 90° per H.

VECTOR (PHASE) ROTATION:
CHANNEL 1 + 90°/H
CHANNEL 2 – 90°/H

Fig. 19-16 shows what this looks like on tape.

Now assume that head "A" plays back over track A1 it will produce a vector output as such:

Head "A" when tracking over A1 will have an output consisting of the main signal (large vectors) and some crosstalk components (small vectors).

Figure 19-17, then is a vector representation of the playback chrominance signal from the head.

One of the most important things down in the

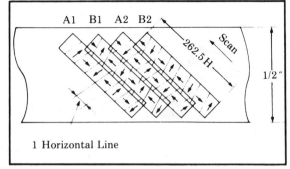

Fig. 19-16. Vector (phrase) rotation.

playback process is the restoration of the vectors to their original phase. This is done by the balanced modulator in the playback process.

This restored signal is then split 2 ways. One path goes to one input of an adder. The other path goes to a delay line which delays the signal by 1 H. The output of the delay line goes to the other input of the adder. Fig. 19-19 explains.

As can be seen in Fig. 19-21, the crosstalk component has been eliminated after the first H line. We have now a chrominance signal free of adjacent channel crosstalk.

The double output in Fig. 19-21 is not a problem because it can always be reduced. The process of adding a delayed line to an undelayed line is permissible because any 2 adjacent lines in a field contain nearly the same chrominance information.

So, if 2 adjacent lines are added, the net result will produce no distortion in the playback picture.

In conjunction with the crosstalk elimination is the reconversion of the chrominance 629 kHz to its original 3.58 MHz. Now the color signal is totally restored.

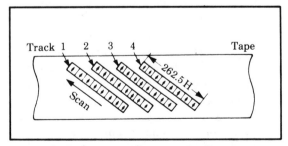

Fig. 19-15. The vector is the same phase for every horizontal line on every track.

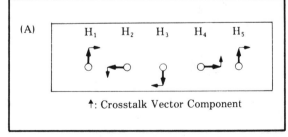

Fig. 19-17. Vector representation of the playback chrominance signal from the head.

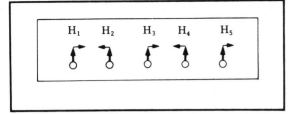

Fig. 19-18. Balanced modulator.

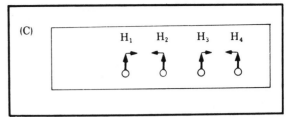

Fig. 19-20. Restoration of the vectors to their original phase.

NEWVICON TUBE

The Newvicon pick-up tube (Fig. 19-22) uses a new photo- conductive material (ZnSe-ZnCdTe) that is extremely sensitive and free from burning. These properties make the Newvicon highly suitable for use in low-illumination surveillance cameras.

This camera has a 2/3"-type Newvicon image receiving tube which uses the electrostatic focus and magnetic deflection system. The integral stripe filter in this system is coated with two layers of the new photo-conductive material, which gives the camera a high degree of sensitivity and color reproducibility totally free from burning.

Conventional electromagnetic focus/deflection pick-up tube systems use external focus coils which form electronic lenses in the pick-up tube, allowing the dc current to flow in the coils so that the beams are focused on the target.

The new electrostatic focus/magnetic deflection pick-up tube system, however, uses electrodes to focus the beams on the target, (Fig. 19-23) thus reducing power consumption by saving the power otherwise needed to drive the focus coils and reducing the power needed for magnetic deflection.

The electronic beam from the guard is accelerated by G2, then passes through the beam limiting aperture in order to generate fine-diameter beams. These beams are then focused by the electrostatic lens composed of G3, G4, and G5. This electrostatic lens replaces the conventional focus coils and circuits. G5 and G6 form a coillimating lens, through which the beams are deflected so that they always hit the target at the proper 90° angle. This improves the resolution around the edges of the lens.

Note: A beam adjustment magnet in the deflection assembly adjusts the magnetism so that the beams are always focussed in the center of the target.

Because the effective diameter of the focus is very small, the beam adjustment magnet must be adjusted with extreme care to prevent decreased picture resolution and dim colors.

Note: The deflection assembly consists of the horizontal/vertical deflection coils and beam adjustment magnet.

Basic Principle of Pick-up Tube

The lens gathers the light from the scene and

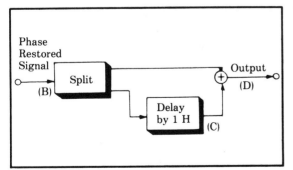

Fig. 19-19. The output of the delay line goes to the other input of the adder.

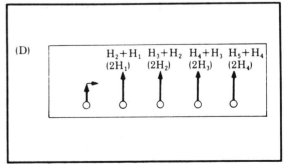

Fig. 19-21. Double output can be reduced.

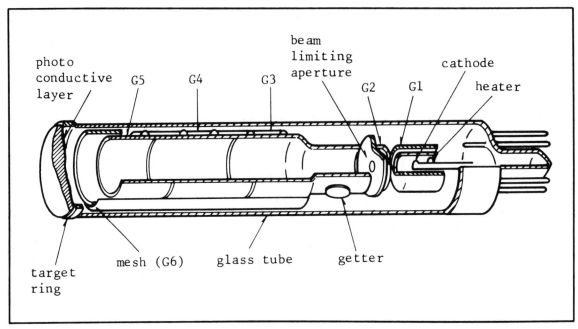

Fig. 19-22. Construction details of the Newvicon.

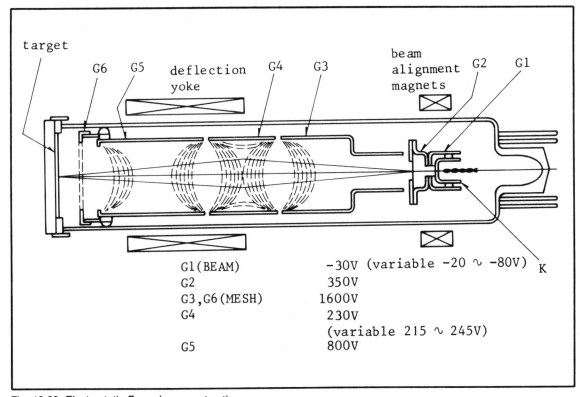

G1(BEAM)	−30V (variable −20 ∿ −80V)
G2	350V
G3,G6(MESH)	1600V
G4	230V
	(variable 215 ∿ 245V)
G5	800V

Fig. 19-23. Electrostatic Focus lens construction.

focuses it onto the face of the pick-up tube. The photo-conductive layer creates a number of individual target elements. These elements are made up of electrostatic capacitance paralleled by light-dependent resistors (Fig. 19-24) forming an RC time constant.

The electrostatic capacitance is basically formed between the nessa glass and the back surface, where the beam strikes the photo-conductive layer which acts as a dielectric. The target elements are all connected on one end to the signal electrode. The other end is unterminated and ready to receive the beam.

When there is no light striking the face plate of the pick-up tube, the light dependent resistors create a high resistance. Whenever light hits the

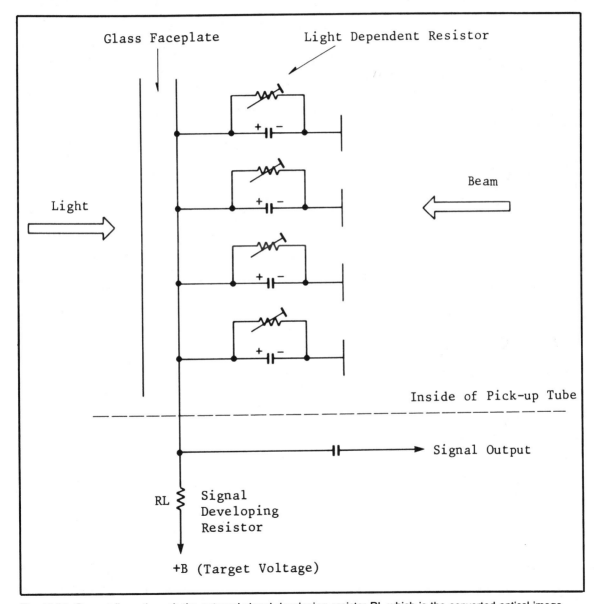

Fig. 19-24. Current flows through the external signal developing resistor RL which is the converted optical image.

face of target area, the resistance drops—the level depending on the amount of intensity of the light.

When a positive voltage is applied to the target (target potential), all the RC networks or elements will charge as the beam first scans the target area.

When the beam is not in contact with the element, the capacitor will slowly discharge through the light-dependent resistor connected across it. Keep in mind that each element's resistance will vary depending on the light level. On subsequent scans of the beam, the capacitors will recharge back to the target potential.

It is this charging current that is sensed to produce the video signal. When the beam scans the target, electrons are deposited on the positively-charge areas, which will return them to the negative potential of the cathode. This causes current to be produced which flows through the external signal developing resistor RL (see Fig. 19-25), and it's this changing current (dependent on light) which is the converted optical image.

Description of the Newvicon Electronic Circuits

The Newvicon pick-up tube is distinguished by the newly-introduced photo-conductive material composed of zinc selenium and the annealed bond of zinc tellurium/cadmium tellurium (ZnSe-ZnCdTe) that is coated in two layers on the stripe filter of the tube.

New Features

1. *Dark Current Characteristics* The Newvicon tube can be satisfactorily operated by using less than one-fortieth of the dark current that is constantly needed to drive conventional vidicon tubes. Also, even though the ilumination signal level is extremely low, due to the stable flow of the dark current, the Newvicon tube produces a very clear picture at all times.

2. *Residual Image* The Newvicon tube reduces the residual image to one half the level of

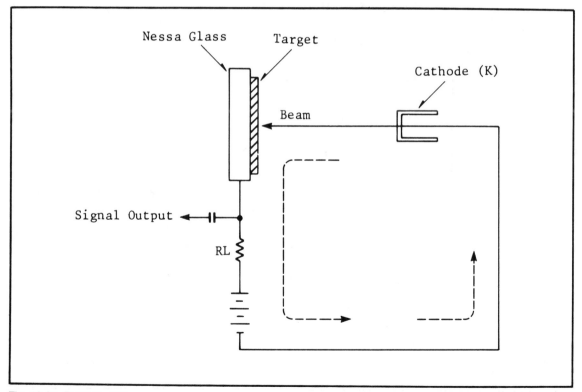

Fig. 19-25. Electron path.

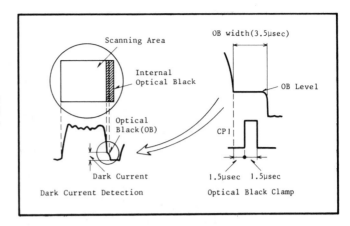

Fig. 19-26. The Newvicon tube detects the optical black (OB) current in the same way as conventional vidicons.

conventional vidicons. Even though the illumination is noticeably low, the Newvicon tube displays sharply improved performance.

3. *Removal of the "Blooming"* Silicon-based vidicon tubes are usually used when high sensitivity is required. However, the image produced by this tube adversely affects the peripheral portions of the picture when an intense light is sent in the tube, and as a result, the image can be visually multiplied several times the actual size. This is called "Blooming".

4. *High Resolution* The resolution of the Newvicon tube can be controlled, depending on the size of the beams. Thus, like the conventional vidicon tubes, the Newvicon tube has a very high resolution.

5. *No Stationary Burn* The Newvicon tube is virtually free from burn under normal conditions. Very slight burning may occur if the tube has continuously received an image with a drastic contrast in light, however, it will never remain on the tube permanently.

6. *Photo-Electric Conversion Characteristics* Since the gamma characteristic is held constant at 1.0 in the Newvicon tube, very satisfactory color balance can always be assured.

7. *Dark Shading* Due to the short flow of the dark current, the Newvicon tube can basically

do away with the dark shading compensation circuit otherwise needed for the deflection circuit. The Newvicon tube detects the optical black (OB) current in the same way as conventional vidicons, by controlling the width of the OB current at 3.5 μsec. using the right end of the tube. (Fig. 19-26).

The Newvicon tube needs only 0.3 to 0.4nA of dark current during operation, whereas a conventional vidicon tube needs about 20nA. However, since the signal characteristics are not sufficient during the rise-up, as the equilibrating means, about 15nA of the dark current is fed to the Newvicon as a means of establishing equilibrium by referring to the bias light.

Versatility of the Newvicon Video Camera

As in conventional vidicon camera, the Newvicon video camera can effectively be applied to a variety of uses; surveillance, industrial and medical applications, plus personal indoor/outdoor entertainment. The Newvicon video camera is particularly advantageous when a conventional vidicon camera does not have the required sensitivity, or when burning is a critical problem.

1. *Surveillance in the Low-Illumination Sites.* The Newvicon video camera is ideally suited for surveillance of warehouses, parking areas, and other facilities where special illumination is not available.

Under bulb-illumination, the Newvicon tube has the same sensitivity as the silicon-based vidicon tube which has the highest sensitivity. However,

Fig. 19-27. Bias light circuit consists of four red LEDS.

under fluorescent lamp illumination, the Newvicon tube surpasses the silicon tube in sensitivity.

2. *For Connection to an X-Ray TV Set.* Since the Newvicon tube is highly sensitive to the fluorescent surface of the image intensifier of an X-ray receiving TV monitor, the operator can minimize the potential hazard of X-ray exposure during operation. Also, since the residual image is controlled at the proper level, the quantizing noise can also be minimized, enabling the viewer to view the image more comfortably.

Bias Light Circuit

In order to obtain improved low-illumination characteristics of the Newvicon tube, a very small current (about 20nA) is fed to the Newvicon tube.

The bias light circuit consists of four Red LEDs (Fig. 19-27). When the power is On, they feed a certain amount of light to the Newvicon film so that the residual image can be minimized.

These four Red LEDs are installed at the upper rear end of the Newvicon tube as shown in the drawings below, and the light is applied to the tube

Fig. 19-28. LEDS are installed at the upper rear end of the Newvicon tube and the light is applied to the tube film through the wall of the table.

film through the wall of the tube (Fig. 19-28).

Gamma Characteristics

The gamma characteristics are identical to the photo-electric conversion characteristics. When indirect light hits the target, the signal output increases. The relationship of the incident light and the signal output is called "Gamma", or "Transfer Characteristic".

The Newvicon tube has a maximum gamma value of 1.0, while the cathode ray picture tube has a transfer characteristic with a maximum value of 2.2.

In order to properly control the photo-electric

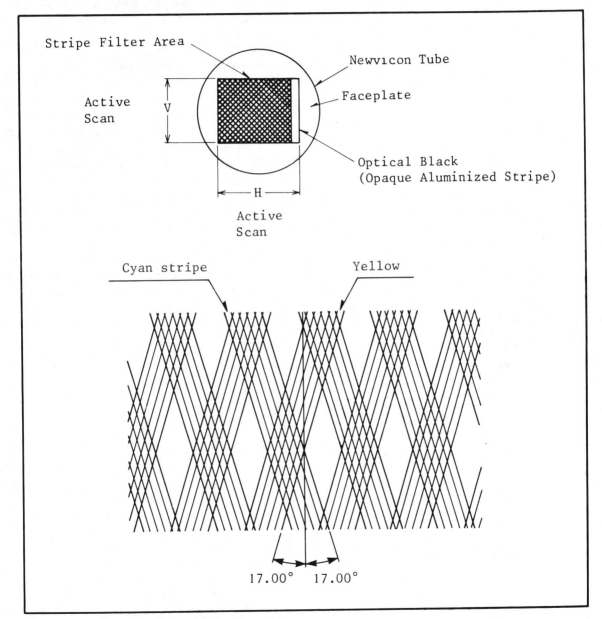

Fig. 19-29. Newvicon Faceplate and Stripe filter.

conversion characteristics and cope with the 2.2 gamma value of the cathode ray picture tube, the gamma value of the video camea must be carefully set at 0.45 by means of the electronic circuit. The Newvicon video camera uses a vidicon that has a maximum gamma value of 0.7, allowing the electronic circuit to precisely control the gamma value for the camera at a constant 1.0.

Stripe Filter

The operation of the stripe filter on the face plate of the pick-up tube depend on several facts which bear review. The composition of what is perceived as white light is a mixture of many wavelengths, which we can group by wavelength or color (A of Fig. 19-30).

While it may be apparent that all the wavelengths or colors will pass through a transparent filter, one must consider the operation of a filter of complimentary colors.

In a tricolor system of colorimetry (B of Fig. 19-30) any two primary colors may be mixed to form a secondary color which is not one of the original three primary colors but the exac opposite of the unused primary color.

White light passed through a filter of this new, secondary color willcontain both of the original colors but none of the complementary color.

Imagine a filter of yellow, a color which is made from Red and Green.

Should white light be passed through this yellow filter, Red, Green and some Magenta and Cyan light will pass, but blue light will not pass. Similarly, if a cyan filter were used, all but Red would pass. Lastly, the use of a color filter will of course allow the passage of image details—for example, the shape, outline and reflectance of the objects seen by a lens—if an image were used in place of the white light described above.

The stripe filter pick-up tube is based on these three details:

1. The color of any object can be carried by the information in the three primary colors.

2. When red, blue and green are used as the primary colors, 56% of the visual information and light energy is green.

3. A cyan filter will pass green and blue (but not red) and a yellow filter will pass green and red (but not blue) (Table 19-1).

Now, let's discuss the color portion of the pick-up tube. When a thin film filter such as that depicted below is placed on the face plate, both the filter stripes and the image from the camera lens will be in focus without the use of additional lenses.

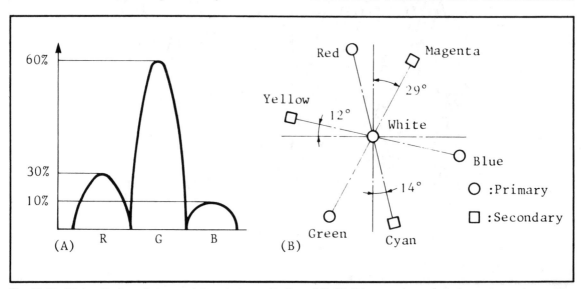

Fig. 19-30. (A) Amplitude and phase relations between R, G, and B. (B) Primary colors mix to form a secondary color.

Table 19-1. Color Passed by Stripe Filter.

COLOR STRIPE FILTER	COLOR PASSED
Transparent (Clear)	Red, Blue and Green
Cyan	Blue and Green
Yellow	Red and Green
Cyan and Yellow	Green

The tube alignment and rotation assure that the horizontal scan exacty bisects the angle formed by the stripes, while vertical scan determines that each horizontal scan falls.

Furthermore, the width of each stripe and of the horizontal scan determines the characteristic frequency of the process, in this case, 5 MHz. As light falls on the stripes, the contrast pattern formed by stripe/no stripe/stripe will optically generate an R.F. carrier above the fundamental luminance information (picture detail). This carrier rides above the luminance.

The integral stripe filter consists of a cyan/transparent stripe filter section and a yellow/transparent stripe filter section. (Fig. 19-31).

These stripe filters are so arranged as to be of the same pitch in the horizontal scanning direction, and of equal angle in the vertical direction. The pick-up tubes even and odd scanning lines pass the elements of the stripe filters that are arranged in a fixed pattern.

Let's assume that a white light of uniform level containing proportioned green (G), red (R) and blue (B) reaches the Newvicon, and the cyan and yellow stripe filter is scanned.

The cyan filter cuts off the R light which is complimentary to cyan, and the yellow filter cuts off the B light which is complimentary to yellow. At the N scanning line, the signal E contains the modulated R and B signals, and G signal.

At the next horizontal scanning line N + 1, the signal F also contains the modulaed R and B signals and G signal. The stripe filters have the same pitch in the horizontal scanning direction and the same angle in the vertical directions so that there is a carrier phase difference of 90° between the N line and the N + 1 line modulated signals. This modulation frequency for the R and B signals can be calculated from stripe width, pitch, and scan width and velocity, in this case, 5 MHz.

The incoming light is thus converted by the integrated stripe filter into a signal modulated to 5 MHz. This signal is sent to the pre-amplifier where it is amplified (Fig. 19-32). The amplified signal G from the preamplifier is sent to a low pass filter circuit, which passes only the luminance (YH) signal (H)) making up the G signal. The amplified G signal is also supplied to the high pass filter (HPF) whose frequency is 5 MHz, through which only the modulated signal 1 passes.

The modulated signal 1 is sent to the 90° phase shift circuit and the 1H (1 line) delay circuit, from which 90° phase-shifted and 1H-delayed, modulated signals J and K are obtained.

The modulated R (Rc) signal (L) is obtained by adding the modulated signals (J) and (K), and a modulated B (Bc) signal (N) is obtained by subtracting the modulated signals (J) and (K).

The Rc and Bc signals obtained by addition and subtraction re supplied to the detectors, from which R signal (M) and (B) signal (O) are obtained.

CORRECTION CIRCUITS

There are two main aspects we have to consider when we think of light. The first is the brightness or intensity and the second is the color temperature (Table 19-2).

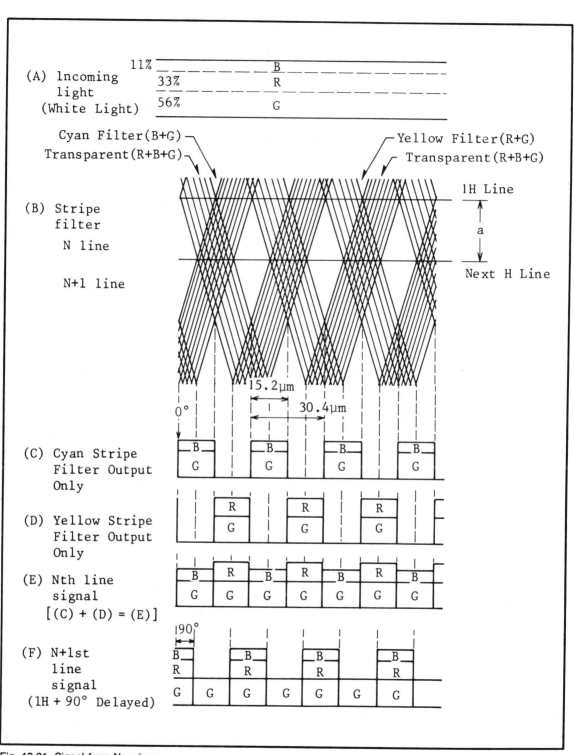

Fig. 19-31. Signal from Newvicon.

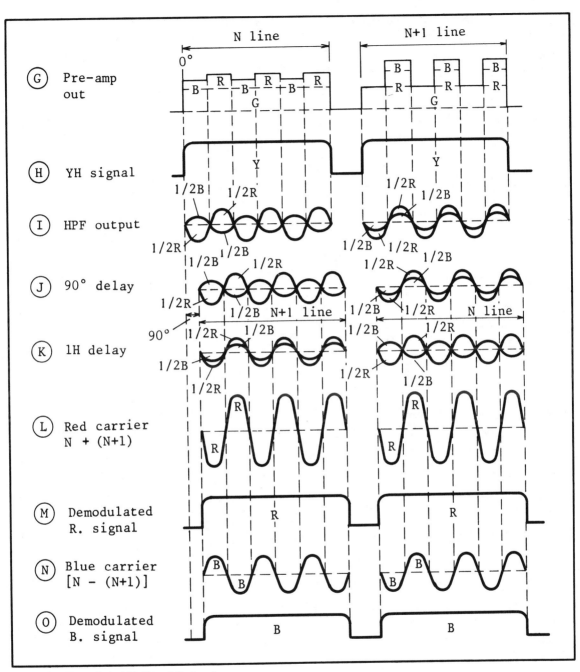

Fig. 19-32. Detection of Y, R and B signals.

Color Temperature Correction

Light is made up of a spectrum of frequencies or colors, with violet being the lowest frequency and red being the highest (Fig. 19-33 and Table 19-3).

The human eye has a unique ability to perceive color correctly even when the light source is changed (i.e., when color temperature varies) from pure white to red-white or blue-white. However,

Table 19-2. Rough Values of Brightness. (The figures in this table are approximate values for reference.)

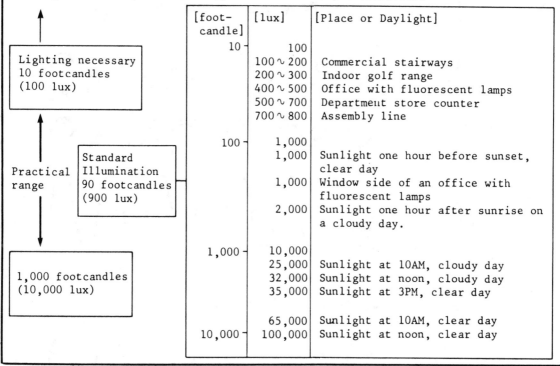

CORRECTION CIRCUITS

(1) Color Temperature Correction

There are two main aspects we have to consider when we think of light. The first is the brightness or intensity (Fig. 14) and the second is the color temperature.

Rough Values of Brightness

The figures in this table are approximate values for reference.

	[foot-candle]	[lux]	[Place or Daylight]
	10	100	
Lighting necessary 10 footcandles (100 lux)		100 ~ 200	Commercial stairways
		200 ~ 300	Indoor golf range
		400 ~ 500	Office with fluorescent lamps
		500 ~ 700	Department store counter
		700 ~ 800	Assembly line
	100	1,000	
Standard Illumination 90 footcandles (900 lux)		1,000	Sunlight one hour before sunset, clear day
Practical range		1,000	Window side of an office with fluorescent lamps
		2,000	Sunlight one hour after sunrise on a cloudy day.
	1,000	10,000	
		25,000	Sunlight at 10AM, cloudy day
1,000 footcandles (10,000 lux)		32,000	Sunlight at noon, cloudy day
		35,000	Sunlight at 3PM, clear day
		65,000	Sunlight at 10AM, clear day
	10,000	100,000	Sunlight at noon, clear day

machines do not have such ability, and "see" even the slightest color change.

The color mix of what we perceive as white light will change.

*** Tristimulus Values:** The amount of the three primary colors required to produce white light.

As we move from indoor artificial light to sunlight, objects illuminated by these different light sources will change the proportions of the red and blue signals and the cameras output will appear to be miscolored. Cameras are normally adjused to 3200° Kelvin Temperature (Fig. 19-36).

It is for this reason that we have an automatic white balance control switch and color control knob mounted on the back of the camera. With these controls, the proportions of the red and blue signals can be changed to achieve a better white balance.

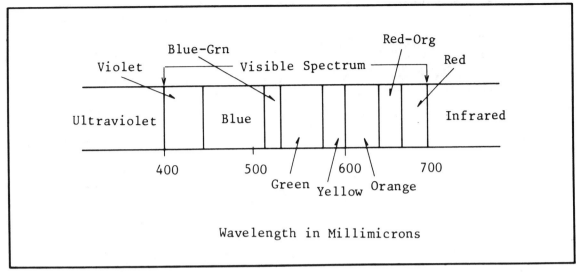

Fig. 19-33. Light is made up of a spectrum of frequencies.

At 3200° K we have a more reddish picture, so less gain is required in the red channel and more in the blue channel.

At 5000° K or 5500° K, we have a more blueish picture and less blue gain is needed and more red.

V Edge Color Error Correction

As described, the Rc and Bc signals are separated from each other by addition and subtraction of the Rc/Bc signal delayed one horizontal line and the undelayed Rc/Bc signal.

When the camera views a dark-to-bright, or bright-to-dark transition, (Fig. 19-34). The undelayed Rc/Bc signal appears, (C) and the Rc/Bc

signal delayed one line (1H) appears as in (D). When we make the transition from dark to bright the Rc/Bc (C) and (D) signals are not of equal level on the N + 1 line and an error signal (green) is created along the vertical edge of the transition.

Thus it is necessary for us to supply a positive vertical (V) edge correction signal (E) to control the level of the N + 1 line (F). This provides vertical correlation between Rc/Bc signals delayed and not delayed ((C) and (D)) prior to color separation. If the transition is from bright to dark, the error signal will be magenta and a negative V correction signal will be used. We will discuss this is more detail later.

Table 19-3. Color Correction Table.

Light Source		Filter Switch	Normal Color Correction	Color Temperature
Studio lighting, such as Halogen lamp or tungsten lamp				3200°K
Room light	Incandescent Lamp			4500°K
	Fluorescent			5000°K
Outdoor scene (sunny or overcast)				5500°K

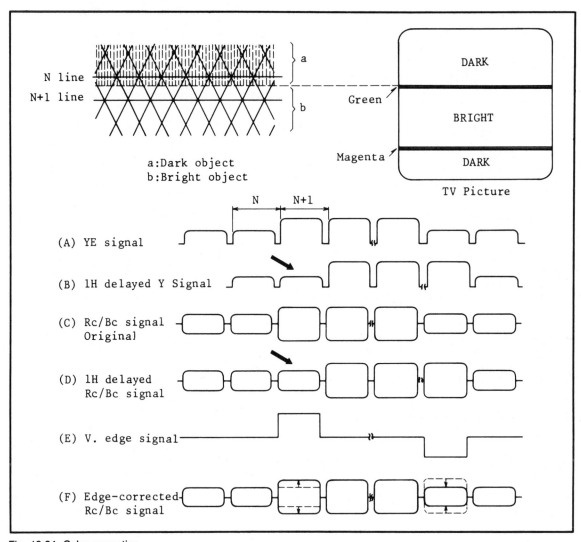

Fig. 19-34. Color correction.

Color Shading Correction

Often the photo conductive layer on the surface of the pick-up tube is uneven. It is necessary to electrically correct for this unevenness. Suppose a uniformly illuminated white object is seen by the camera and the R color component signal has a shading (error).

In this case, a shading correction signal (B) is generated by the shading correction circuit (which is set to the proper level during alignment).

The R signal (A) is modulated by the shading correction signal (B), and a corrected R signal (C) is produced. This shading correction signal is mixed with the R signal (C) by a differential amplifier, and the R signal (D) is obtained. The color shading correction of the B signal is similar.

These correction waveforms are horizontal rate sawtooth and parabola waveforms. The two signals are formed from the horizontal deflection drive and injected in just the right amount to get an overall flat color waveform (Fig. 19-35).

De-Gamma Correction Circuit

As described earlier, the pick-up tube does not

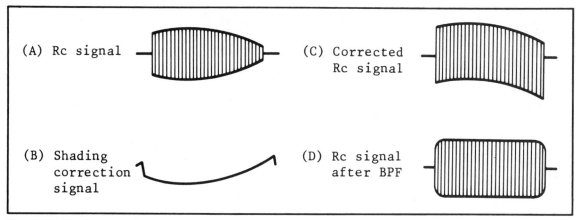

Fig. 19-35. Shading correction.

have linear photo-electric conversion characteristics. A typical pick-up tube gamma characteristic is shown in Fig. 19-36.

Because of this inherent characteristic, the higher levels of the video signal will be compressed.

Since the pick-up tube in this color camera produces 5 MHz modulated red (R) and blue (B) signals mixed with a green (G) signal (see Fig. 19-37) the higher levels of the modulated R and B signals obtained by separating the mixed signals are also compressed (B). The de-gamma correction signal circuit generates a de-gamma corretion signal (D) to compensate for the compression of the higher levels of the R and B signals.

This correction signal will be applied to both the Rc and Bc circuits as needed.

Optical Black Clamp

A metallic stripe (optical black) (Fig. 19-38) is built into the pick-up tube for cutting off the incoming light at the end of the horizontal scanning. When the beam scans the optical black portion, the dark current of the pick-up tube is sampled and is clamped to a fixed dc potential, so that the black level variations due to a change in dark current can be tracked.

High Luminance Chroma Clip Circuit

When the incoming light is extremely bright, the luminance level increases in direct proportion to the incoming light, therefore, the modulated chroma signal from the pick-up tube is lowered in the inverse proportion to the incoming light until

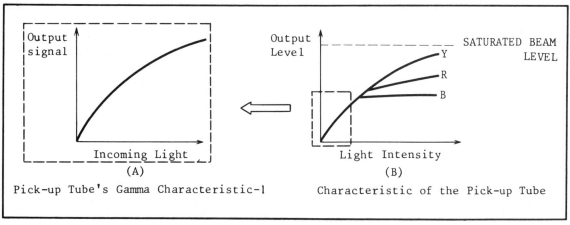

Fig. 19-36. De-gamma correction circuit.

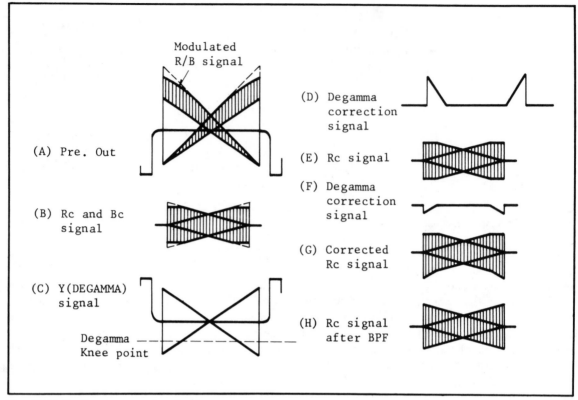

Fig. 19-37. De-Gamma correction signal.

it finally disappears, resulting in a greenish picture on the TV screen and loss of white balance.

Therefore, a signal must be sent to the encoder to turnoff the NTSC chroma modultors at peak whites (Fig. 19-39). Since the chroma informtion in the NTSC signal is difference information, the lack of chroma makes the peak signal appear white, rather than miscolored (greenish picture).

Horizontal Aperture Correction

The electronic beam has some thickness, so that when the electronic beam scans the pick-up tube face or CRT, it causes some loss of resolution.

To enhance the horizontal resolution, a correction circuit generates a horizontal aperture correction signal (Fig. 19-40).

Overall Block Diagram and Description

Let's look at the simplified overall block diagram in Fig. 19-41. The Newvicon tube S4165

is supplied with not only high voltae for tube elements, but also with horizontal and vertical drives for the deflection coils wrapped around the pick-up tube.

The pick-up tube is also supplied with a target voltage through the pre-amp. The output of pick-up tube.

The pick-up tube is also supplied with a target voltage through the pre-amp. The output of pick-up tube is amplifier (80dB) and maintained a good S/N ratio by the preamplifier circuit.

The signal is now sent to the process and encoder circuits for the video to be amplified and to seprate the luminance from the red and blue carriers.

It is also gamma and de-gamma corrected, V edge-corrected, color shading corrected and also temperature-corrected. The signal is also sent through a matrix to produce R-Y and B-Y components. The R-Y and B-Y signals are modulated

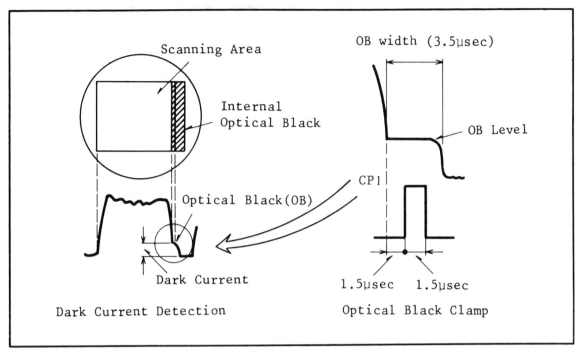

Fig. 19-38. Optical Black Clamp.

with red and blue carriers. The signal is further clipped and finally sent to an AGC circuit and out to the EVF and NTSC output. The process and encoder circuits also drive the automatic iris. The sync generator supplies the process and encoder circuits with the necessary drives and carriers. The camera can be powered by the VCR or with an AC power supply.

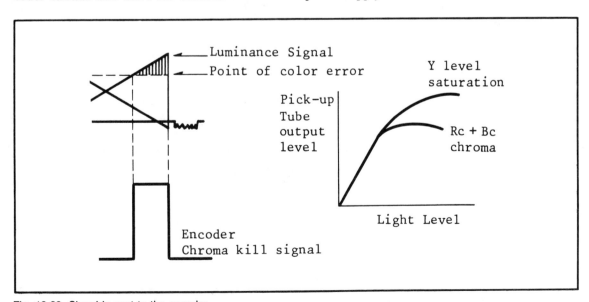

Fig. 19-39. Signal is sent to the encoder.

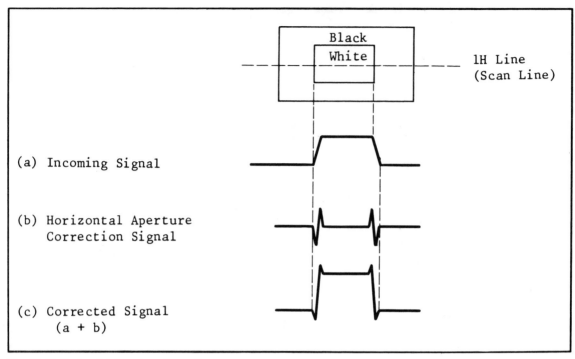

Fig. 19-40. Horizontal Aperature Correction.

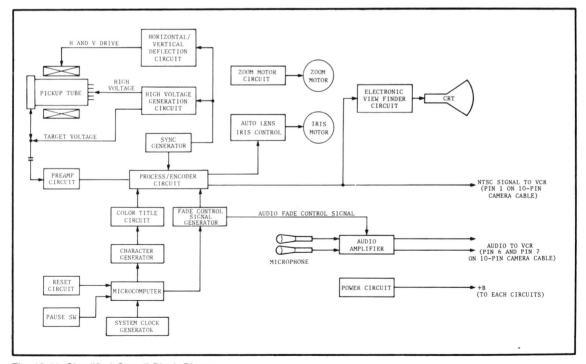

Fig. 19-41. Simplified Overall Block Diagram.

Chapter 20

Video Trends

Trends continually change, upgrading video cameras as they become more compact and operationally efficient. In this chapter we will examine features of up and coming videocamera offerings.

MINI-CAMS

The newest, scaled down mini-cameras are much the rage with home movie buffs of old; they are compact, and easy to transport and use, even though in some cases a separate portable VCR is also essential. The mini-cams will adapt to existing portable VCR units as well as standard home console units (direct or through "black box" power adapters).

The mini-cam is small and fits easily into the palm of the hand (Fig. 20-1), with all pertinent controls at the fingertips. A number of mini-cams are enjoying success in the field offering resolution quality akin to larger videocamera issues.

The Quasar 714XE (Fig. 20-2) by Matsushita offers all features such as auto-focus, power zoom, low light efficiency, auto white balance, and corrective eyesight eyepiece. It is a true "palm"

camera; extremely light with major controls finger tip accessible. A "less frill" model, the VK704XE is also marketed with manual focusing which to this author is preferable. This author feels that auto focus lenses tend to "float" in and out of focus effected by such extraneous factors as ambient light changes, dominant movement (subject) and predominantly light areas.

Similar palm cameras of the VK714 and VK704 design are marketed by Canon, Panasonic, Curtis-Mathes and GE with only brand marques as differentiation.

The GX-N7 compact Lo-Lux camera from JVC (Fig. 20-3) relies on the new 1/2-inch Newvicon tube for image pickup and weighs about two-and-a-half pounds. It contains a TTL infra-red auto focus system. Auto color tracking using a new semiconductor color sensor eliminates the need for troublesome white balance adjustment. Auto focus also provides a manual override for under unusual lighting conditions. With a 6X power zoom lens as standard issue, the GX-N7 can utilize auxiliary lenses designed for 35mm cameras marketed by

Fig. 20-1. Palm cameras are small, compact, and they offer high resolution.

Fig. 20-2. Quasar 714 XE mini-camera.

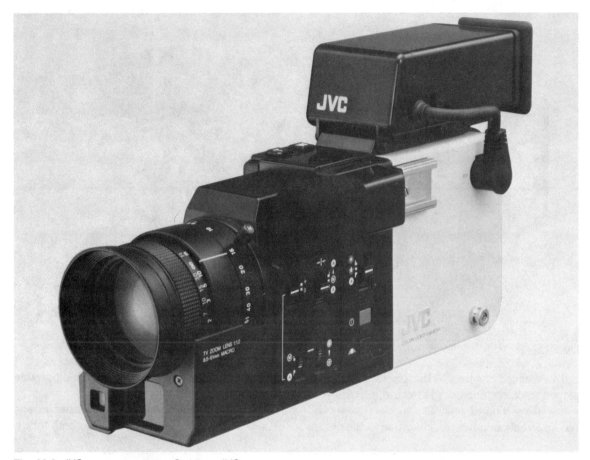

Fig. 20-3. JVC compact camera. Courtesy JVC.

most single lens reflex manufacturers.

The Minolta K 520S-AF mini-camera packs all of its useful features into an excellent mini-cam package. It weighs three-and-a-half pounds, featuring an electronic viewfinder as well as video and sound fading, 6:1 power zoom, auto-manual focus switch and variable iris/white balance controls. This little camera produces some of the most accurate colors in videocameras to date.

CAMCORDERS

The most recent advances in Video technology have served to produce the "Camcorder," in all-in-one combination of video camera and cassette recorder. In the camcorder, the cassette is housed in the elongated camera body making the entire entity almost as compact as some older 16mm movie cameras. Serious videophiles will soon discover that the camcorder is the ideal camera for optimum videography. The following units are worthy of merit and considered top offerings in the camcorder field.

The JVC GR-CIU VHS videomovie is the smaller and lighter of the half-inch camcorders weighing a mere 4.3 pounds. Its recorder faction employs a new four-head sequential system utilizing a newly developed miniature drum system and a 270 degree wrap parallel loading system (see Fig. 20-5). The tape signal pattern maintains full VHS compatibility for excellent reproductive quality. The GR-CIU contains a 1/2 inch "High Band" Saticon tube for pickup as well as a 1/2 inch electronic viewfinder. This camcorder permits both camera recording and playback relying on a spe-

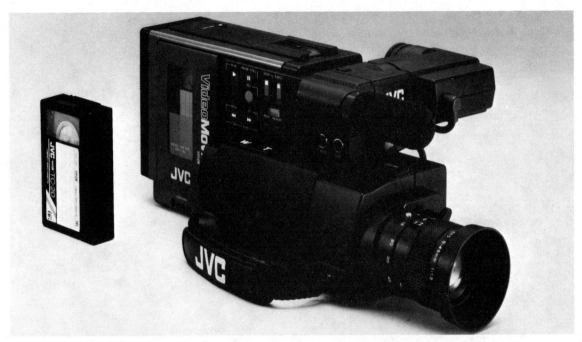

Fig. 20-4. JVC-VHS Videomovie camcorder.

cially designed compact VHS cassette that can be played back in standard VHS console VCRs with a special insertion adapter. The special cassette will record twenty minutes of video. Due to the design factors of this unit, it is most compact and portable (Fig. 20-6).

Betamovie is Sony's answer to the camcorders; the newly designed Beta format unit is both formi-

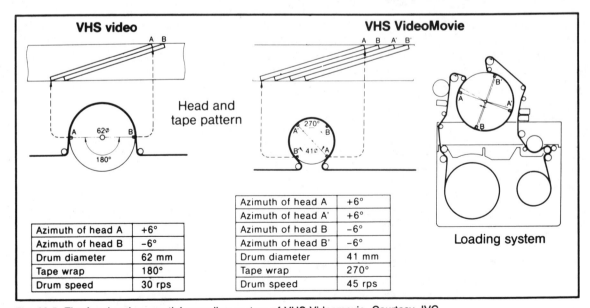

Fig. 20-5. The four-head sequential recording system of VHS Videomovie. Courtesy JVC.

Fig. 20-6. The JVC Videomovie is light, compact, and easy to carry. It is a good all-in-one camcorder.

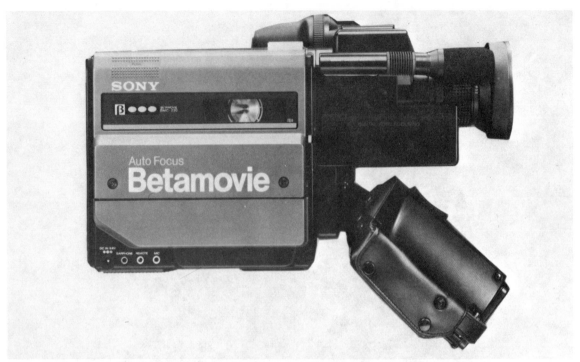

Fig. 20-7. Sony Betamovie camcorder. Courtesy Sony.

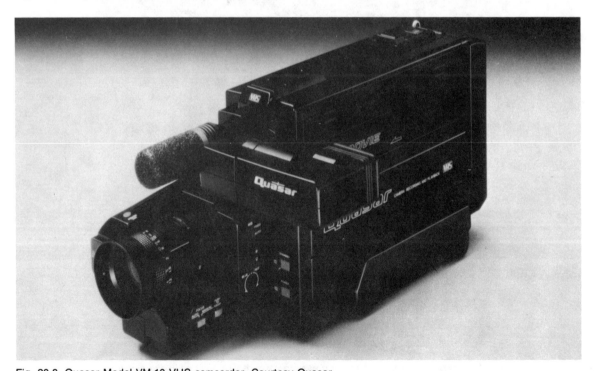

Fig. 20-8. Quasar Model VM-10 VHS camcorder. Courtesy Quasar.

dable and efficient as well as very high in resolution quality. The Betamovie BMC 220K system (Fig. 20-7) incorporates auto focus with manual override, CCD pickup for electronic detection of out of focus subjects plus a new 1/2 inch Trinicon pickup tube for excellent color reproduction stability and uniformity. The F1.2 lens offers low light sensitivity (35 lux), allows macro focus and 6X power zoom. The side mounted through-the-lens optical viewfinder includes five LED's to indicate auto focus, low light, white balance set, tape run and head cleaning requirements. The BMC-220K records in Beta II speed cassettes that insert readily into any Beta VCR for playback.

The Quasar VM-10 camcorder (Fig. 20-8) allows videotaping on standard size VHS video cassettes operating on battery pack, ac converter or car battery. An infra-red focusing system gives correct focus throughout shooting allowing manual focus setting for special situations.

The VM-10 is equipped with a 6X zoom lens with macro capability. The electronic viewfinder provides electronic review; after shooting a scene, pressing a REC-REVIEW button allows the operator to monitor the last few seconds videotaped. The VM-10 recording system consists of four heads mounted 90 degrees apart with tape loading 270 degrees around the cylinder. By switching the video signal between the four heads, the same head tracing pattern is achieved as in a two-head VHS video cassette recorder where tape is loaded 180 degrees around the cylinder. To obtain equal head-to-tape speed the direct drive cylinder rotates at 45 R.P.S. 1.5 times the usual cylinder speed. The VM-10 is one of the leading VHS camcorders. Similar camcorders in the same format will be marketed by Panasonic, GE, Curtis-Mathes, and Magnavox is also due to release their camcorder immediately.

8MM VIDEO

This newest of video formats is slowly gaining acceptance; its true impact is yet to be evaluated. Polaroid and Kodak were the first to introduce and pioneer this format and the first 8mm units were conceived as camcorders which seem to be the standard in 8mm video. The latest company to go 8mm is Canon and their system camera weighs a minimal 3.2 pounds. Optional power supply offerings for the Canon are a 40 minute battery or an ac power adapter pack. The VC-200 can be used with the Canon VR-E10 portable video recorder for in-the-field videography.

Performance in 8mm is less sharp, not as refined as in VHS or Beta half inch formats. What improvement in resolution quality the future will bring has yet to be seen.

The Kodavision 2400 camcorder 8mm system by Kodak has gained some favorable acceptance. It offers many features the video public has grown accustomed to in the half inch VHS and Beta formats: Macro, zoom, auto/manual focus, white balance etc. The Kodavision system consists of a light camcorder, cradle, tuner-timer, ac or battery power supply, two types of 8mm videotape and slide to tape devices making it a wide range system.

Polaroid convinced of 8mm's potential is marketing a Toshiba made camcorder using a metal oxide semiconductor (MOS) charge coupled device image sensor. The Polaroid 8 camcorder (weighing 4 1/2 lbs.) plays back through a docking deck that will connect to a TV or monitor for viewing on a VCR deck for dubbing. Other features of the Polaroid include an F 1.4 9.5 - 57mm power zoom macro lens, low light (30 lux) capability, wired remote and LCD tape counter.

RCA at this point is not taking 8mm seriously (nor is Hitachi). GE is having problems with their system, so it will not release their version till the problems are solved. Sony intends to invade the 8mm market as well even though at present the company only provides metal particle videotapes for the 8mm consumer market.

It is too early to discern what will transpire between 1/2 inch format video and 1/4 inch. I believe that VHS and Beta will always remain the high level, quality formats. It is doubtful that 8mm can offer real competition, only serving as a third alternate system, more favorable to the casual videophile or home movie buff.

Glossary

ACC—Automatic color control used in color circuits to maintain constant color signal levels.

adjacent track—Video track adjacent left or right to track of concern.

AFC—Automatic Frequency Control.

AGC—Automatic Gain Control.

APC—Automatic Phase Control.

audio dubbing—Process in which audio is transferred to video tape.

audio track—Sound track of videotape.

Azimuth—Terminology describing left to right tilt of recording head gap if it is viewed head on.

B/W—Black and White.

C signal—Color portion of videosignal (also known as Chroma).

cel animation—Animation art procedure where separate drawings to comprise consecutive movement are rendered on "Cels" or acetate sheets.

computer animation—Pseudo animation, somewhat more static than true animation composed with the aid of computers to provide designs and graphics.

control signal—Signal recorded on videotape which during playback serves as reference for servo circuits.

crosstalk—Overspill of signals from one track to an adjacent one.

cuing—Scanning videotape at faster than normal forward speed.

Degrees Kelvin—Light measurement factor to indicate color temperature.

dropout—A momentary absence of signal in the tape usually due either to uneven oxide or dust on the tape or dirt and oxide buildup on the video heads.

EQ—Equalization.

field—One half of TV picture; a field is comprised of 262.5 horizontal scanning lines (on picture tube). Two fields are necessary in order to compose a fully scanned picture (frame).

head cylinder—Cylindrical drum housing the video heads.

jitter—Quivering effect or wow and flutter in which the picture appears to have a shaking movement.

pixilation—Form of animation utilizing still pictures in sequence.

review—Reverse direction playback viewing at faster than normal speed.

search—Picture review at fast forward or fast reverse direction.

tracking—Playback action of spinning video heads when accurately tracking Video rf information on tape. Good tracking prevails when the heads are correctly positioned, thus picking up the entire rf signal. When the heads are misaligned, inadequate signals and noise are picked up.

video head—The electromagnet which develops magnetic flux alternately transferring rf signals onto the videotape.

video track—Picture producing track of the videotape.

VCR—Video Cassette Recorder.

Y Signal—Black and white portion of video signal containing B & W information and synchronization.

Index

OTHER POPULAR TAB BOOKS OF INTEREST